SO-BEZ-897

THE EVENING DRESS

First published in the United States by
Rizzoli International Publications, Inc.
300 Park Avenue South, New York, NY 10010
www.rizzoliusa.com

First published in the United Kingdom by
Scriptum Editions
565 Fulham Road, London, SW6 1ES

Produced by Bound Creative for
Co & Bear Productions (UK) Ltd.

Executive Director David Shannon
Jacket Design Andrew Prinz
Publishing Assistant Ruth Deary
Indexer Dorothy Frame
Rizzoli Editor Eva Prinz

Third printing in 2005
10 9 8 7 6 5 4 3
ISBN-10: 0-8478-2468-1
ISBN-13: 978-0-8478-2648-3
Library of Congress Control Number: 2004094658

Additional Picture Credits
pages 4–5 photo: Peter Lindbergh for US Vogue;
models: Christina Kruse, Shalom Harlow, Carolyn Murphy,
Ling Tan, Margaret
page 6 photo: Tim Walker, courtesy Bluemarine
pages 8–9 photo: Christophe Kutner; model: Lisa Winkler,
wearing Atelier Versace (left) and Chanel Haute Couture (right)

THE
EVENING DRESS

ALEXANDRA BLACK

RIZZOLI
NEW YORK

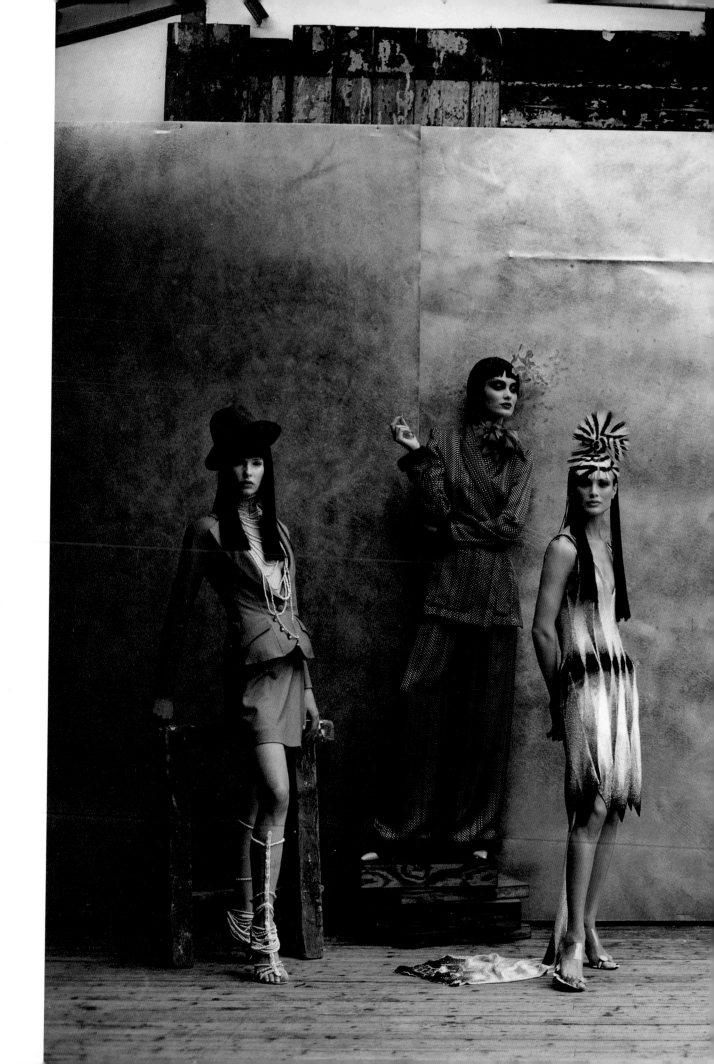

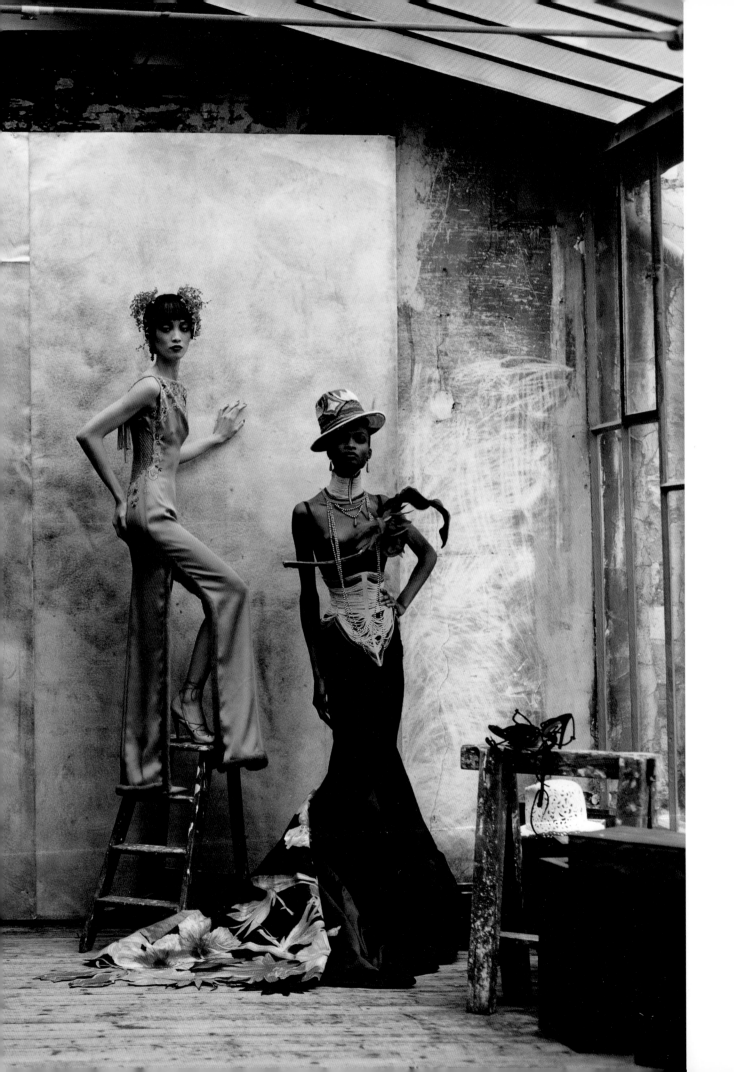

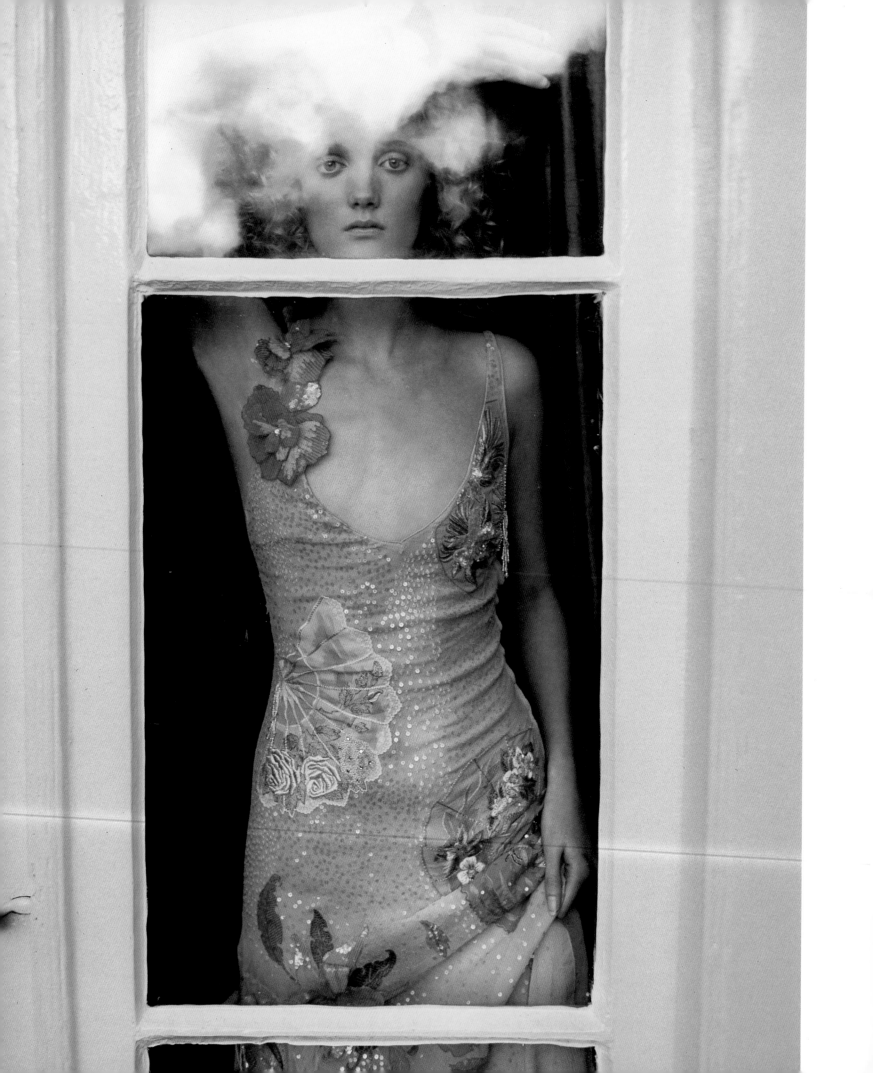

"O, thou art fairer than the evening air
Clad in the beauty of a thousand stars."
FROM *FAUSTUS*, CHRISTOPHER MARLOWE

Contents

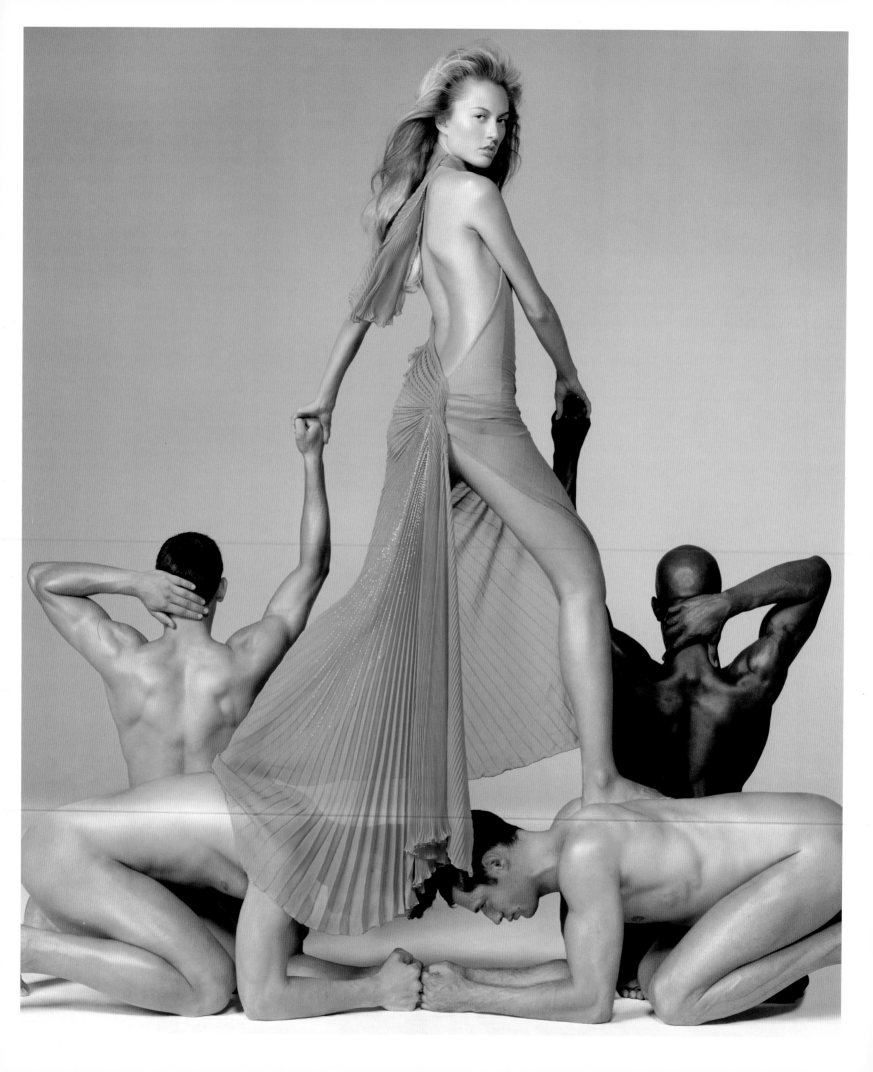

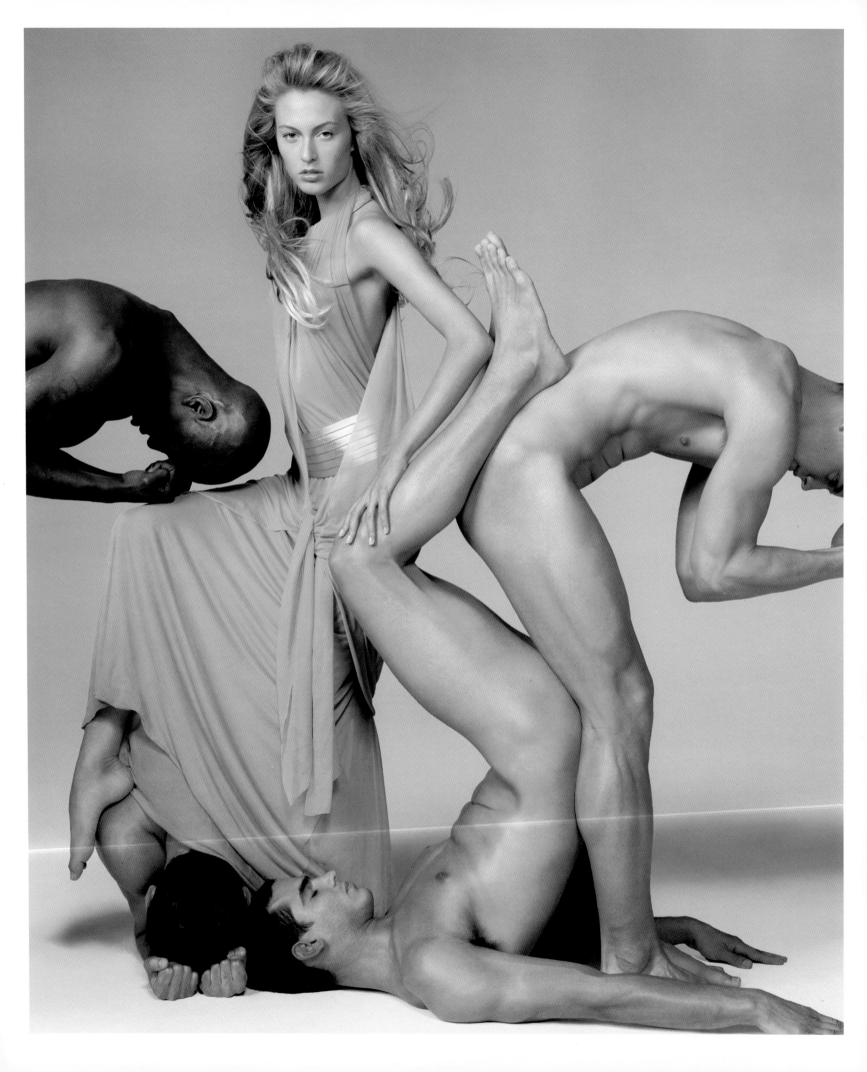

INTRODUCTION

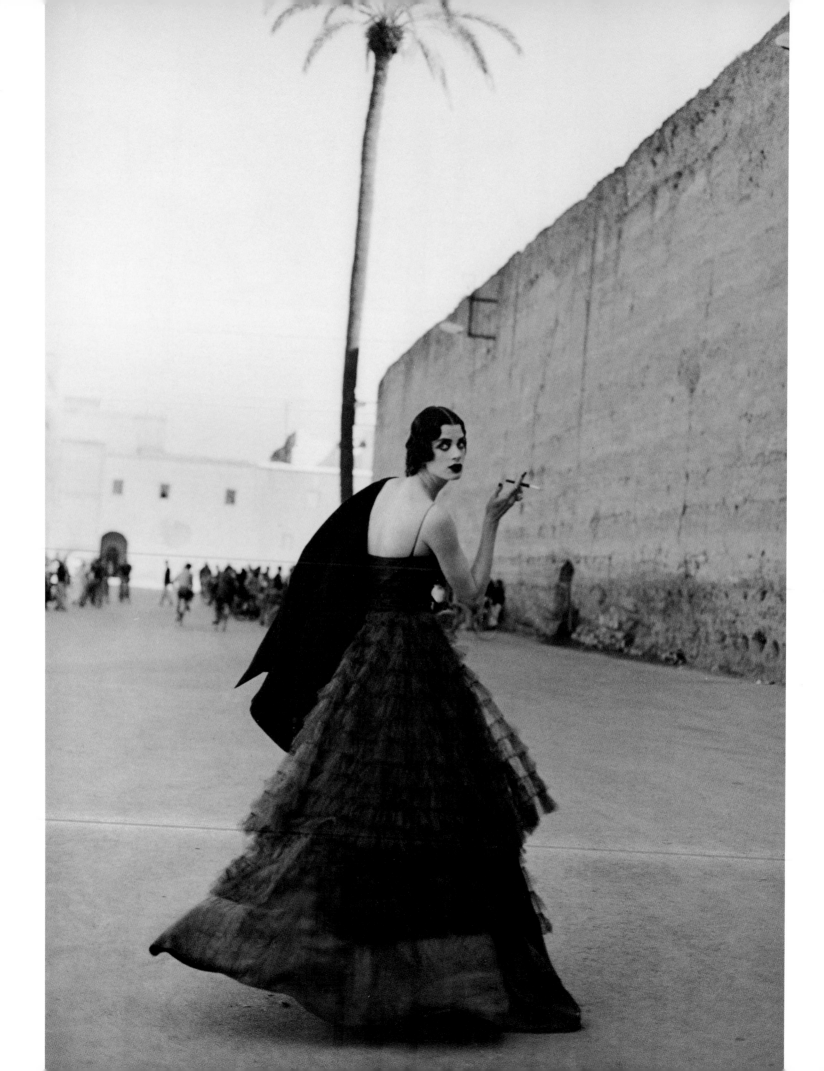

THE EVENING DRESS

"One should never give a woman anything she can't wear in the evening."
OSCAR WILDE, *AN IDEAL HUSBAND*

Dusk is a magical time. Brief and fleeting, lasting not much more than an hour, it marks the close of day and the onset of night. The light changes and so, too, does our mindset. The day is for work, the night is for rest and leisure. The daylight is clear and revealing, the night sky is luminous and mysterious. Day is for practical matters, night is for fantasy. What more tactile expression of the difference between night and day than the evening dress, a beautiful concoction designed to transform the wearer. An evening dress has the power to make a woman seducer, nymph, queen or coquette.

Even Coco Chanel, renowned for her low-key elegance and comfortable daywear, saw evening fashion as something quite separate, not to be constrained by matters of practicality. "Be a caterpillar by day and a butterfly at night," she advised. "Nothing could be more comfortable than a caterpillar and nothing more made for love than a butterfly." Sex, of course, is at the heart of the evening dress. The idea of taking on a different appearance at night for purposes of lovemaking, or at the very least romance, is ingrained in human culture. The classic story of Cinderella explores the magical transformation that can happen at night, leading to everlasting love and the life of a princess. For the character of Eliza Doolittle in *Pygmalion,* the process of her social escalation from cockney flower-seller to lady of elegance culminates at a grand ball, where in evening dress she outshines all others to attract the attention of the prince.

Historically, in well-to-do society, a teenage girl was introduced into adult circles by appearing at evening events — balls, dinners and parties — dressed up with a view to attracting a suitable mate. Her dress and toilette were designed to make her as alluring as possible, and also indicated her family's status by the style and ornamentation of the gown. Elements of this practice persist in the ongoing tradition of the debutante ball. Even in societies where little clothing is worn, the putting on of special

∞ *Peter Lindbergh's photograph of Kristen McMenamy was taken in Marrakech, Morocco, in 1990 for French* Vogue. *Entitled "Nuits d'Orient", it evokes the mysterious and seductive qualities of the evening dress, and the power of the woman who wears it. Intrigue is created through the combination of traditionally masculine and feminine elements. The confident pose of the smoking woman with her close-cropped hair, black eye make-up and tailored jacket contrasts with the delicate ruffles of the full skirt.*

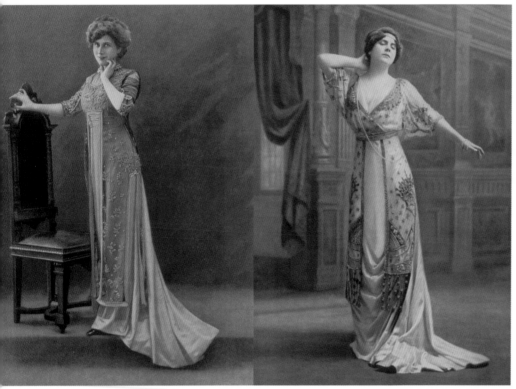

Babylonians, Persians, Syrians and Jews. Yet remnants of the old beliefs continue — the word fortnight means fourteen nights. And our regard for the mysticism of the night continues in ways we cannot always explain. The moon and the stars still seem to exert a mystical pull on our senses in a way that sun and blue skies cannot.

The sexual senses are among those most affected at night, and the evening is often a time of heightened sexual impulses. Just as the natural environment changes at dusk, there is also a change in the physiological state of humans. As darkness falls the pupils of the eyes dilate in order to allow more of the fading light onto the retina to facilitate vision. Our pupils also dilate when we are excited, signalling to the opposite sex that we find them attractive. In other words, the low light of dusk can trigger a similar physical reaction. According to sexual researchers such as Masters and Johnson, the dilation of the pupils is associated with the dilation of the clitoris, one reason most people prefer to have sex in low light.

garments or adornments is key to nighttime rituals concerned with fertility and forming partnerships. These clothes are worn especially to arouse sexual interest.

Beliefs about the power of the night are almost universal. In ancient cultures supernatural beings were believed to come out at night. As in Shakespeare's *A Midsummer Night's Dream*, enchanted things were thought to happen under the moonlight. The moon itself was associated with fertility and female deities, such as Isis. Ancient Celts believed that day began at sunset, rather than at dawn as we now perceive it, as did the ancient Greeks,

In dressing for evening, women have typically dressed to emphasize their sexuality. Some women dress overtly to play the vamp (think of the reaction to Elizabeth Hurley's appearance in the Versace safety-pin dress); others are more discreet. But all evening dresses are designed with a similar aim in mind, to draw attention to the wearer's sexual allure — by exposing acres of flesh, or by revealing just enough

∞ The revelation of the body, especially the zones considered erotic at any particular time in history, is the point of any evening dress. Note the difference between two dresses (above) by Paquin, both dating from 1909. The blue afternoon dress on the left, while elegant and beautifully beaded, is demure in comparison with the ball dress on the right, with its décolletage. An evening dress from Hardy Amies (opposite), photographed by Bryan Adams, uses the device of a bow to draw attention to the buttocks.

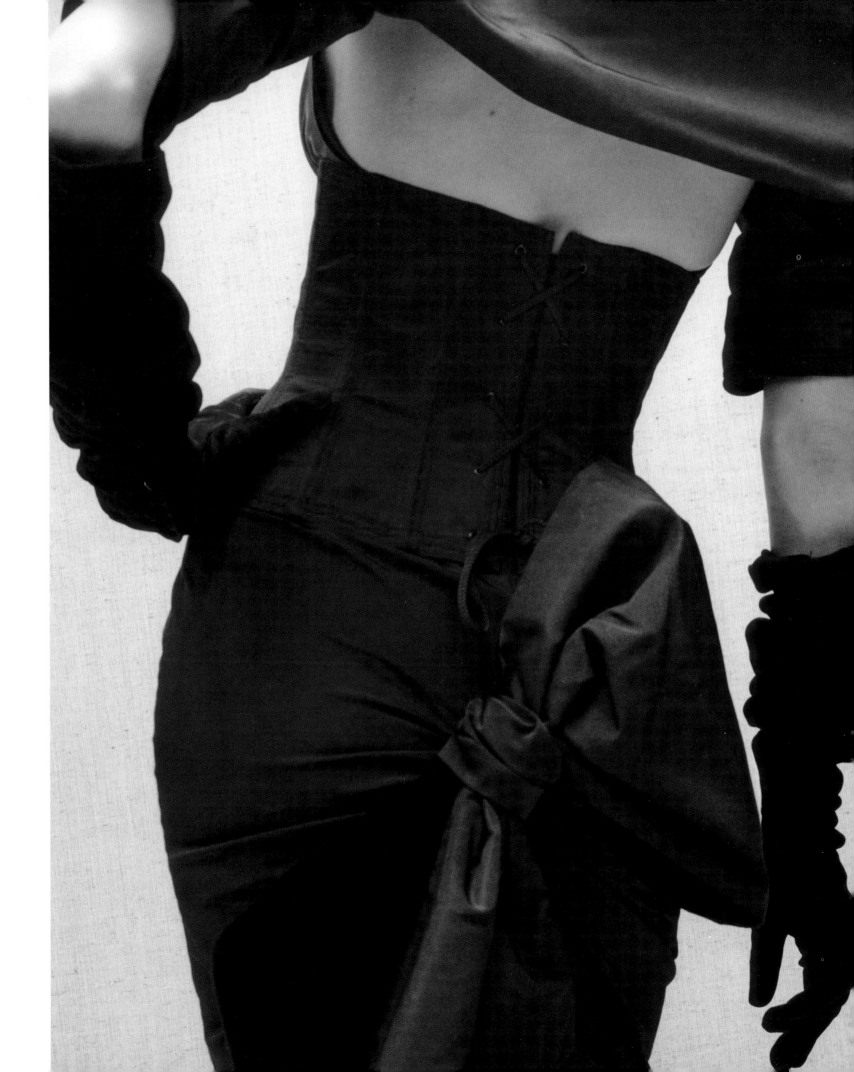

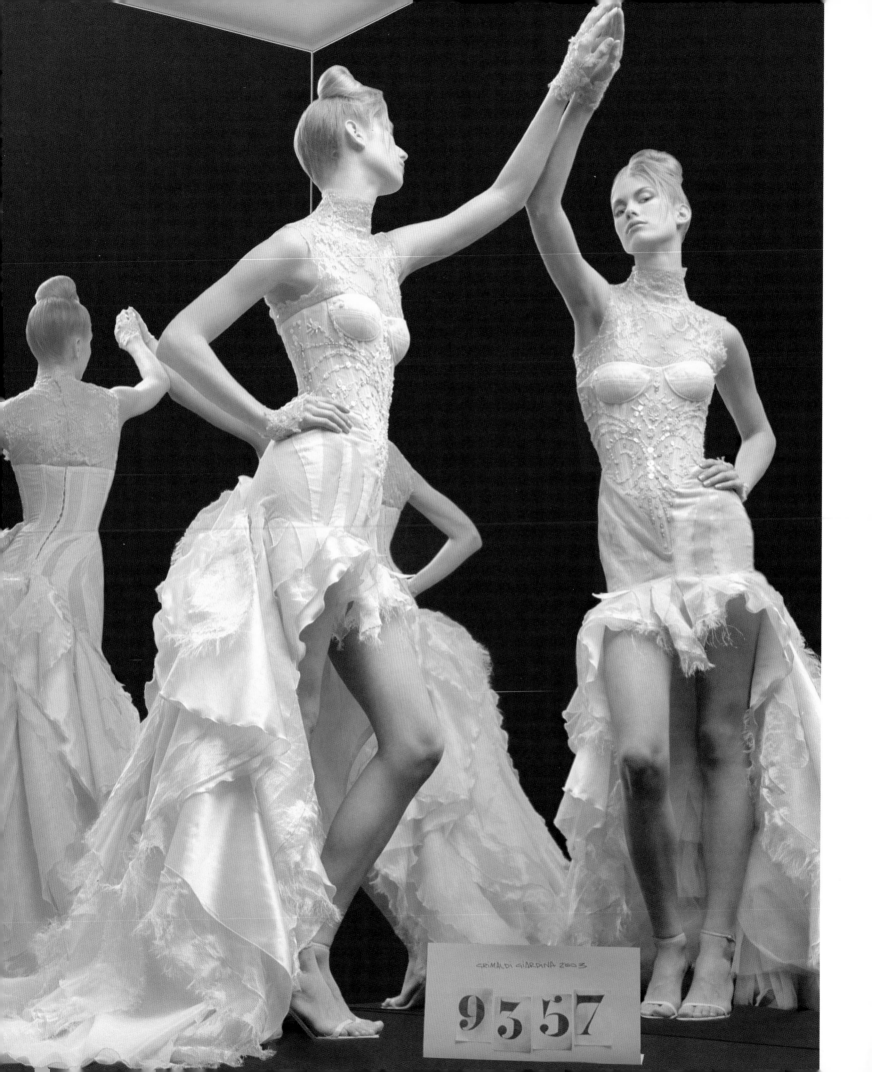

GRIMALDI GIARDINA 2003

9357

(a flash of cleavage, a bare back, a perfumed shoulder) to tantalize and excite.

As a tool for stimulating sexual desire, at least within the bounds of public decency, the evening dress is hard to beat. Where as garments designed for work or for general social interaction are generally more modest, designed for practicality and comfort, the evening dress maximizes the impact of the wearer by concealing and strategically revealing at the same time. Traditionally the evening gown is long, covering much of the body. Hence the eye is drawn to those parts of the body that are revealed. Transparency is another device used in eveningwear to reveal, while assuming a pretence of covering the body. This combination of feigned modesty and erotic zoning makes the evening dress a socially powerful garment in the wardrobe of women throughout the centuries of fashion history.

At one time men would also dress with sexual attraction in mind. But in modern times this type of clothing is largely reserved for women. At a formal evening event these days, the men dress virtually alike in black tuxedos, blending in, while the women could not be more extravagant in their attempts to look dazzling and different. The greatest faux pas of all on such occasions is for a woman to wear the same dress as another.

In the words of Lawrence Langer in his book *The Importance of Wearing Clothes*, "Dress is woman's subtle invention to tempt, but not insist on, masculine admiration... The color, the materials, the texture, the lines, the fit, all these conspire in a good costume to set off the wearer.

∞ *Delicate frayed fabrics lend an ethereal quality to Grimaldi Giardina's corset-style dress (opposite). Akira Isogawa uses three layers of silk organza appliquéd and beaded with blossoms (right) to allude to the fleeting nature of beauty.*

Thus she becomes queen over all other creatures, for she can change the color of her skin with more variety than the chameleon, to outdo the animal kingdom in the richness of her furs, and vie with the birds of paradise in the glory of her jewels. And, for most women, the purpose of all this enchantment is to capture the male she wants as her own and hold him with the superiority of her beauty and rainment." In the wardrobe of Langer's woman, the evening dress takes pride of place.

Projecting sex may be the subtext of the evening dress, but other purposes of the dress are to convey the wearer's overall taste and elegance, to establish or reinforce her position in fashionable society, and also to convey class and wealth. In other words, the evening dress is about status — whether sexual or social.

Linked with its role as a sexual signifier, the evening dress is also entwined with fantasy. It is at night that most fantasies are lived out, when the mundane matters of day seem far away. Fantasy themes recur constantly in the design of evening dresses. The ball gown for fancy dress is a classic example, but there are more subtle ways in which the evening dress expresses fantasy. Natural motifs or elements of nature are classic means of creating a fantasy outfit. The wearer becomes associated with the powerful and mysterious forces of nature. Much as tribal warriors and chiefs wear feathers from exotic birds or other natural insignia to symbolize their powers and alliance with natural forces, the woman in evening dress has often adorned herself with feathers and scale-like sequins, chainmail or other elaborate and exotic coverings to align herself with nature.

But what exactly is the evening dress? How do we define it? And just what makes it so different from clothing worn in the daylight hours? These questions are constantly being considered by women in the limelight and their stylists, who spend vast amounts of time and money to acquire just the right evening dress for a particular event. Consider the consequences of those few red-carpet moments on Oscar night. The right dress will generate untold publicity for the star wearing it, securing front-cover status on the newsstands for weeks after the event, and assuring their place in the Hollywood firmament, at least for another twelve months. Of even greater significance, wearing the wrong dress can turn a woman into a laughing stock, guaranteed to be seen in unflattering photographs for months afterwards, especially at the end of the year when the media round up the year's fashion disasters.

Those in need of general advice about how to dress for evening might consult De Brett's *Etiquette and Modern Manners*, in which the author notes that "Balls, galas, and any invitation that stipulates 'black tie' for men, require that women wear something festive. Long or short dresses, or even decorative evening trousers, may work, according to fashion and preference, but they must be of sufficiently opulent fabric or design to acknowledge the specialness of the occasion."

However, getting the dress just so for a big night is a matter of great judgement, which tests the sartorial skills of stars and stylists to the utmost. Negotiating the myriad dress styles and colors available, and interpreting the look of the moment, while bearing in mind the wearer's age and physical attributes, truly requires a deft hand.

Making these decisions was not always so difficult. In centuries and decades past, dress codes were more strictly laid down. There was far less freedom in fashion styles. In 1900, for example, evening dress for unmarried and married women was sharply distinguished, and anyone crossing, or even blurring, those boundaries ran the risk of social exclusion. In *The Language of Clothes*, author Alison Lurie explains that while the unmarried woman was expected to

The contrast of innocent female beauty with sexual allure is a recurring visual device used by designers of eveningwear. This couture dress by Grimaldi Giardina, for example, combines a fitted, elaborately beaded top with a deconstructed skirt. The organza pieces, layered like rose petals come to the end of their life, appear to be barely secured, as if they might fall to the ground at any moment.

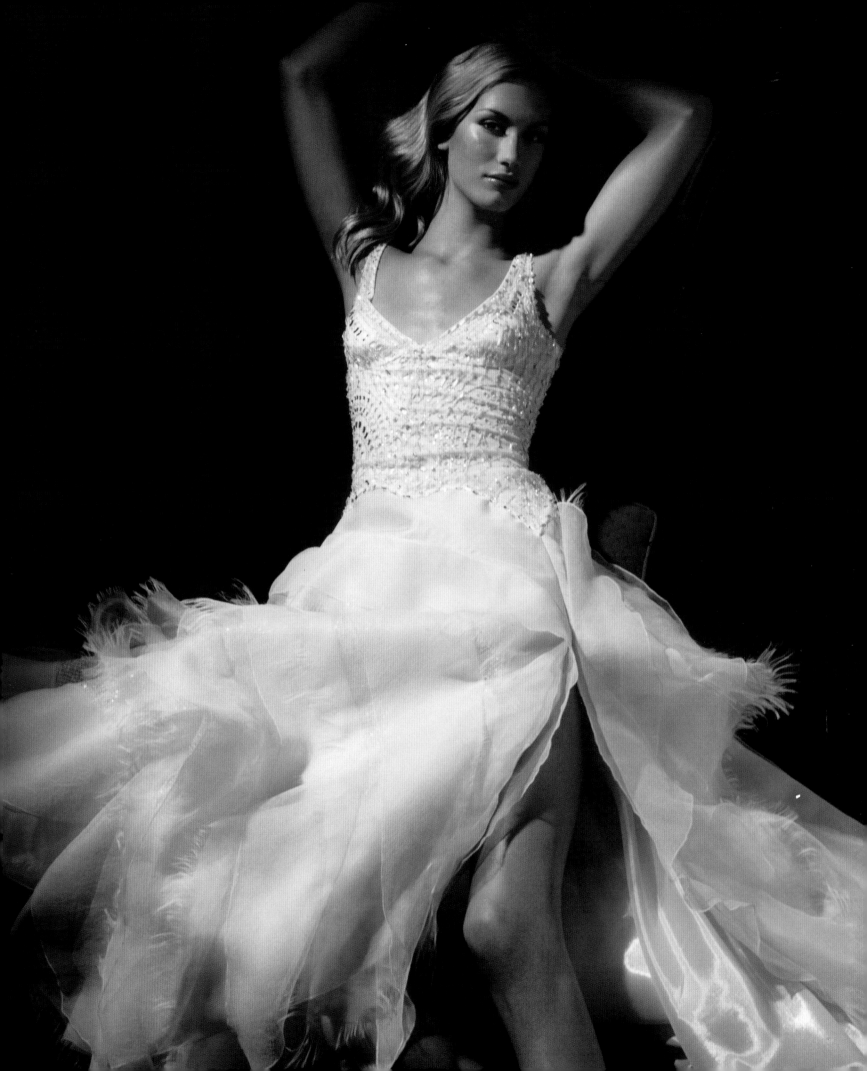

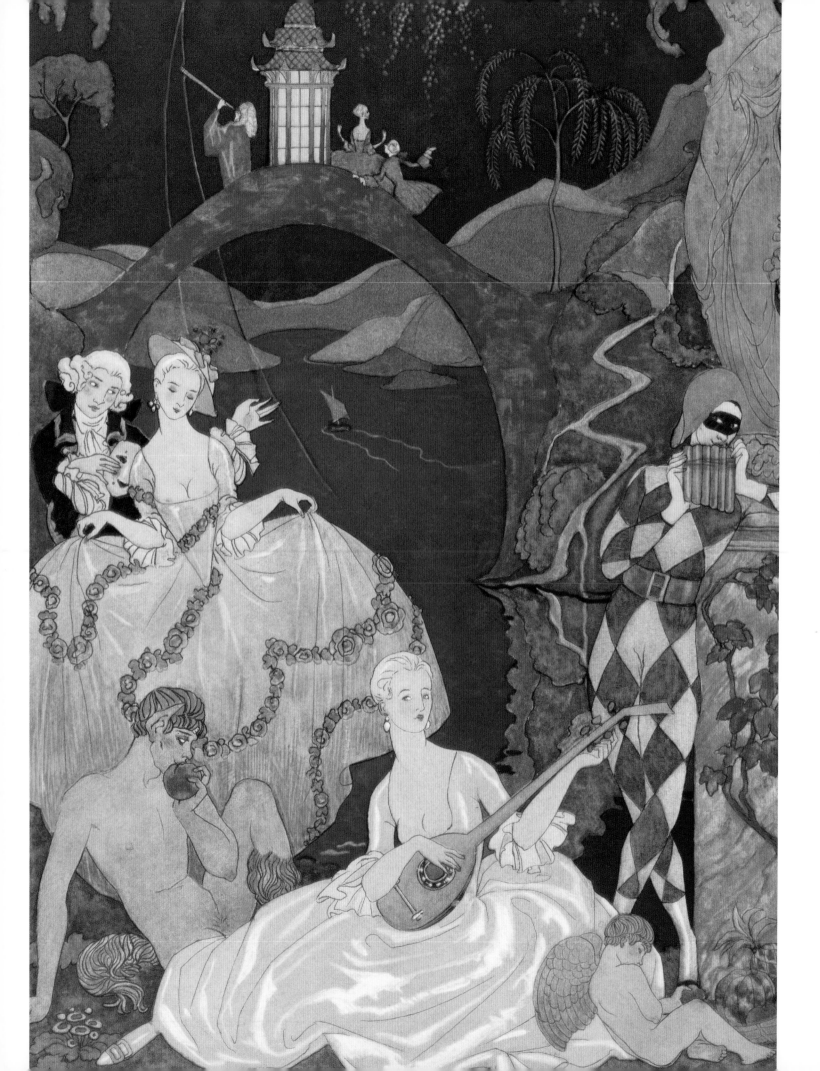

wear evening dresses in delicate fabrics and pale colors, married women could wear deep, brilliant colors such as ruby red and emerald green in rich, ornamented fabrics. If an unmarried woman stepped out in the same sort of dress as her mother might wear, she would be considered to have "loose" morals.

Despite the freedom of dress that had emerged by the 1920s, rules of dress still had to be negotiated, particularly for evening, and even in the most unlikely of situations. In the colonial Kenya of the 1920s depicted in James Fox's *White Mischief*, soirées at the country club offered dancing "from sundowners to sunrise". In the so-called "White Highlands", balls were held nightly during the race weeks and women needed a different gown for each occasion.

The doyenne of tasteful 1920s dress was Emily Post. In her 1922 *Guide to Etiquette* she went to great pains to define the various types of evening dress:

"A dinner dress really means every sort of low, or half low evening dress. A formal dinner dress, like a ball dress, is always low-necked and without sleeves, and is the handsomest type of evening dress that there is. A ball dress may be exquisite in detail but it is often merely effective. The perfect ball dress is one purposely designed with a skirt that is becoming when dancing."

Also warranting her attention under the heading "What is an Evening Dress?" were the informal dinner gown and the tea-gown. "An informal dinner dress is merely a modified formal one. It is low in front and high in the back, with long or elbow sleeves," Mrs Post explained. "The informal dinner

∞ *Historically the ball has been the venue for parading opulent gowns (opposite). The physical scale of a ball demands a dress that will command attention, if not by decoration or color, then by volume, as in Viktor & Rolf's example (right).*

dress is worn to the theater, the restaurant (of high class), the concert and the opera — on ordinary nights, such as when no especially great star is to sing, and when one is not going on to a ball afterward." The tea-gown, on the other hand, was strictly for wearing for dinner at one's home, or at the home of a close friend. Described as "a hybrid between a wrapper and a ball dress ... it has always a train and usually long flowing sleeves; is made of rather gorgeous materials." Material, whether expensive or just expensive-looking, is one of the defining qualities of the evening dress.

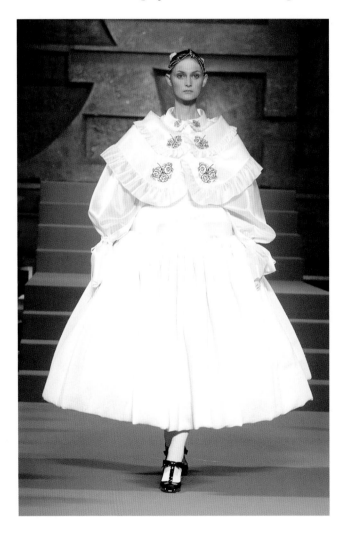

Even more important than length, which can go up and down from decade to decade and from year to year, according to the fashions, the evening dress is characterized by beautiful fabric.

Textiles were once the primary form of wealth display. Before industrial times luxurious fabrics were incredibly expensive, as desirable as gold, and clothing therefore became an important means of showing off one's wealth.

During the seventeenth and eighteenth centuries, middle-class and upper-class women used vast quantities of expensive fabric to fashion their evening dresses. At the close of the seventeenth century, the trend was for skirts to be hitched up on one side or at the back to reveal layers and layers of silk or satin petticoats, adorned with frills, golden lace and braid. All these qualities found ultimate expression in the evening dress, when the subdued lights showed off brilliant shimmering fabrics, ornamentation and trim to perfection. What better means for a man to advertise his family's wealth, and attract a suitable son-in-law, than the dresses of his daughters at society balls.

In Ancient Egypt wealthy women stood out because of the sheer material used for their sheaths, which was far more expensive than the coarse linen worn by other women. And although the transparent draped gowns of well-to-do Egyptian women were fairly simple, they could be dressed up for formal occasions with shawls trimmed with embroidery, semi-precious stones, silver and gold, and also with jewellery. Shawls have been a recurring feature of evening dress down through the centuries. They were often the most expensive component of the evening outfit, as they were made from the finest fabrics available, again a display of wealth that would have been instantly recognized by others both within and outside the wearer's social circle.

Predating the pashmina fetish of the late 1990s, rare Tibetan cashmere shawls were all the rage in Europe at the turn of the eighteenth century. They were regarded by fashionable women, according to the *Journal des Dames et des Modes* in 1815, as "the only acceptable proof of true love". Shawls have typically been in vogue in partnership with classical styles of dress, and they reference ancient times when the fabric and its cost, rather than the cut or style, was the most important element of an evening outfit.

Little research has been done on the concept of evening dress in the ancient world, although different garments were worn for special occasions. Yet the trends and developments from centuries of historical dress are nowhere more clearly seen than in the evening dress, which unlike other forms of dress has not had to conform to demands for practicality, utility or comfort.

Still today the evening dress harks back to a time when only rich people wore luxurious clothes. Although sophisticated manufacturing processes and slick retailing have now made evening fashions equally accessible to those on lower incomes (through the inexpensive but often cleverly designed and prettily decorated versions sold in department stores), the styles and details of these clothes recall centuries of prestige dressing.

Versace's gold sheath references the centuries predating the Middle Ages, when dresses were simply slipped over the head with no fastening required. Between the fifteenth and early twentieth centuries dresses were fitted with lacing, buttons or hooks. It was not until the 1920s that the slip dress returned to fashion history. While appearing essentially unstructured, Versace's gowns are renowned for their interior system of support, which lifts the bust, holds the waist in and hugs the hips and buttocks to enhance the female form.

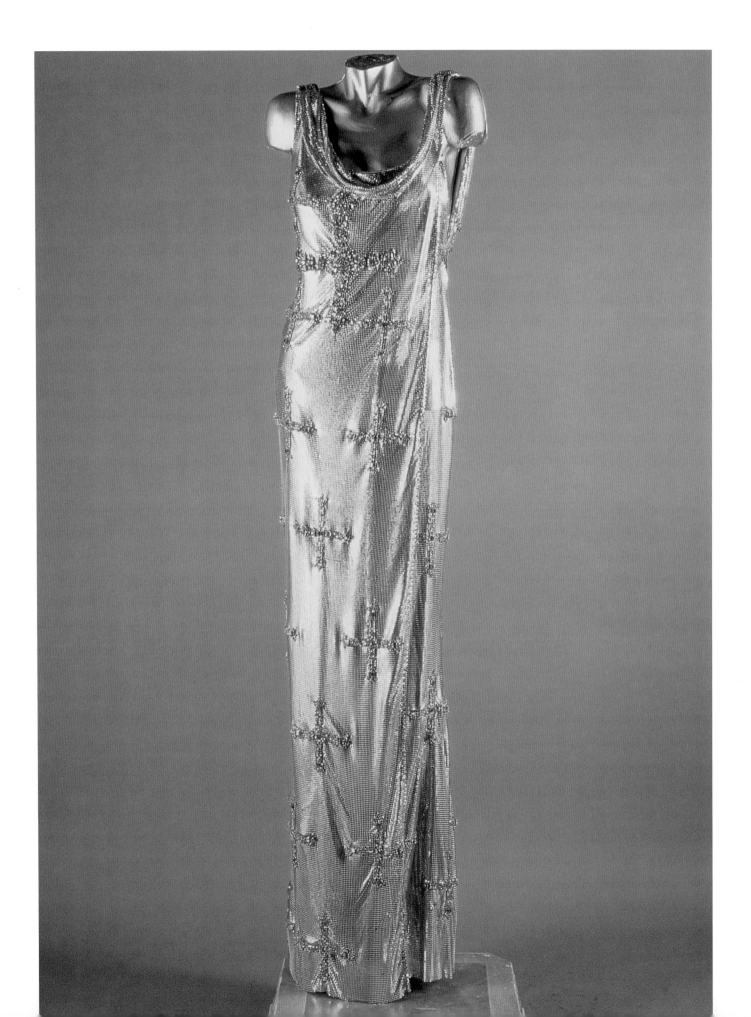

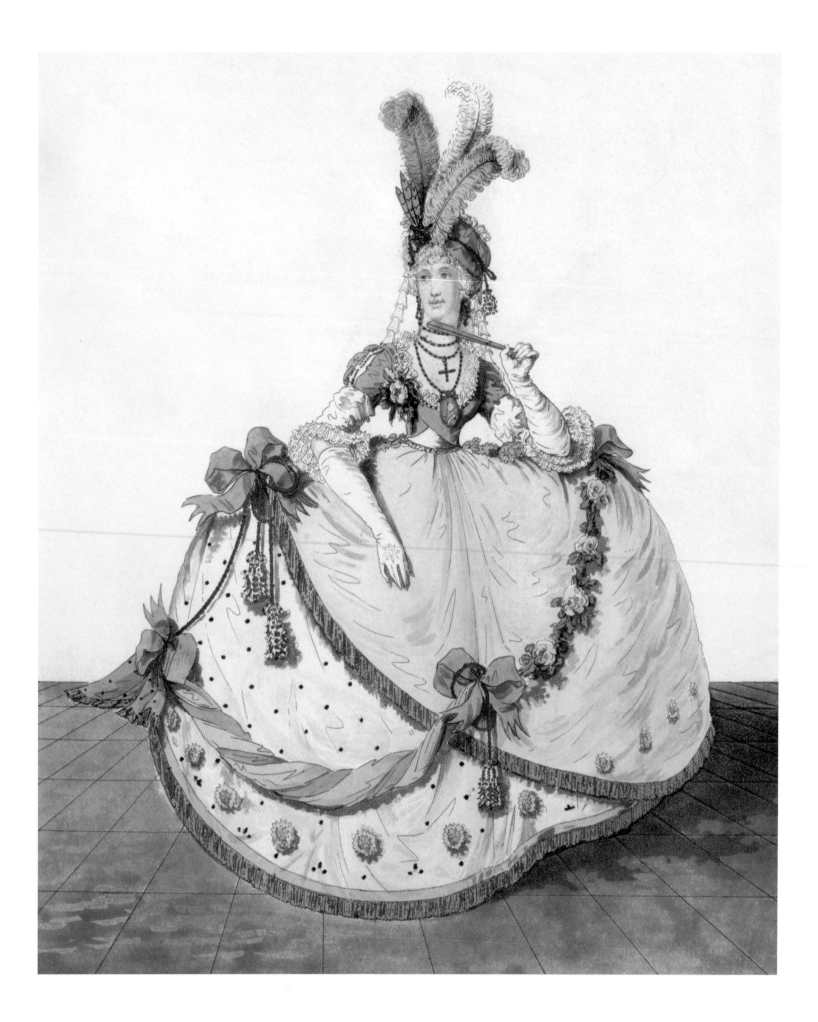

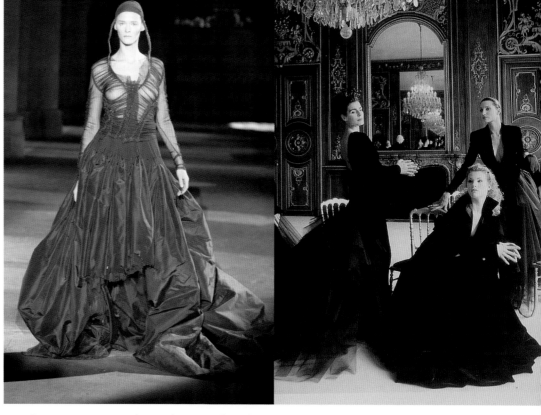

The custom of "dressing up" seems to have emerged early on in history. But essentially it was only royal women, wealthy women or courtesans who had both the opportunity and the means for special-occasion dressing. Women (with the exception of courtesans and prostitutes) generally stayed at home and were not much part of social life beyond their front door. High-class courtesans, who did not necessarily offer sex, can be considered the arbiters of alluring fashion in their day, and there are suggestions that women who were not courtesans aped the dress style of these often influential women.

In Ancient Rome both courtesans and noblewomen wore fine, diaphanous silk, which was so precious it could be paid for only with gold. Venetian courtesans during the Renaissance were among the few women, along with actresses, singers or poets, who were out and about in the evening, attending the newly established salons and casinos. They would wear low-cut gowns, with an open panel laced over the stomach, and are credited with starting the fashion for wearing pearl necklaces and lace.

The splendour of the noblewoman's evening dress was usually displayed in public at banquets, parties and royal gatherings. A ball for Henry III was reputedly attended by 200 of Venice's most beautiful noblewomen, their white gowns ornamented with gems, pearls and gold, which glittered in the candlelight. Even sumptuary laws aimed at restricting extravagant dress could not deter upper-class Venetian women from wearing evening dresses made of silver and gold cloth. The cloth was made using thread from the precious metals and was accordingly very expensive. It

was banned in 1443, but there are records of women defying the law. In 1523 the niece of the doge was reported to have worn cloth of gold to a banquet, but no fines or punishment were administered in this case. Later the same year, when the niece of the newly elected doge attended his party wearing a dress made from the precious gold fabric, she was ordered to change her dress. Even the law could not deter the women of Venice from donning lavish eveningwear.

For a long time there was little change in the basic shape or construction of garments, so any differentiation between daywear and eveningwear was made by using different types of fabrics, different colors, or through details such as embroidery, jewelled embellishments and other rich adornments. Innovations in tailoring and fabric during the

∽ Before the twentieth century black dress for evenings was the preserve of women in mourning. A widow, for example, might be expected to wear black for at least a year; everyone else wore colors (opposite). In the twentieth century black became fashionable for eveningwear, even when dresses were based on historical styles: gowns by Akris (preceding pages); Alexander McQueen (above left); and Gianfranco Ferre (above right).

Grimaldi Giardina's formal gown (above) relies on Elizabethan proportions and details for effect, while maintaining a muted color palette. In complete contrast, Gianfranco Ferré's dramatic ball gown (opposite) uses shocking pink for high impact. Pink has remained a popular color for evening dresses since Elsa Schiaparelli popularized it in the 1930s – at that time it was quite controversial.

"Pink … bright, impossible, impudent, becoming, life-giving, like all the light and the birds and the fish in the world put together … a shocking color, pure and undiluted."

ELSA SCHIAPARELLI

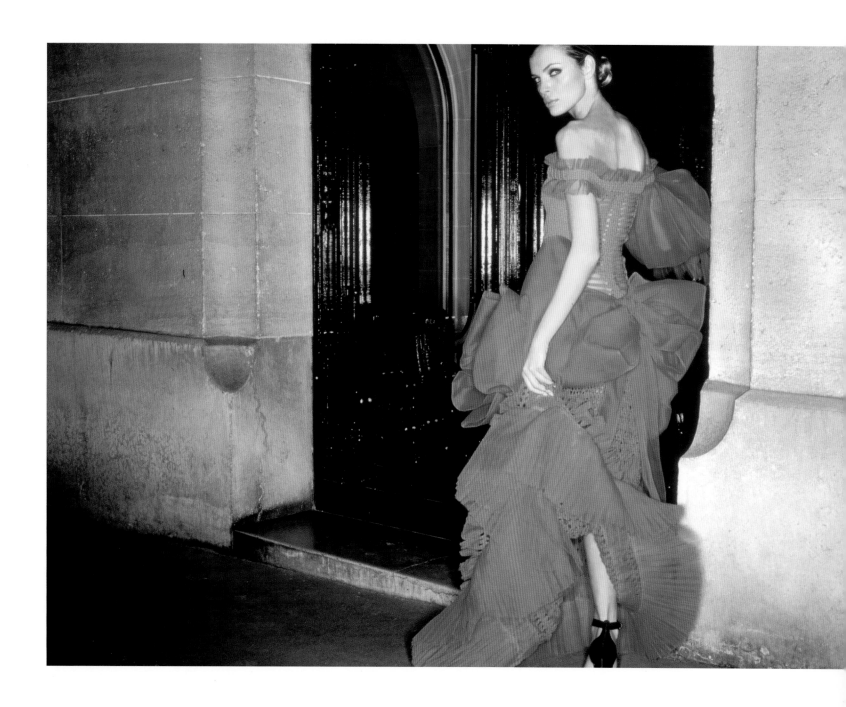

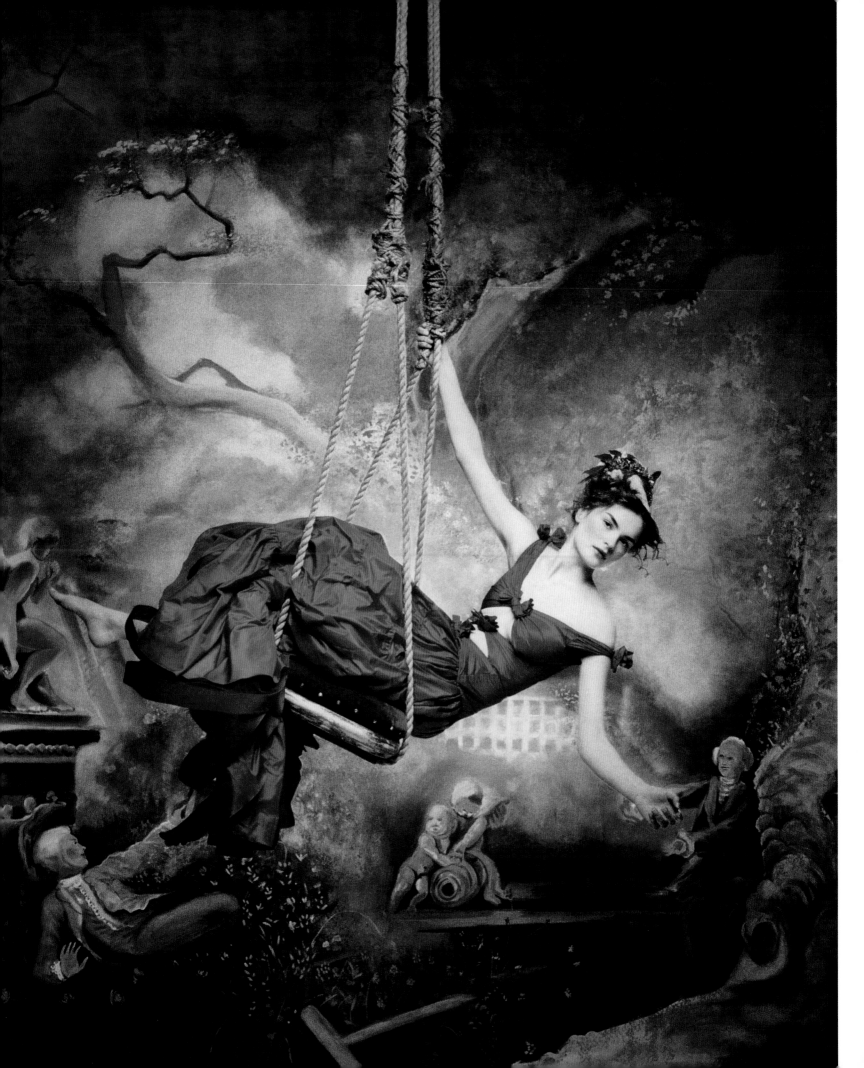

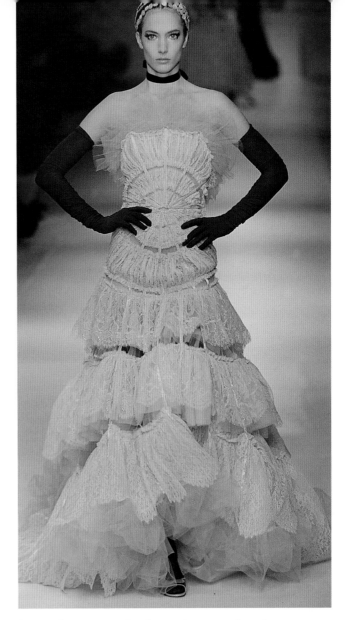

late Middle Ages allowed for much greater variety in dress styles. One of the most significant, for women's evening dress, was the invention of décolletage, a neckline that was cut away to reveal the top part of the breasts. Even so, the main differentiation between daywear and eveningwear continued to be in the use of fabric and its ornamentation.

Not many evening dresses survive from before the seventeenth century. The materials were so delicate that they have tended to perish. Most visual records of evening dress before that time come from paintings or engravings, showing women at balls or dance parties or feasts. But to modern eyes the outfits worn by wealthy women for day, or for court appearances during daylight hours, often seem just as elaborate as those worn for evening, with certainly little variation at all in the actual style of dress.

Of those evening dresses that have been preserved, one of the earliest complete costumes is now at the Museum of Costume in Bath, England, and dates from about the 1660s. It is an evening dress comprising a separate bodice and skirt and is made from a fabric called silver tissue, which was a fine cream silk woven with real silver thread. It is trimmed with cream parchment lace, another expensive material typically worn only by the very rich.

One of the earliest gowns in the costume collection of London's Victoria and Albert Museum is a magnificent affair in ribbed silk covered in embroidery that used 10 pounds of silver. It dates from the 1740s, when the fashion was for incredibly wide skirts; this skirt is some 6 feet across, all covered in elaborate embroidery and supported by seven layers of petticoat. This dress is known to have been worn at a formal occasion at the court of the English king, George II, probably to attend a royal party, and would seem a good indicator of evening dress fashion at that time.

The evening dress came into its own in the European courts and noble households of the seventeenth and eighteenth centuries, when balls, parties, card nights and other evening entertainments were scheduled almost

History provides inspiration for contemporary designers. Photographer Patrick Demarchelier pays homage to the painting by Alexandre Fragonard, "Girl on a Swing" (1766). The dress by Valentino is both luxurious in its full crimson silk taffeta skirt and provocative in its slashed and knotted bodice (opposite). Jean Paul Gaultier's flesh-colored strapless gown (above right) deconstructed into separate panels through which the wearer's body can just be glimpsed, references the excesses of the Belle Epoque.

nightly. Some of the most elaborate gowns in the history of evening dress were worn in the courts of France. They were considered a crucial element in the power plays among courtesans and royal women for favour. Madame de Pompadour was an influential figure at the court of Versailles during the mid-eighteenth century and set the styles for fashionable dress. An inveterate entertainer and organizer, she went out of her way to amuse her king, even performing in theatre events herself. She was known to stay up till the early hours partying and playing cards, yet still rise in time for Mass the next morning.

Balls, too, were a key feature of court life in France, as they were in England. Just as today, this special event dictated a distinct type of evening dress, the ball gown. A ball was the one occasion at which a woman could lose herself completely in the realms of fashion fantasy. Her only priority that evening was to look utterly sensational. For this, the fancy-dress ball offered great opportunity for excess. The restrained elegance that might be called for in a dinner dress or theatre ensemble played no part at this special event. Even now, the ball gown is not as subject to

the whims of fashion as other types of evening dress; it is still very much grounded in historical tradition.

The ball was a popular diversion for many centuries in the royal houses of Europe, and the fancy-dress ball was especially favoured. These balls, or "masques" as they were known, originated in Italy and were being held in England by 1512. Queen Elizabeth I was very fond of this type of evening entertainment, and great pains were taken to ensure that both the setting and the dress were utterly fantastic. Jane Ashelford describes one of the temporary London venues built especially for the Queen's fancy-dress balls in her book *Dress in the Age of Elizabeth I*: "Its extraordinary interior was lined with canvas to look like stone, the walls were set with 'two hundred and ninetie and two lights of glass', and the canvas ceiling was painted with flowers, fruits, stars and sunbeams all studded with spangles."

An important consideration in the design of costumes that would be seen in such a setting was that they should look effective in candlelight, since performances were always at night. Ashelford goes on to cite Francis Bacon, who in his 1594 essay, *Of masques and triumphs*, advises the

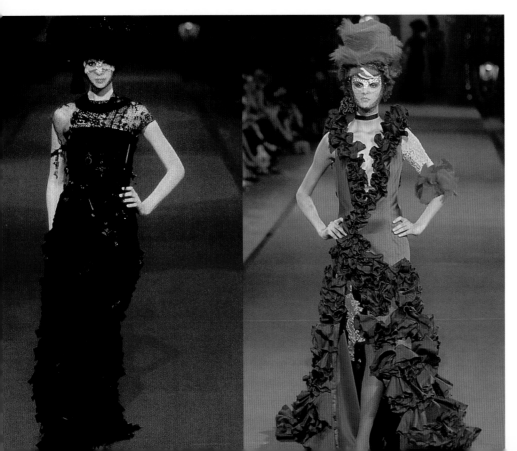

With his models in rich, ruffled gowns and elaborate headdresses (left), Christian Lacroix conjures up the spirit of the Belle Epoque, when intricate details, jet beading, vibrant color and long trains were the fashion for eveningwear. Hardy Amies' gown (right) puts the focus of attention on the waist. Although the eye is drawn first to the corsage and bow at the shoulder, these features serve to enhance the smallness of the waist.

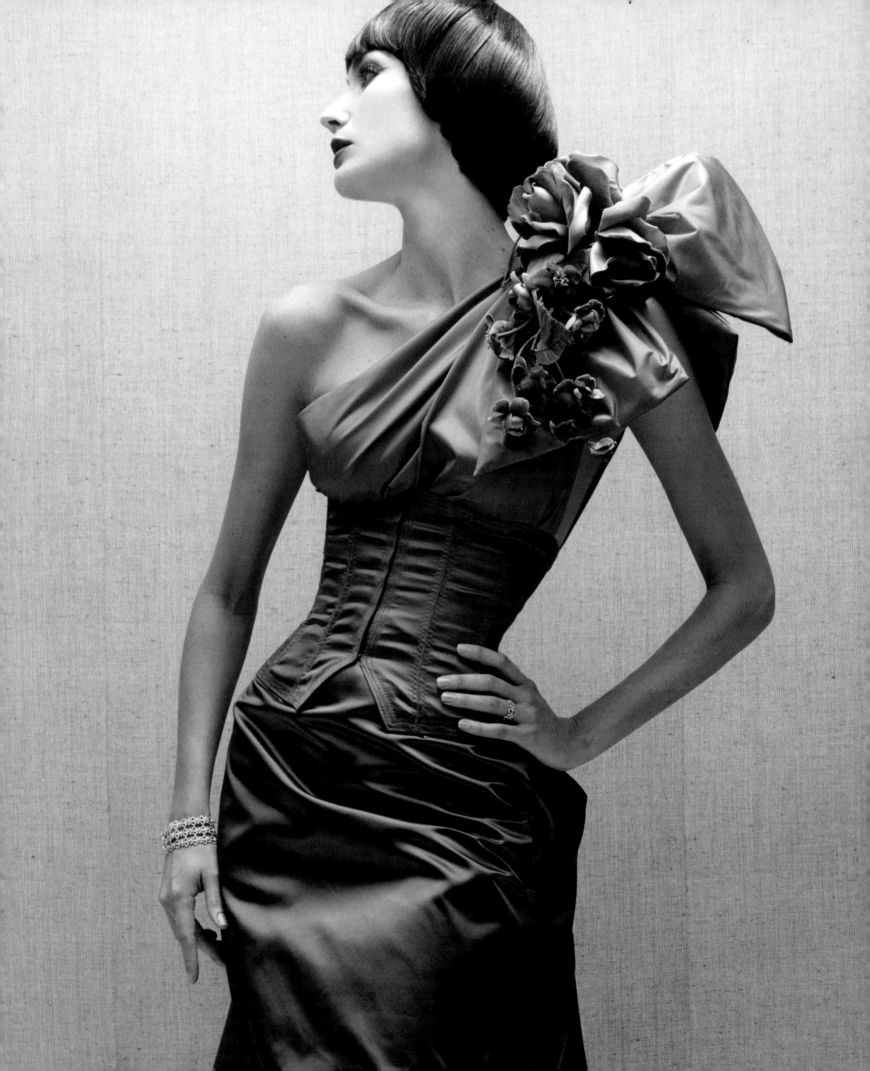

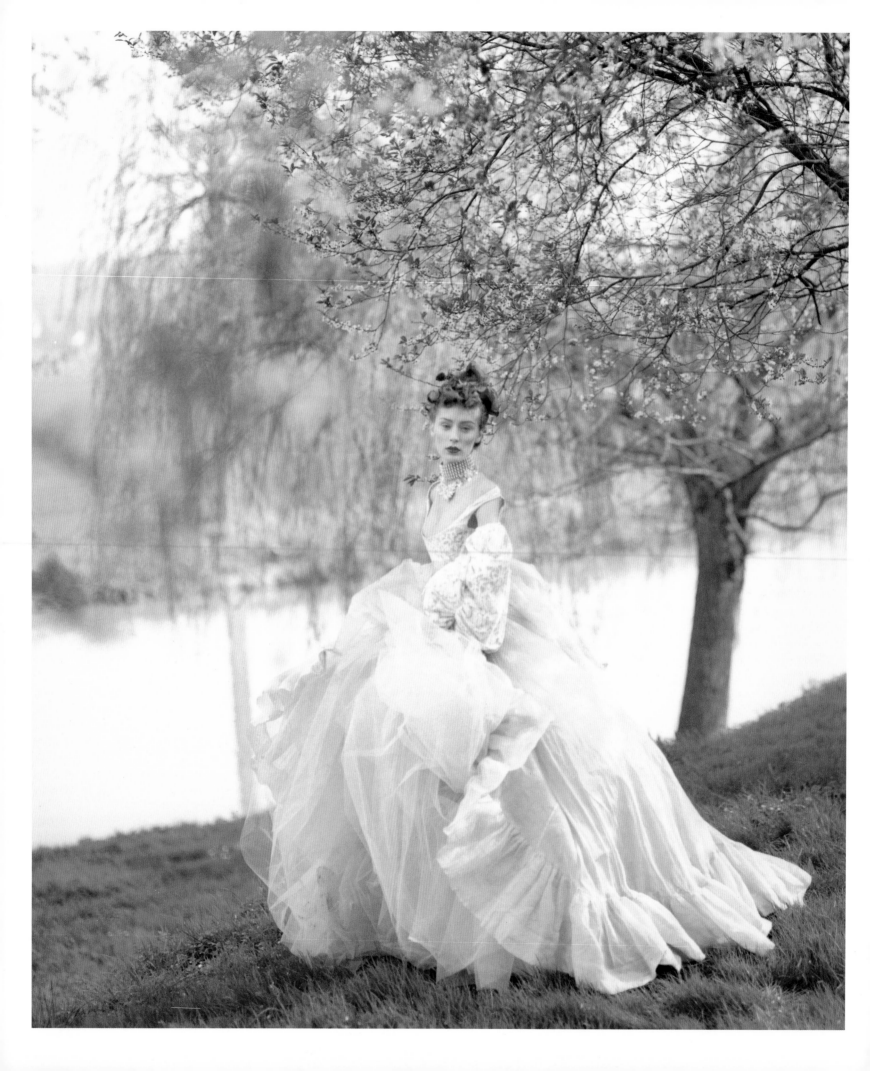

masque attendee that "the colors that shew best by candlelight, are white, carnation and a kind of sea-water-greene; and oes, or spangs [sequins], as they are of no great cost, so they are of most glory..."

There can be little doubt that without the candlelit setting, the impact of the ball would have fallen flat. The entire event, including the dress of both men and women, relied on the dark of night, or in the case of Queen Elizabeth's venue, the magical presence of the moon and stars, even if they were artificially rendered.

Masques were also popular at the English court of King James I. The court has been described by Arthur Wilson in his memoirs of the reign of James I as a "continued maskerado where the Queen and her ladies, like so many nymphs or Nereides, appeared often in various dresses, to the ravishment of the beholder, the King himself being not a little delighted with such fluent elegance as made the nights more glorious than the days."

These balls have their twentieth-century counterparts, in the One-Thousand-and-Two-Nights Ball thrown by Paul Poiret in the 1920s, the magnificent Venetian fancy-dress ball thrown by Charles de Beistegui in 1951, the Black and White Ball hosted by Truman Capote in 1960s New York, and the legendary fancy-dress balls hosted in England by Sir Elton John. The passion for evening costume, for the exaggerated effect of spectacular evening dress, does not seem to have abated over the centuries.

But ball gowns have not always been elaborate, nor made from the rich fabrics and glittering ornamentation that have become associated with evening dress. For a brief time,

Paolo Roversi's romantic image for British Vogue *(opposite), of a Vivienne Westwood ball gown, echoes the illustration of ball gown styles from the 1770s (right).*

in the early years of the nineteenth century, the nature of formal dress changed entirely from one of powerful and elaborate display to one of simplicity and romance. The earliest item in the Victoria and Albert Museum costume collection to be termed an evening dress is from 1806 – a simple white muslin dress from France, empire-line in style with short sleeves, a low square neckline and a long train. Closer inspection reveals it to be embroidered all over in white cotton, with a central panel and train border of more elaborate embroidery comprising French knots, satin stitch and chain stitch making up a pattern of oak leaves.

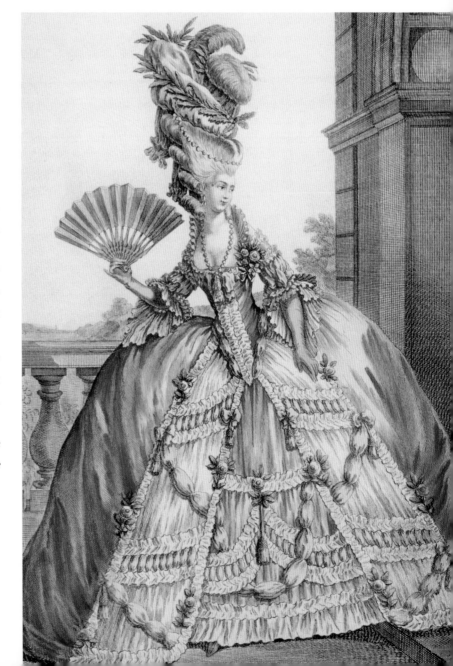

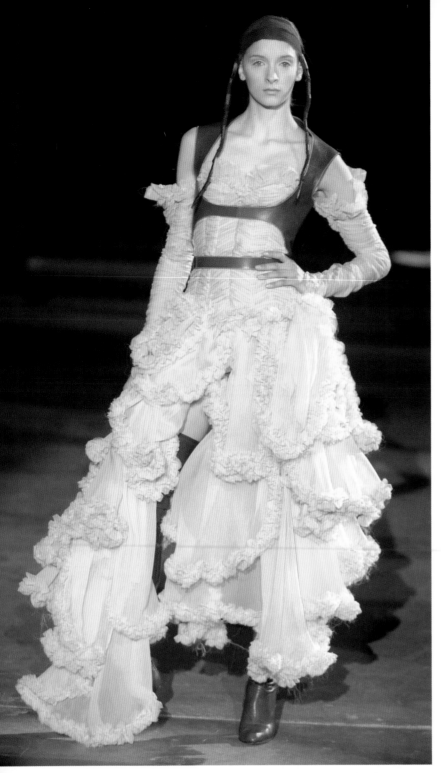

Alexander McQueen references historical styles to create something entirely new for evening (above). The romance of the ruffles contrasts with the leather strapping at the bodice and the boots, which are atypical for eveningwear. Anna Molinari's dress of pink ruffles (opposite) mixes ultra-feminine color and details with the daring of transparency.

Another preserved example from this period, dating from between 1806 and 1809, is a full evening dress in plain white muslin, held in the Snowshill Collection in England. It features the high waist, low square neckline and tiny sleeves of the time, and is described by Nancy Bradfield in *Costume in Detail: Women's Dress 1730–1930*, as "a very simple dress made of the plainest possible muslin but heavy with the weight of the gold fringe at the hem. The embroidery [at neck, sleeves and hem] is exquisite, being sewn with very fine strands of colored silks in pink, blue, yellow, green and grey for the flowers, buds, and fern, and with the leaves and stalk in silver-gilt thread."

Although decoration like this would have been extremely costly, the overall effect was low-key, the kind of understated luxury sought after in modern times. In comparison to what had gone before, and what would come afterwards, this dress reflects the simplified approach to eveningwear that followed the French Revolution.

Classical costume was the inspiration for French evening dress from 1795 when the Directoire assumed power and it seemed safest to jettison all of the rich trappings and luxurious clothing associated with royalty and the aristocracy. That winter of 1794–5 saw hundreds of dance halls open in Paris, enthusiastically attended by women dressed in sheer neoclassical robes in white cotton. Rich women wore similar styles, although with luxurious details such as a gold belt around the waist, a cameo brooch pinned at the shoulder, or an artfully draped cashmere shawl. These evening costumes were quite risqué even by today's standards, the semi-transparent fabric of the dress clinging to the outline of the buttocks and the breasts. Dresses for day were quite modest in comparison.

Compared with the excesses of dress from the pre-Revolution days, when the French queen Marie-Antoinette

∞ *Two examples of Chanel eveningwear that mix the lingerie influences of this century with the silhouette of Edwardian evening costume, characterized by a small hat or headdress worn high on the head, a deep décolletage, smooth hips, a skirt that flared out towards the ground, and above all a passion for lace.*

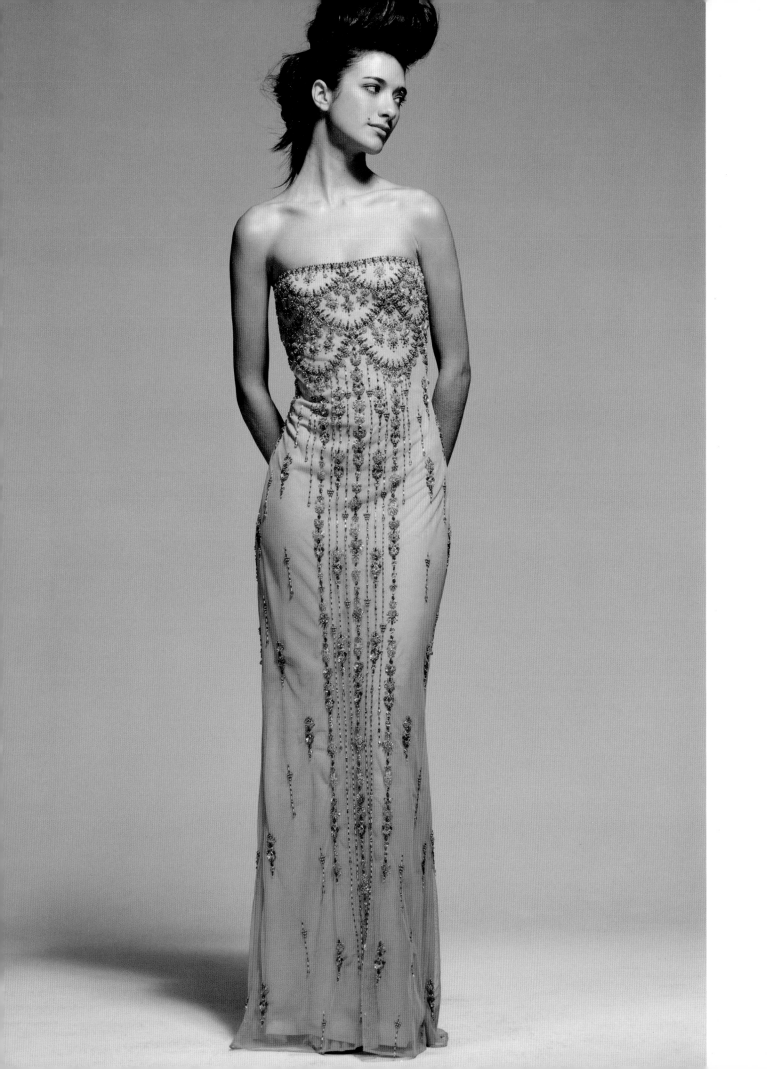

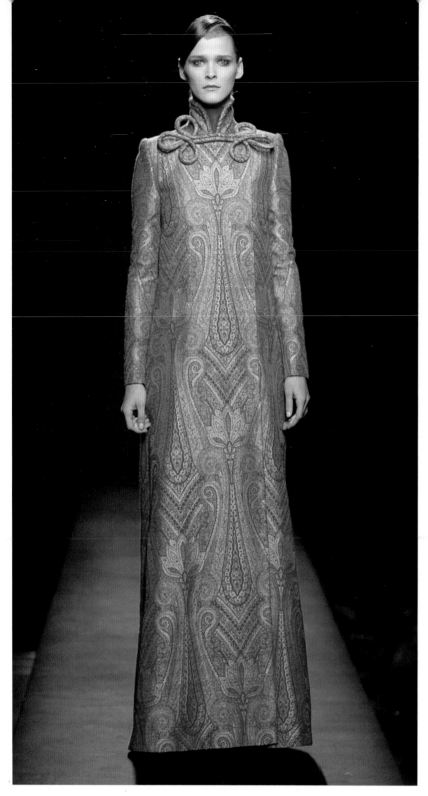

∞ *In the postmodern era, designers raid history. Military themes are evident in an evening coat by Viktor & Rolf (above) and in the jacket topping Jean Paul Gaultier's luxurious patchwork dress (opposite). René Lezard's ball gowns (overleaf) are inspired by nineteenth-century riding dress.*

held court at Versailles, the Directoire styles were dramatically different. In her memoir detailing her life serving under the French queen, Madame Campan gives a fascinating insight into the evening wardrobe of her employer: "The valet of the wardrobes on duty presented every morning a large book to the first *femme de chambre*, containing patterns of the gowns, full dresses, undresses, etc. Every pattern was marked to show to which sort it belonged. The first *femme de chambre* presented this book to the queen, on her awaking, with a pincushion; Her Majesty stuck pins in those articles which she chose for the day: one for the dress, one for the afternoon undress, and one for the full evening dress for card or supper parties, in the private apartments ... For the winter, the queen had generally twelve full dresses, twelve undresses, called fancy dresses, and twelve rich hoop petticoats for the card and supper parties in the smaller apartments. She had as many for the summer. Those for the spring served likewise for the autumn. All these dresses were discarded at the end of each season."

However, in the new order that followed Marie-Antoinette's beheading, and as the fashions of the Directoire period indicated, distinct new codes of women's dress were coming. Gradually the fashion grew for a different type of dressing altogether for day and for evening. In England this had also begun to emerge at the time. A letter to *The Lady's Magazine* of April 1783 gives a fascinating insight into this trend. The writer, who signs himself as "your humble servant W.G." complained that since his marriage a few years back to "a very pretty girl" and his subsequent military posting, she had taken to wearing riding habit by day, and flimsy gowns by evening.

"During the last two years we frequented the camps ... and during that time it became the fashion among the ladies

of the officers to appear in riding habit ... my wife whips on her riding habit as soon as she gets out of bed, sets down to breakfast in her beaver, and goes to market in her boots. She appears, indeed, in no other dress till towards evening, then all close covering is thrown off, and she sallies forth in a large bell-hoop, low stays, and so transparent a piece of drapery is thrown over her bosom that it discovers what it attempts to conceal. She is so enclosed from head to foot all day when she is with me that I cannot see a single charm lower than her chin. At seven or eight in the evening she is quite undressed for company and every man who falls her way has an opportunity to gaze on those beauties which are exhibited for the observation of all men."

The gap between the day and evening styles of dress gradually widened. The riding habit was de rigueur for informal daywear in England during the Regency period, and in 1802 a specially designed walking dress made its debut. Unlike formal and evening dresses, it did not have a train and the hem finished just short of the ground to make movement easier. This trend to easier daywear was entrenched by the end of the century, when women adopted more masculine styles of clothing such as a shirt and skirt with a jacket, and a straw boater for day.

The move to a distinctly different type of day dressing was hastened by an interest in sports. Tennis, cycling and golf all became popular with women of the middle and upper classes, necessitating more practical and comfortable forms of dress. At about the same time, the dress reform movement

∞ A feature of Edwardian evening dress was a low-cut neckline. In a similar vein, the tartan ruffle on an evening dress by Bill Blass (opposite) draws the eye upwards to the throat and face. An ensemble by Caroline Charles (right) also focuses attention on the neck and face, while revealing the cleavage.

was advocating less restrictive, more comfortable forms of dress for women and was to have quite an impact on women's fashion, especially in the United States. The preferred clothing was a shirtwaist blouse and an ankle-length skirt, in place of trailing skirts, bustles and corsets. While many women happily converted to easier dressing for day, evening clothes were considered something apart. As the curator of the Louisiana State Museum, Mary Edna Sullivan, has noted of the local late nineteenth-century fashions: "Even as dress became simpler, society events in New Orleans, especially Carnival balls, reflected opulence. Carnival queens wore satin and silk gowns embellished

with beads and heirloom lace, along with ermine trimmed mantles."

Although some, generally younger, women in Europe were making the move to more sportive dress, many upper- and middle-class women were indulging in elaborate, decorated and colorful dresses for both day and evening. One catalyst for this trend was the invention of the sewing machine and manufacturing processes that made it possible freely to add frills, flounces and all manner of stitched decoration. A new range of chemical dyes also brought into circulation a range of new and desirable fabric colors. It was now possible for middle-income women to emulate the dress of wealthy and aristocratic women in more detail than ever

before. They could, for example, visit one of the fashionable new department stores that had sprung up in Europe and the United States to shop for a ready-to-wear evening dress that had been copied from the latest Parisian models. Trade had also begun to widen the choice of fabrics available.

The first mention of evening dress in James Laver's *Costume and Fashion* comes in the period 1800–50, when "Evening dresses were décolleté, off the shoulder and either straight across or with a slight dip in the middle ... the body of the bodice came to a point in front and was strongly boned. The favourite materials for day dresses were broadcloth, merino, foulard, organdie, gingham and tarlatan. Evening dresses were usually made of shot silk or taffeta." Laver's distinction between the largely "sensible" materials for day dresses and the luxurious fabrics of silk and taffeta for evening reflects the wide variety of fabrics available in Britain thanks to the expanding British Empire.

Symbolic of the Empire, and a champion of British fashion, was Queen Victoria. She sponsored three balls a year, partly as a way of supporting the legions of seamstresses and designers required to clothe the attendees in splendid evening dress. The queen was especially fond of fancy-dress balls. Despite her reputation for sober dress, at the Plantaganet Ball she and Prince Albert threw in 1842, Victoria appeared wearing an eighteenth-century-style gown with jewelled bodice that was estimated to be worth £60,000. In Victoria's age the crinoline was the most-worn style of evening dress. The Empress Eugenie wore one

∞ *The crinoline often inspires Vivienne Westwood (left and opposite). Despite its cumbersome shape, the crinoline has been revived many times since the peak of its popularity in the mid-nineteenth century. There are few styles as imposing. The vast skirt creates a barrier between the wearer and those around her.*

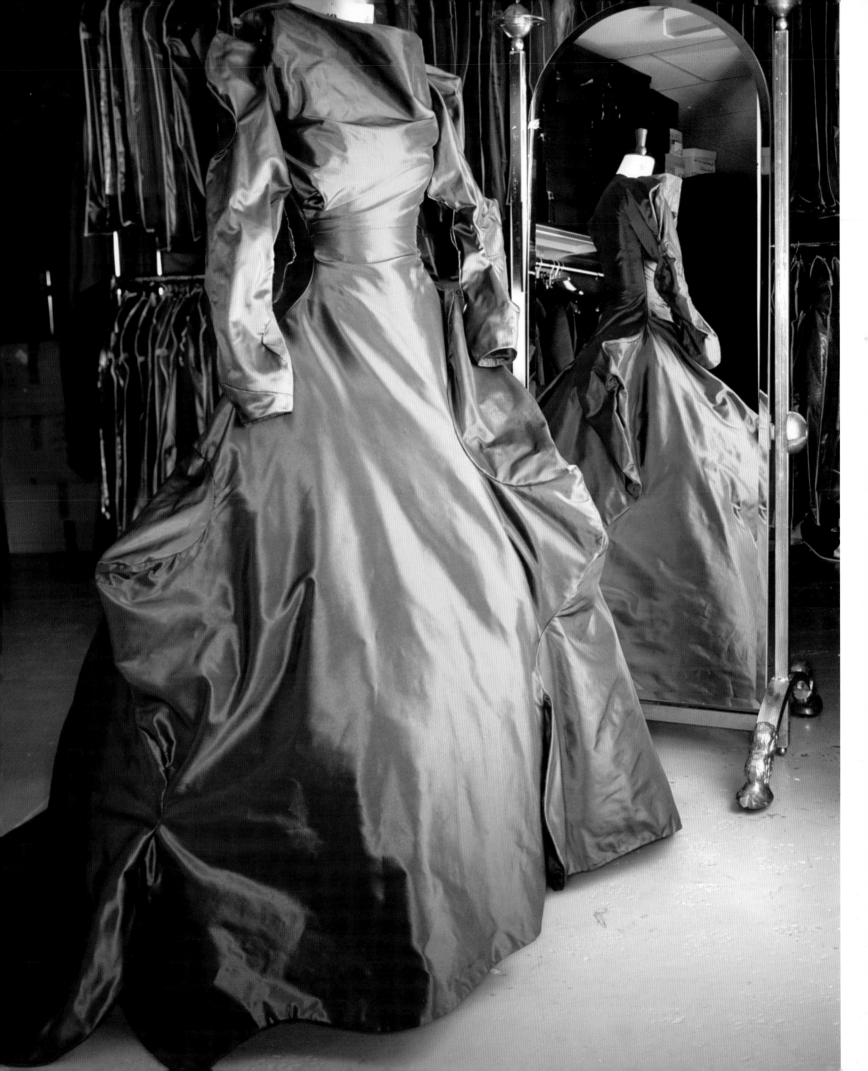

when she was presented to the English queen, sparking a widespread fashion for the bulky gowns.

By her example Victoria set the trend for balls at this time, and aristocratic hostesses with the means to do so threw fabulous gala balls. During the spring/summer season, there were balls almost every night of the week in the grand houses of London. One of the most famous party-givers of the day, Louisa, Duchess of Devonshire, held several events each season, including at least one dance. In the year of Queen Victoria's Diamond Jubilee, she decided upon something special, a fancy-dress ball to which guests should come in "allegorical or historical costume before 1815". The matter of what to wear was the subject of much deliberation. It was to be the ball of the year, if not the decade.

The Duchess herself decided to host the occasion as Zenobia, Queen of Palmyra, and she went to visit Monsieur Worth, the Parisian couturier. He created not simply a historical costume, but a gorgeous and fashionable evening dress. This consisted of three parts: a robe of cloth of silver worked all over with silver thread and diamonds; a green gauze over dress embroidered with green and gold and decorated with jewels; and a turquoise velvet train sprinkled with colorful gems and embroidered with gold. Some of the duchess's guests were equally resplendent. Lady Londonderry came as Maria-Theresa, Empress of Austria, wearing a white satin dress embroidered with gold and seed pearls, and with a stomacher covered in diamonds.

The lavish standard of dress set by the Duchess of Devonshire's Ball was echoed across Europe in the Belle Epoque era as aristocrats lived life to the hilt. There had never been so many evening occasions for the well-to-do woman. She wore elaborate high-necked dresses by day, changing outfits several times a day as the occasion dictated. Evening dresses were often cut very low and were usually white silk with short sleeves, worn with long white gloves. Lace was immensely popular and used extravagantly in evening dress. Feathers, flowers, jet beading, embroidery, ribbons and silk tulle provided lavish trims.

But the world was changing and so, too, was women's fashion. In particular, daywear and eveningwear were becoming more differentiated. The trend towards plainer day dressing that had emerged in the sporting outfits of the nineteenth century was now about to take off, as more women entered the workforce. Young middle-class women were entering employment as governesses, shop assistants or office typists and adopted a tailored style of dress. Upper-class women were also beginning to dress in more practical mode for visits to the country and for travelling.

By the beginning of the twentieth century, the boundaries between classes and what they wore were also becoming blurred. This was nowhere more obvious than in the evening dress. Of course, women with money could always afford more expensive fabrics and handmade, couture dresses, but for the new breed of working woman there were cheap mass-produced versions that did a good job of simulating the rich woman's luxurious evening dress.

As the century opened it was clear that not only were fashions changing dramatically, so, too, were women's lifestyles. From the working classes to the upper classes, dancing would become the rage, and women at all levels of society would indulge, clad in daring — sometimes revolutionary — new evening styles.

∞ *Historical dress is clearly the inspiration for this bustier and sweeping silk skirt by Guy Laroche, photographed by Steven Meisel. A fantastical white feathered hat heightens the sense of luxury; the military jacket by Marc Jacobs adds a note of sobriety.*

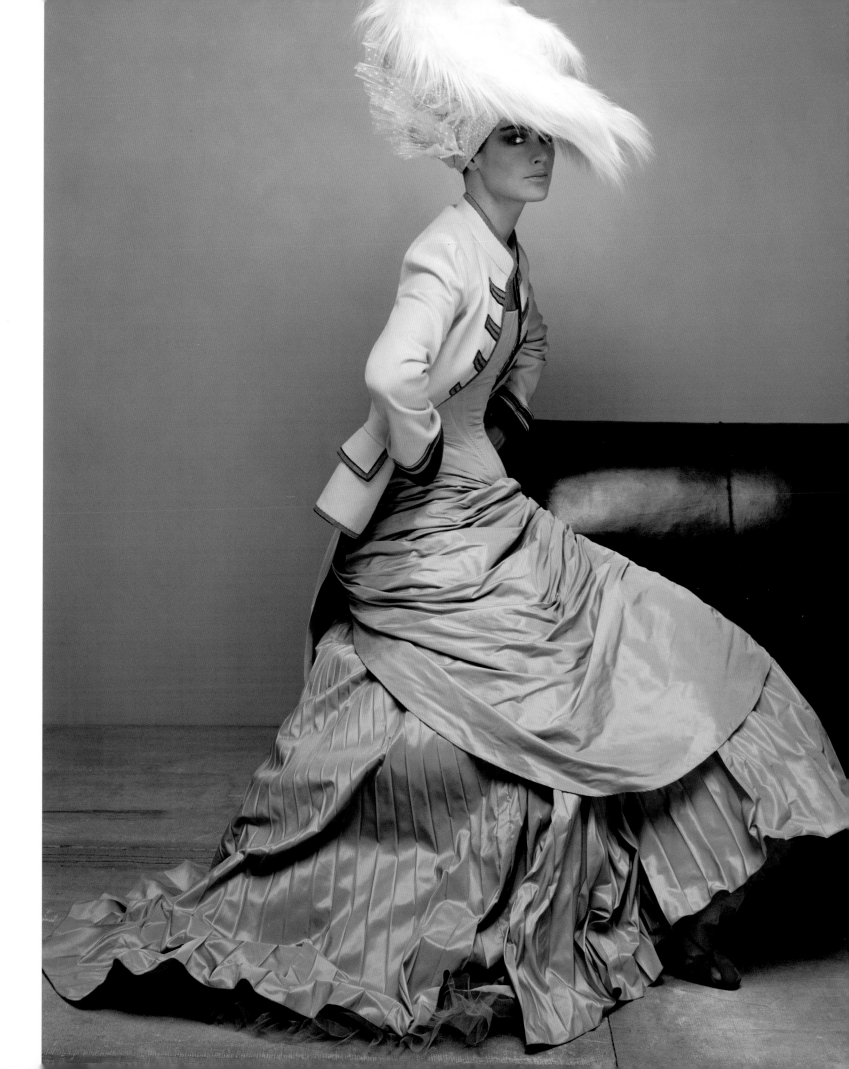

CHAPTER ONE

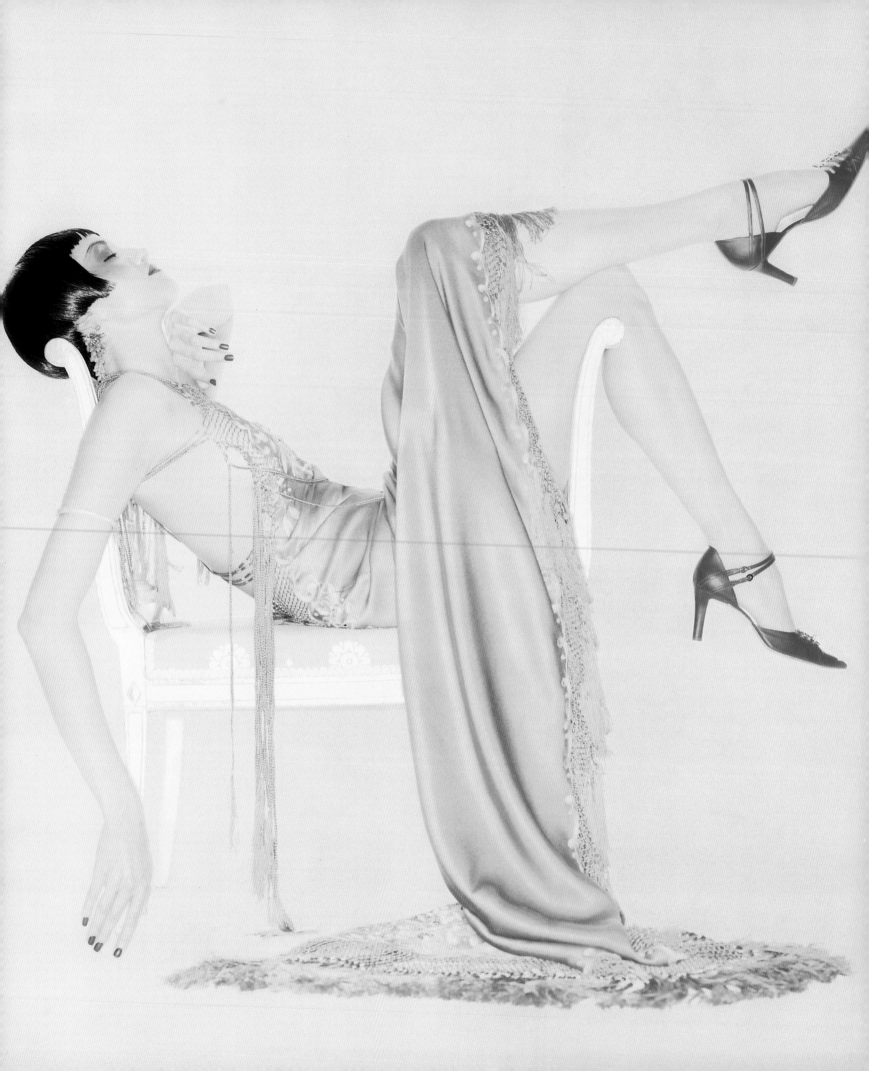

FLAPPER CHIC

"She wore her evening dress, all her dresses, like sports clothes ... there was a jauntiness about her movements as if she had first learned to walk upon golf courses on clean, crisp mornings." F. SCOTT FITZGERALD, *THE GREAT GATSBY*

Although the golden age of the flapper lasted just a few years, from 1925 to 1928, she remains one of the most recognizable characters in fashion history. She was daring, new, different. She bobbed her hair, she liked to smoke, she learnt to drive and listened to jazz, but most of all she loved to dance. In the imagery of the day, and in evocations of her in the popular culture of ensuing decades, she is invariably pictured wearing an evening dress made for dancing in.

Dance halls, nightclubs and parties were the flapper's natural habitat, and out at night she made a strong style statement. Her dress was sleeveless, the cut loose and low-waisted, and her hem finished on, or a few inches below, the knee, and glittered and swung with the sparkle and weight of beading and fringing.

Coupled with the key flapper accessories — long ropes of pearls or beads, T-bar dancing shoes and feathers — the 1920s look for evening has been a mainstay in fashion ever since the Jazz Age. The 1960s was closely allied to the 1920s in its androgynous ideal, short skirts and bobbed hair. Twiggy brought the era to life for the 1960s generation in *The Boyfriend*, which inspired a wave of 1920s-style frocks for evening.

Flapper styles also made a comeback in the 1970s, when many historical periods were reworked to produce fantasy eveningwear. The London emporium Biba excelled at the Bohemian Twenties look. It has always come naturally to the House of Chanel, which had been founded in 1921 and helped to promote the new looser, straighter lines of that decade. In the hands of Karl Lagerfeld, the Chanel evening dress has continued to evoke the early tradition of creating exquisite but easy dresses made for movement. To see the 1920s style revivals in context, it helps to explore what occurred in that dynamic and revolutionary age.

In the 1920s the difference between daywear and eveningwear was perhaps greater than it had ever been

John Galliano conjures up the Jazz Age with the most luxurious pink satin flapper dress for Christian Dior's haute couture collection of autumn/winter 1997. In doing so he demonstrates his masterful ability to incorporate fashion history into his designs. The flapper dress was a revolution in its time. Women simply slipped it over their heads and no fastening was required. Thus women no longer needed the help of servants to dress fashionably, and they could move with abandon, especially when dancing.

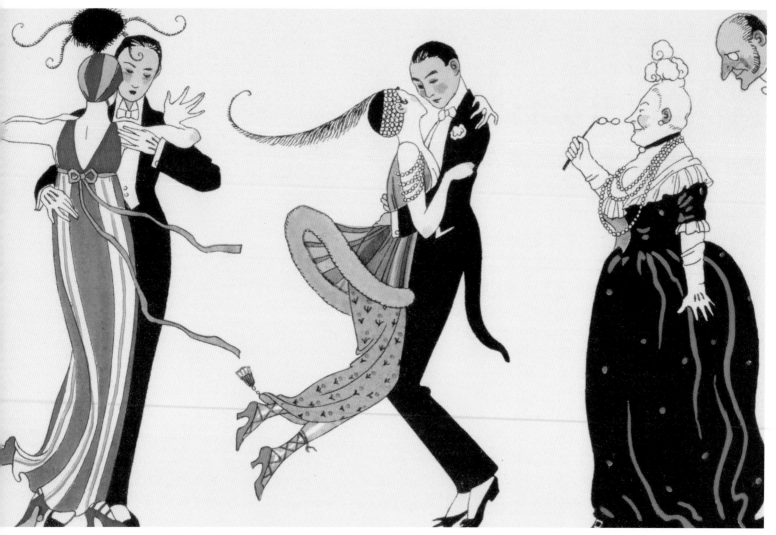

before in the history of fashion. While actual styles were not so different for day and night – both were essentially a straight tunic – the level of luxury certainly was.

Compared with the everyday fashions of the previous century, 1920s daywear was positively plain. One of the main reasons for this was that many more women were

working, and so required smart but practical garb for commuting and days spent in the office. Even well-off women who did not work adopted the androgynous, sportif clothes that were then considered the height of fashion. This made the contrast with eveningwear all the more stark. While their mothers had worn evening gowns in stiff, heavy

∞∞ *Georges Barbier's illustration of 1913 (above) parodied the new obsession with dancing and captured the decadent new clothing styles. Gianfranco Ferré's evening dresses (opposite) evoke the narrow yet fluid fashions of the early twentieth century. Exotic influences from the Middle East and Asia inspired Parisian designers to bring abstract pattern and looser lines to eveningwear, as is evident in Paul Poiret's silver cape (overleaf, left) and the fur-trimmed coat in J. Goje's* A Lady Dressed for the Theater *of 1914 (overleaf, right).*

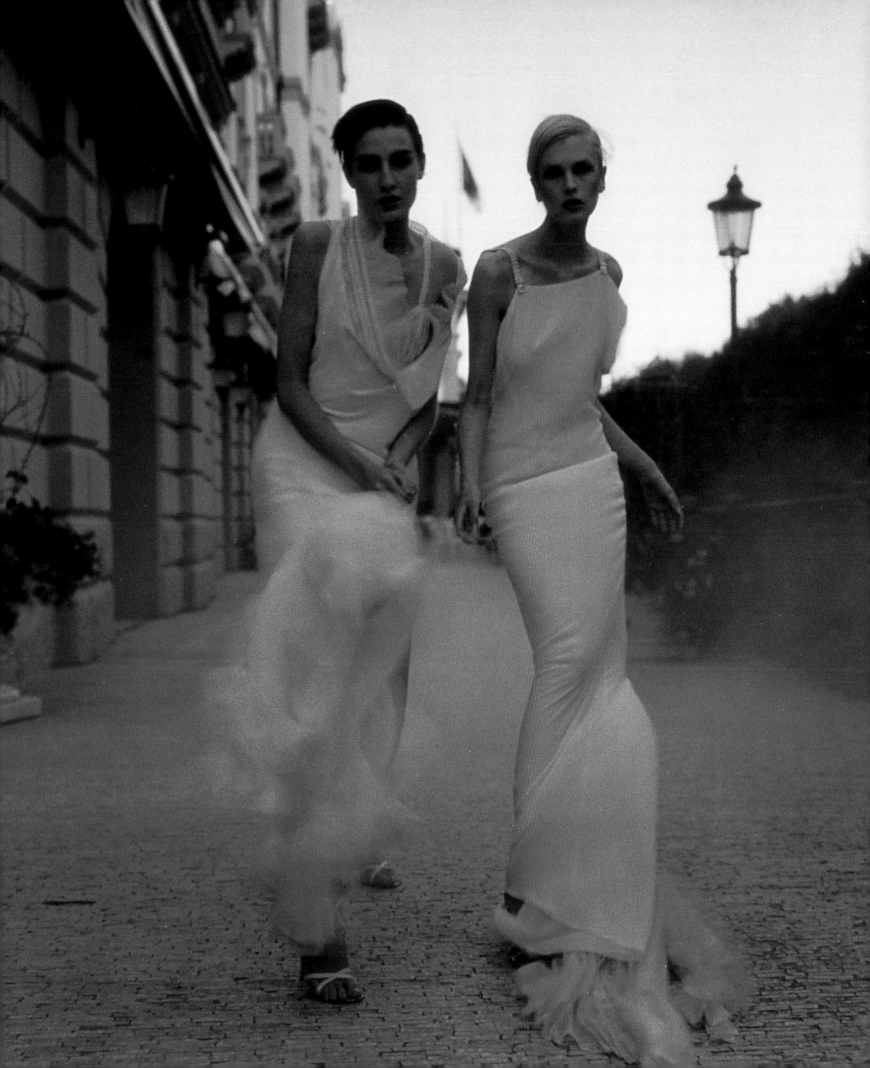

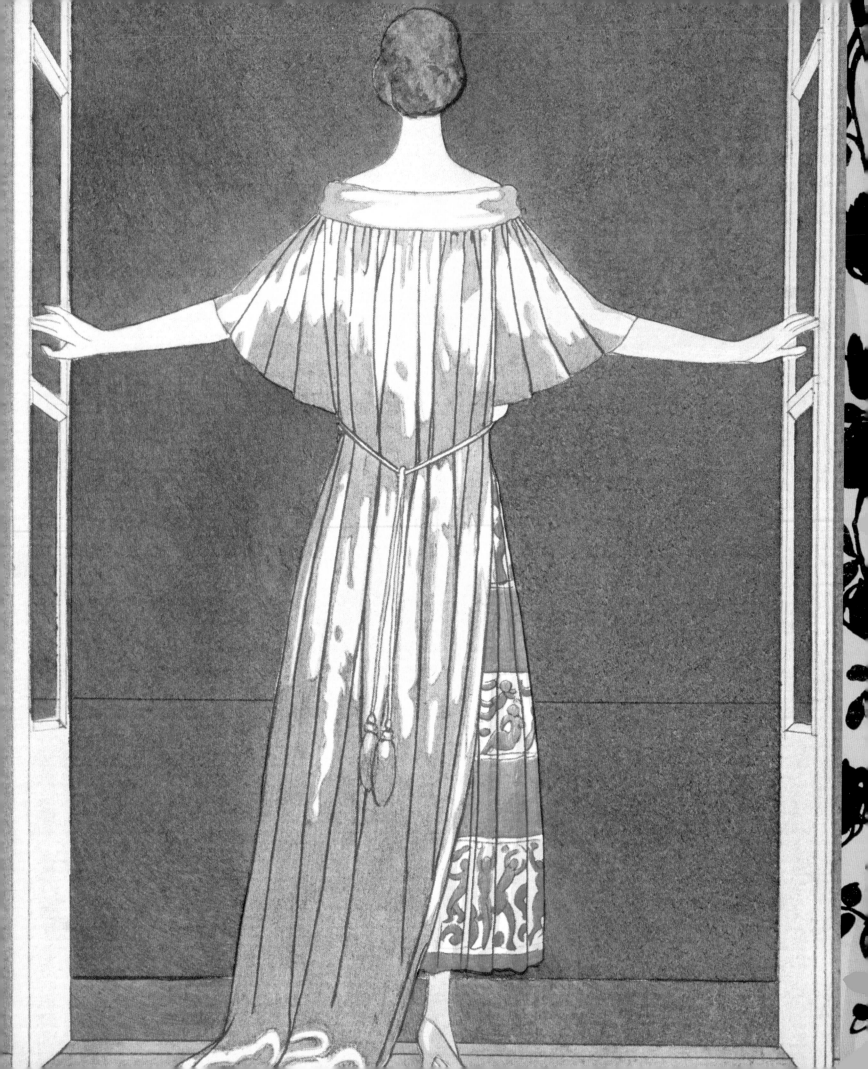

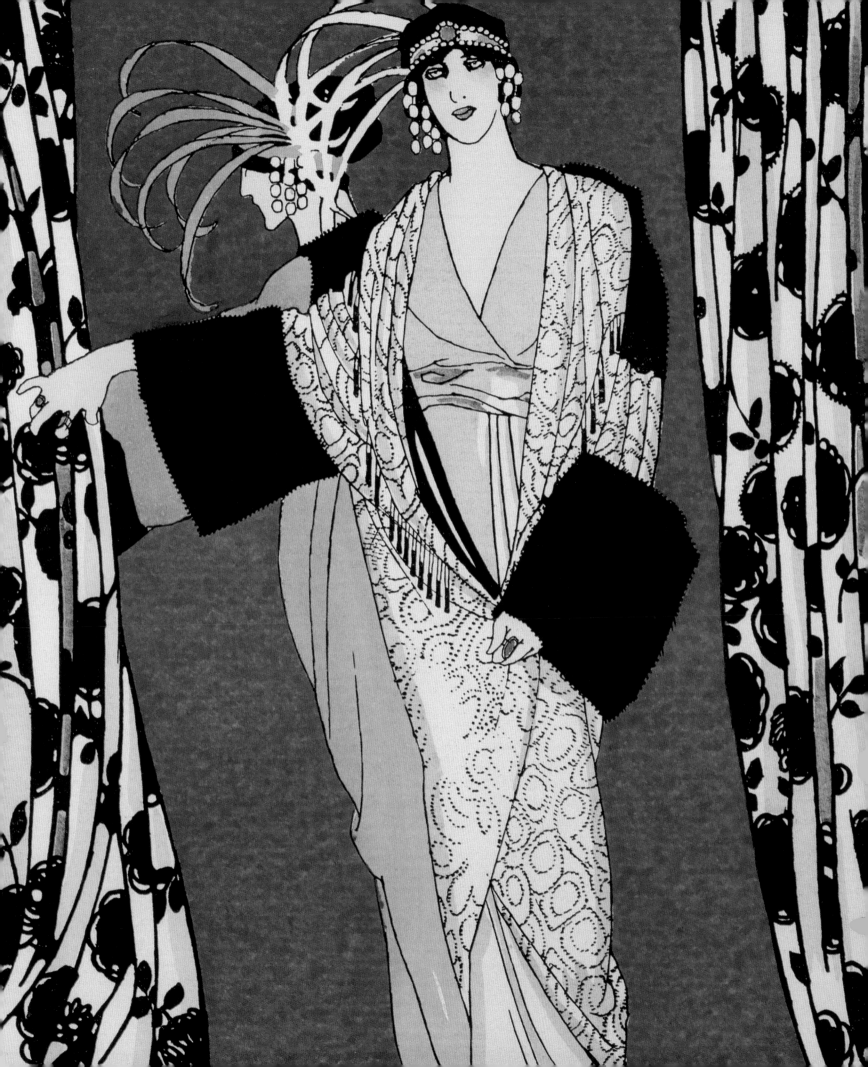

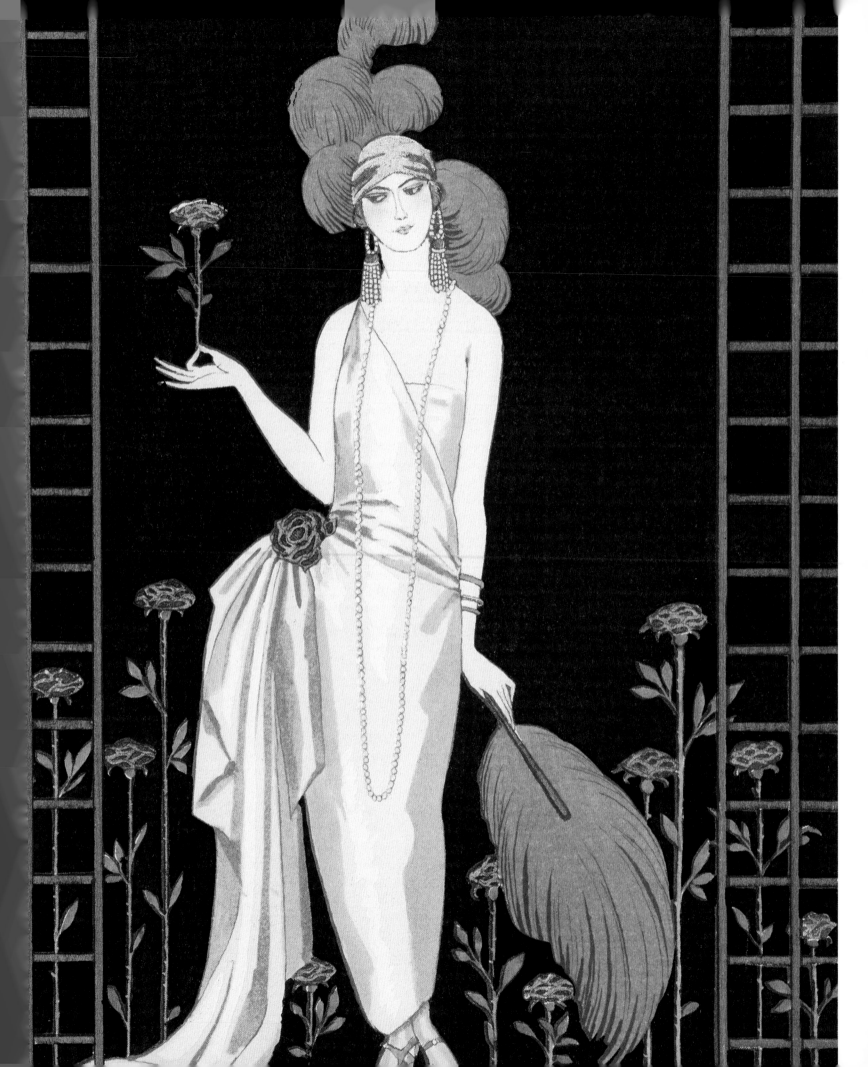

silks with leg-of-mutton sleeves and trailing skirts, Jazz Age women wore light and fluid evening dresses, made from chiffon and lightweight silks or one of the new artificial silks. The dress was designed to reveal the wearer's arms and legs, and it did not require the heavy underpinnings and corsetry of late nineteenth-century fashions. And where her mother had favoured white evening dresses, the flapper went the opposite way. For evening she wore black, silver, gold and vibrant colors.

The difference between the two generations could not have been greater. The flapper was the icon of young womanhood in the 1920s, but a generation before, at the turn of the century, it had been the Gibson Girl: a tall, voluptuous figure with masses of upswept hair. She was the cartoon invention of illustrator Charles Dana Gibson and in the United States she came to represent the strong, self-confident "new woman" of the late nineteenth and early twentieth centuries. A few decades on, however, with her prominent bosom, tiny waist and protruding bottom, she looked positively archaic.

Consider F. Scott Fitzgerald's description of a dance party in his short story of 1920, "Bernice Bobs Her Hair":

"At these Saturday-night dances it was largely feminine; a great babel of middle-aged ladies with sharp eyes and icy hearts behind lorgnettes and large bosoms. The main function of the balcony was critical. It occasionally showed grudging admiration, but never approval, for it is well known among ladies over thirty-five that when the younger set dance in the summer-time it is with the very worst intentions in the world, and if they are not bombarded with

stony eyes stray couples will dance weird barbaric interludes in the corners, and the more popular, more dangerous, girls will sometimes be kissed in the parked limousines of unsuspecting dowagers."

Fitzgerald had a knack for capturing the decadent and sophisticated lifestyle of the 1920s, and here his portrayal of the gap between the generations seems particularly apt. From the poised, curvaceous S-shaped female idea of the late nineteenth century, moving graciously beneath her heavy trained dress, to the lithe

As evening dresses became less structured, accessories became an increasingly important part of getting dressed, as Charles Worth's dress of 1922 (opposite) and Anna Sui's flapper dress (above) show. Feathers were popular, as were turbans and headdresses. Dangling earrings, long beads and dancing pumps with ankle straps are now considered synonymous with the 1920s look.

flapper kicking up her heels in her short swinging skirt, represented a sea change in fashion. In the centuries of evening-dress fashions that had preceded this point in time, there had never been quite such a leap.

The revolution in dress had begun in the early years of the twentieth century, and it was centred on Paris. Several events here would shake up the way women dressed for night and day. It all boiled down to a new awareness of the body that had manifested itself in sporting pursuits during the daytime, and dancing in the evening. Clothes began to be designed for freedom of movement.

In 1905, the Parisian designer Paul Poiret presented his "Nouvelle Vague" collection, a series of dresses that did not require a corset to be worn underneath. The looser style of dress fell from a high Empire-style waistline, creating a tunic effect. Unlike the Empire styles of the late eighteenth and early nineteenth centuries, however, Poiret's expanse of draped skirt was often fantastically decorated for evening. As the form and structure of the dress had become much simpler, surface texture took over as the defining element for evening. Poiret's evening dresses were sequinned, beaded and embroidered, often using silver or gold thread.

Poiret's efforts to forge a new dress code for women were spurred on by the arrival in Paris in 1909 of Sergei Diaghilev's Ballets Russes, a groundbreaking dance corps that would take Europe by storm. Most especially, it was the vibrant and exotic costumes that caught the public imagination.

Designed by Russian artist Léon Bakst, the costumes for the Ballets Russes were dazzling in their bright colors and rich ornamentation, and they maximized freedom of movement, revealing the dancers' well-honed bodies. Couturiers such as Poiret and Jeanne Paquin were inspired to incorporate elements of the Ballets Russes' costumes into their clothing designs. Evening dress lent itself particularly well to these exotic influences. While women might still have been hesitant to wear exotic and colorful ensembles by day, they felt more freedom to do so at night. The nighttime mood and the softer lighting lent themselves well to the fantasy elements and rich bright colors inherent in the new, opulent evening styles. As has often been the case, designers tried out new ideas with evening dresses before extending those ideas into their daywear ranges.

Experimenting with Oriental themes, several designers created kimono-style evening dresses and coats. Paul Poiret swathed his opera-goer in a cocoon-like cape with loosely cut sleeves, and he used its large surface area for embellishment with rich embroidery. Evening dresses also incorporated the wide, loose sleeve and crossover neckline of the kimono.

When the dance craze for the tango hit Europe from Argentina, Jeanne Paquin designed a "tango dress". She kept the silhouette fashionably narrow, but incorporated concealed pleats to allow the wearer freedom to move on the dance floor. The style was the hit of 1912 and became the basis for suits and day dresses as well. Designers in London and New York also created "tango dresses" with slits or shorter hems to facilitate dancing.

Dance, and dancers, had a profound effect on eveningwear in the years leading up to 1920. In 1914

Although, compared with evening dresses from the previous century, the 1920s-era model was relatively streamlined, it was by no means lacking in beautiful detail, as this pink gown from 1921 suggests, in a lithograph by Georges Barbier entitled Yes! *Barbier, the foremost fashion illustrator of the Art Deco period, was passionate about dance and illustrated many books on the subject.*

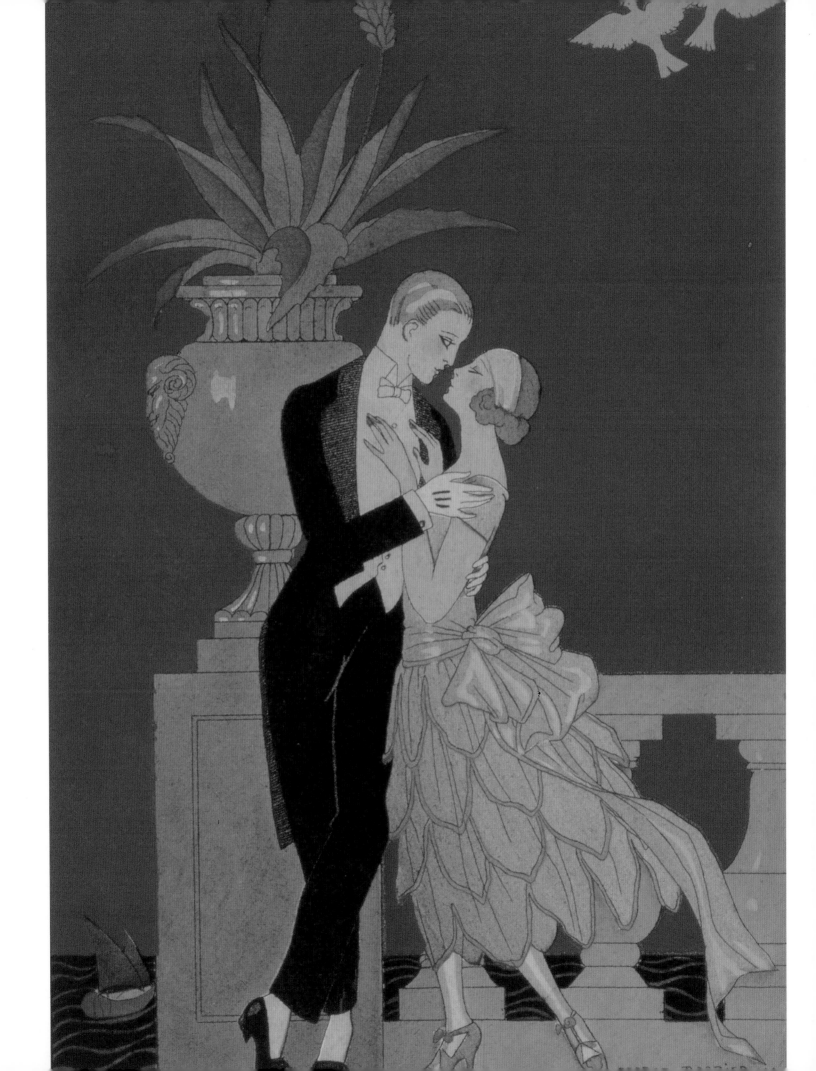

∞ *The actress Gloria Swanson was something of a fashion icon in her time. Here, in a movie still from* My Own Party, *Swanson demonstrates stylish garb for a formal party – a long, slim tube of a dress in black and white adorned with hundreds of tassels.*

American ballroom dancer Irene Castle arrived in Paris to perform with her partner and husband, Vernon. Slim, graceful and with a toned athletic physique, Castle was the antithesis of the matronly ideal that had been in vogue before World War I, and she proved an inspiration to couturiers such as Patou.

As Patou himself explained, "The slow-moving prewar era sponsored trailing, clinging draperies and showy trimmings, all features suggesting wealth and leisure. The woman who wore such clothes seldom walked, and if she did

it was with great majesty and dignity ... The fashions of today are indicative of a new and changed way of living, at any rate so far as a woman's evening activities are concerned."

Dance was the thing that now often dominated women's evening activities, and hence their wardrobes. For the Paris couturiers the passion for dancing meant that evening dresses were the first to explore new ground in fashion, becoming straighter and shorter. Social life was now centred much less on entertaining in private salons and more on going out to cafés, restaurants and nightclubs.

In the United States dancing had been popular since the early years of the twentieth century, and Irene and Vernon Castle had become celebrities, with their performances of the new ragtime dance crazes sweeping the country. Commenting on the dance trend, music publisher Edward Marks noted that; "The public of the nineties had asked for tunes to sing. The public of the turn of the century had been content to whistle. But the public from 1910 on demanded tunes to dance to."

Of course, dancing has always been a fixture of evening entertainments throughout history, but this type of dancing was nothing like the formal dances of previous centuries with their strict codes of etiquette. Indeed, the syncopated rhythm of ragtime brought with it expressive new dance styles that were easy to get the hang of. This was dancing to throw yourself into, and it required appropriate clothes that not only allowed movement but also expressed the dancer's exuberant mood.

New restaurants, cabarets, ballrooms and dance clubs

Sequins and metallic fabrics made dresses shimmer at night. Actress Bebe Daniels models a dress covered with silver sequins and an elaborate headband of drop crystals (opposite). Vivienne Westwood captures the mood with her sparkling gold dress (left).

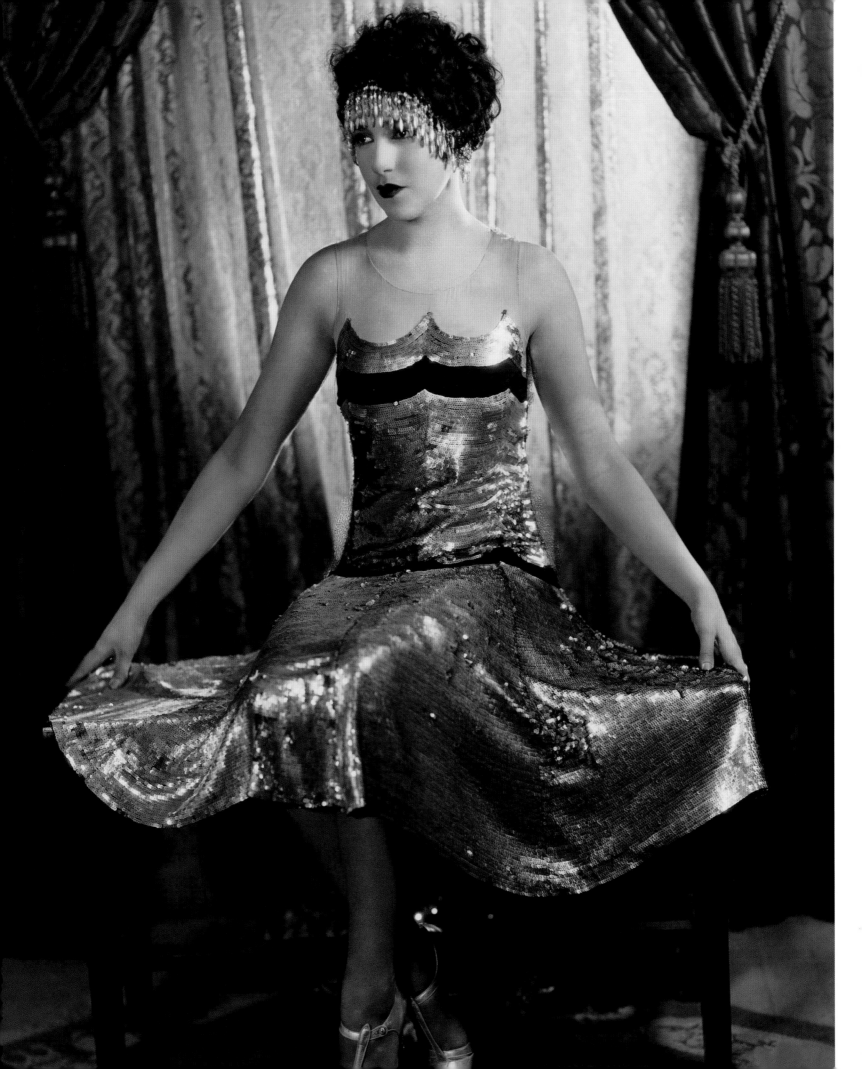

∞ *Designer Gabriel Scarvelli uses couture techniques, drawing on knowledge passed down from a dressmaker who worked in the couture ateliers of Paris in the 1920s, to bead his evening dresses painstakingly by hand (right and opposite). Many of the women working for couturiers in Paris in the 1920s were Russian emigrées – White Russians who were highly skilled in handicrafts. Elaborate beading continues to feature as a signature element of 1920s-inspired eveningwear: for example, the charming flapper dress by Blumarine (overleaf).*

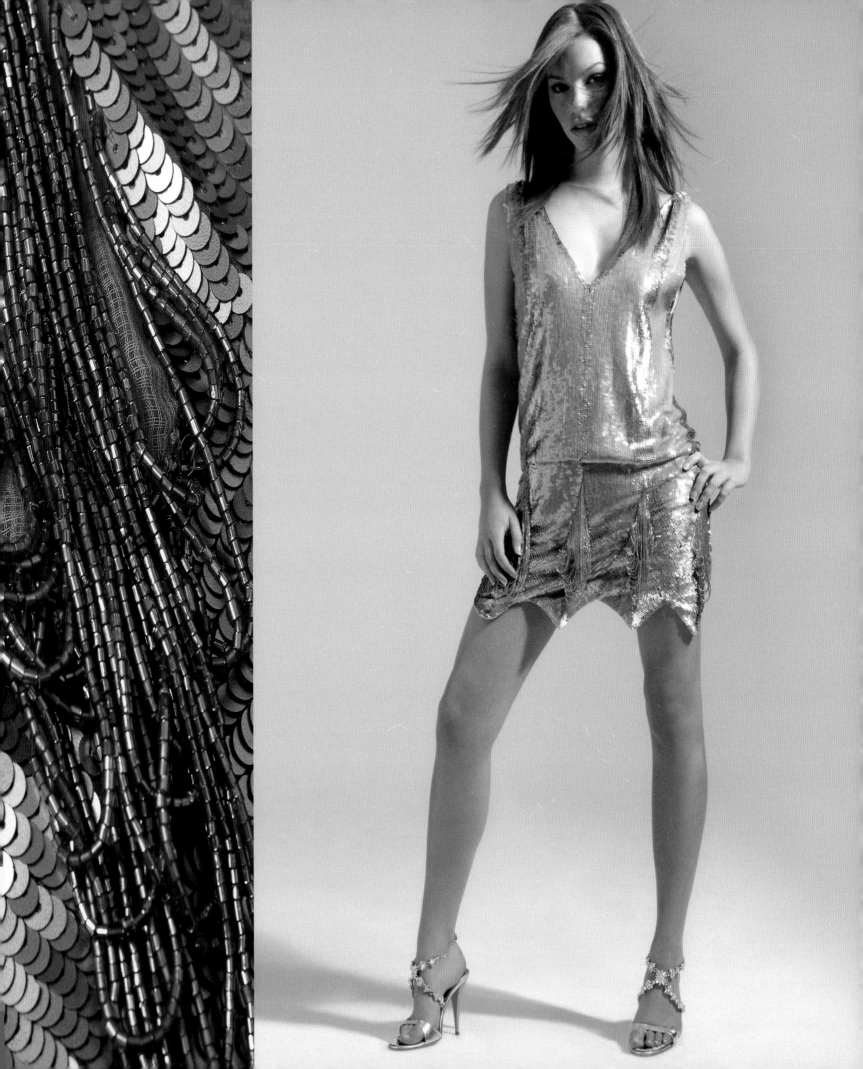

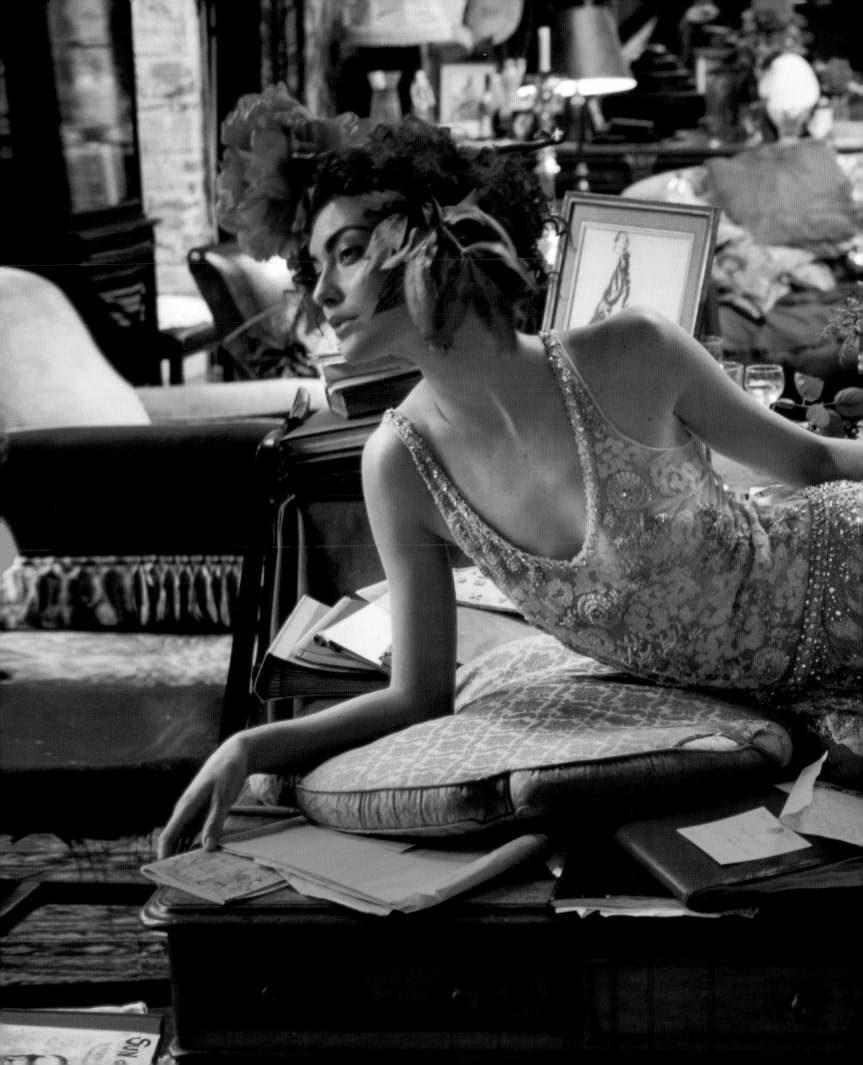

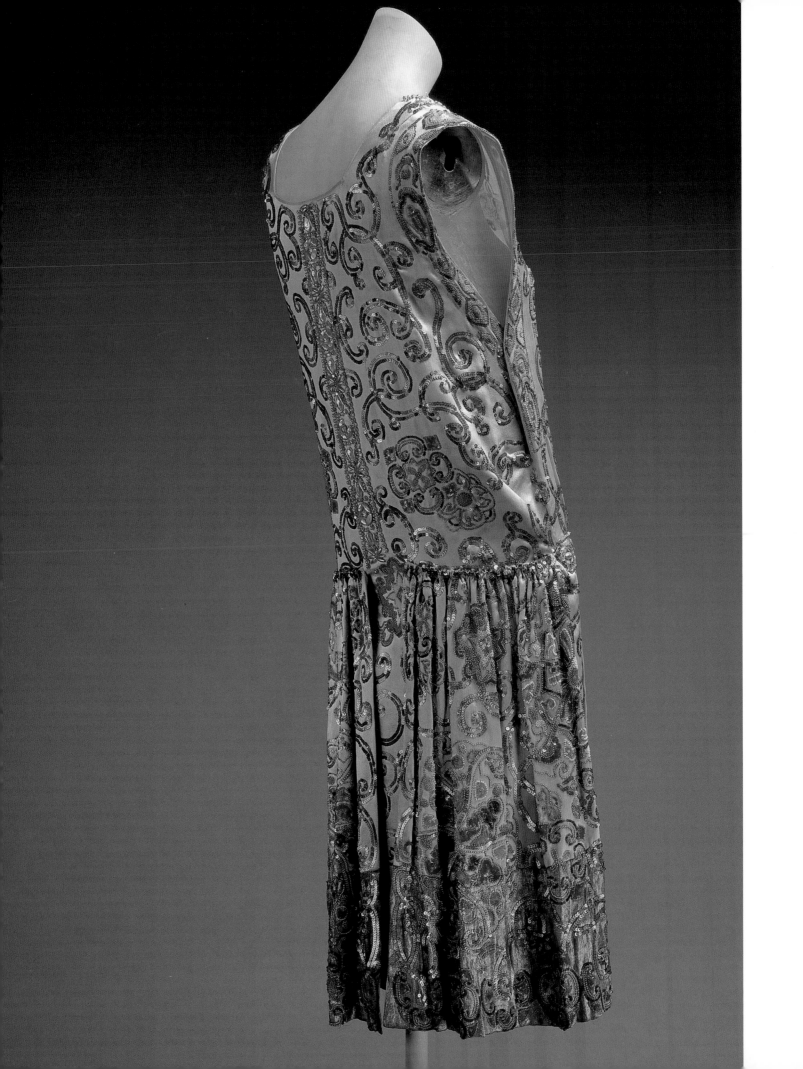

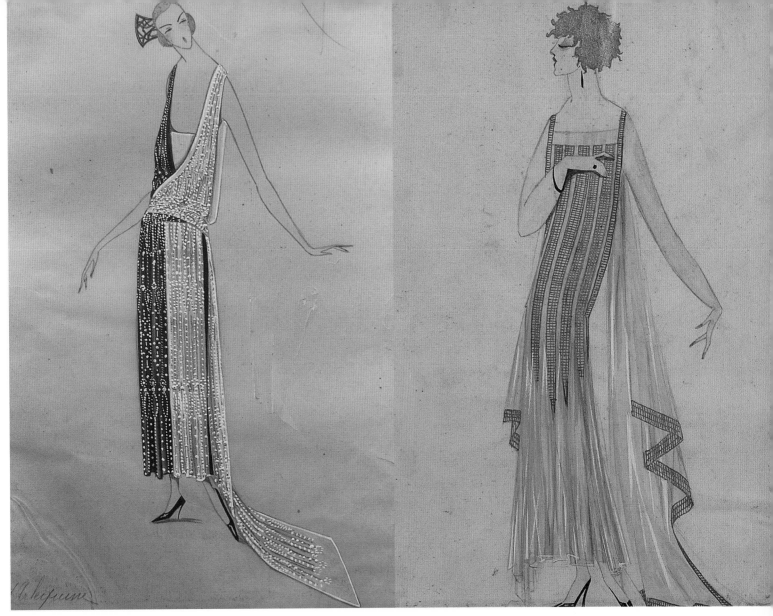

sprang up to cater to the craze for ragtime dances, and when Irene and Vernon Castle invented the simple foxtrot step in 1914, it must have seemed as if half of America lived in their evening clothes. Certainly millions of women followed suit when Irene Castle abandoned tight-fitting, corseted evening dresses in favour of the straighter, looser style she had seen in Paris, giving her freedom to dance.

While Irene Castle introduced a slimmer and more dynamic physical ideal to the fashion ateliers of Paris, on her return to the United States she took back with her not only a new dress style but the European signature of modernity, the bob. It took a few years before the look gained popularity, but when it eventually did catch on it came to symbolize a new breed of women, usually young, who were not content to live as their mothers had done.

The impact of World War I on the psyche of women was enormous. After the war the mood in Britain and elsewhere shifted radically. The horrors of war had imbued the

∞ *Sportswear was a major source of inspiration for designers in the 1920s. The line of Jean Patou's dress from 1927 (opposite) is essentially that of a tennis shift, but lavish embroidery transforms it into eveningwear. Similarly, two dresses by Jeanne Lanvin (above) rely on beading and luxurious silks to lend them an elegance appropriate for nighttime dressing.*

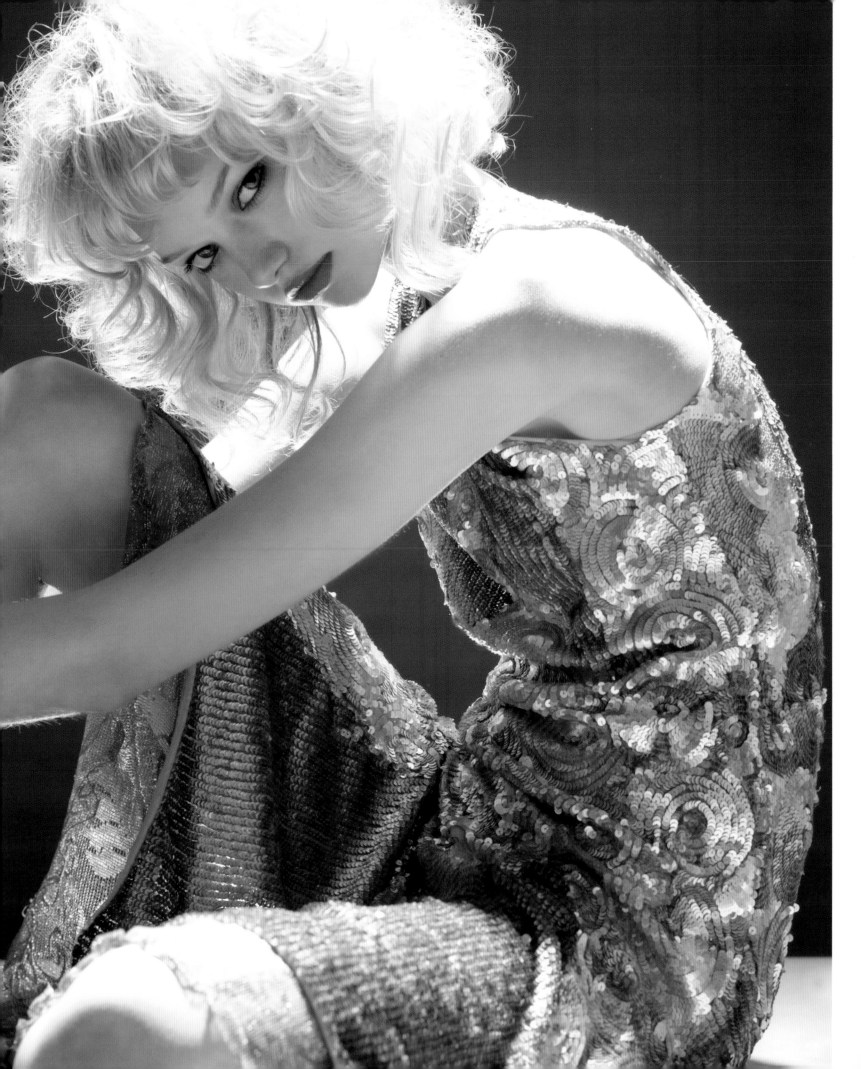

younger generation with a sense that life must be lived for the moment. The huge death toll among young men — one in every seven eligible men according to British *Vogue* at the time — left the single woman feeling that there was no point in putting all her energies into finding a husband and settling down quickly. In addition, work in factories and offices during the war had given women more confidence and independence. They had begun to earn their own living, and were determined to enjoy their newfound freedom.

Much of their leisure activity was nocturnal, and much of it centred around dancing. Her day began at dusk. Zelda Fitzgerald conjures up the excitement of evenings in New York after World War I in *A Millionaire's Girl*:

"Twilights were wonderful just after the war. They hung above New York like indigo wash ... Through the gloom people went to tea ... On all the corners around the Plaza Hotel, girls in short squirrel coats and long flowing skirts and hats like babies' velvet bathtubs waited for the changing traffic to be suctioned up by the revolving doors of the fashionable grill. Under the scalloped portico of the Ritz, girls in short ermine coats and fluffy swirling dresses and hats the size of manholes passed from the nickel glitter of traffic to the crystal glitter of the lobby."

Young people went to hotels for evening tea, where they also danced between courses. If they were old enough to go on to one of the new nightclubs, or enterprising enough to get in if not, they danced between drinks.

While private parties and balls were still thrown with regularity for the rich and well-to-do, the new arena for evening entertainment for the burgeoning middle classes was public. John Buchan describes the change of mood in his book *The Dancing Floor*: "I had a sharp impression of the change which five years had brought. This was not, like a pre-war ball, part of the ceremonial of an assured and orderly world. These people were dancing as savages danced — to get rid of or to engender excitement."

In London, dance clubs and dance halls opened after the war to cater to the public passion for dance, which seemed to pick up where it had left off before the war, except that the social etiquette was now much more relaxed. Escapism was a major theme of life, it seemed, and this sense was heightened by the influenza epidemic of 1919, which killed more people than the war had. For those without children, and with enough money, life was a seven-night-a-week whirl of entertainment — theatre, cinema, cabarets, balls, cocktails and dancing.

Nightclubs were vibrant and exciting, the places to go and hear the dynamic music style sweeping through America and Europe — jazz. In New York City, Harlem had the best clubs for jazz, the greatest of which was the Cotton Club. White society flocked there to hear the likes of Cab Calloway, Louis Armstrong and Duke Ellington. Prohibition did nothing to deter the avid audience for jazz, men and women alike.

In London, there was the Savoy for tea dances, followed by the theatre and then drinks and dancing at the Mayfair, or the Embassy, or at the Kit-Kat or the Silver Slipper. Nightclubs were often taken over for private parties given

A gold sequinned flapper dress by Lisa Ho (opposite) is easy in its style, as the pose of the model shows, but is ultimately luxurious in its mantle of sequins and beads. Worth's "Robe du Soir" from 1921 (overleaf, left) uses a trim of pearls and fabric roses to add romance to a simple black dress. Grimaldi Giardina's fresh take on the flapper dress employs chiffon and a hand-beaded bodice (overleaf, right).

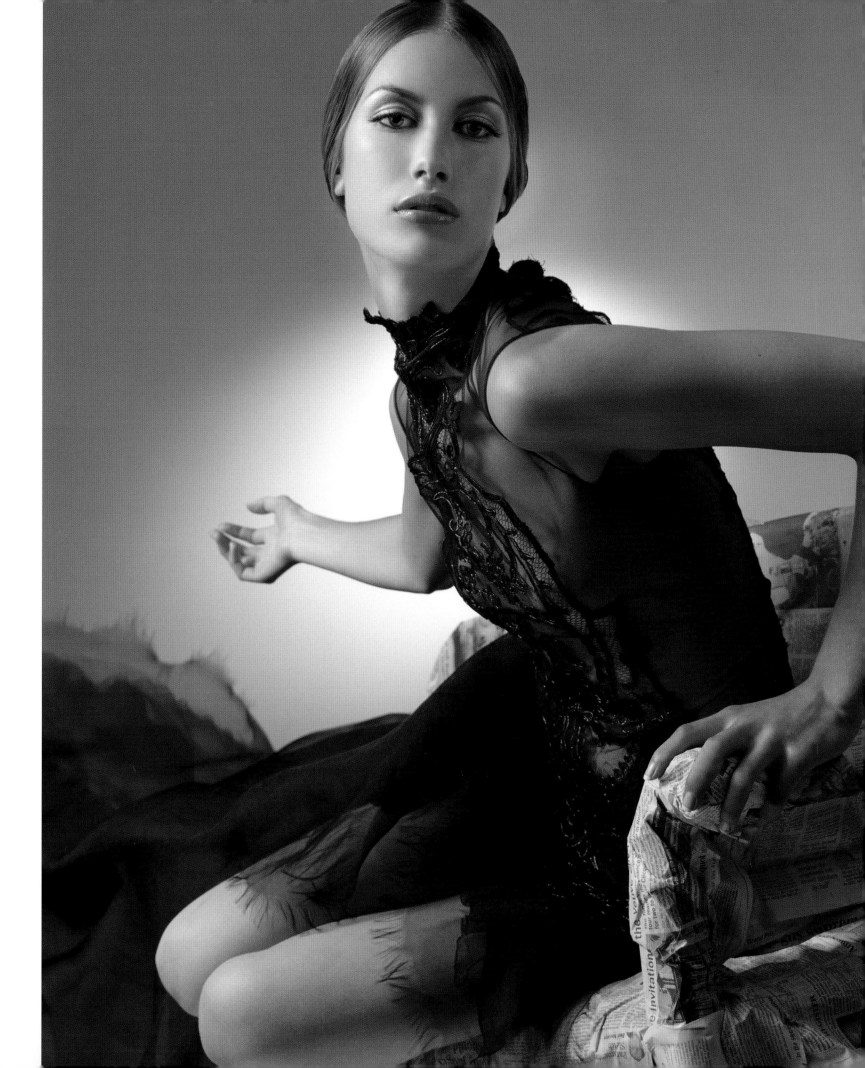

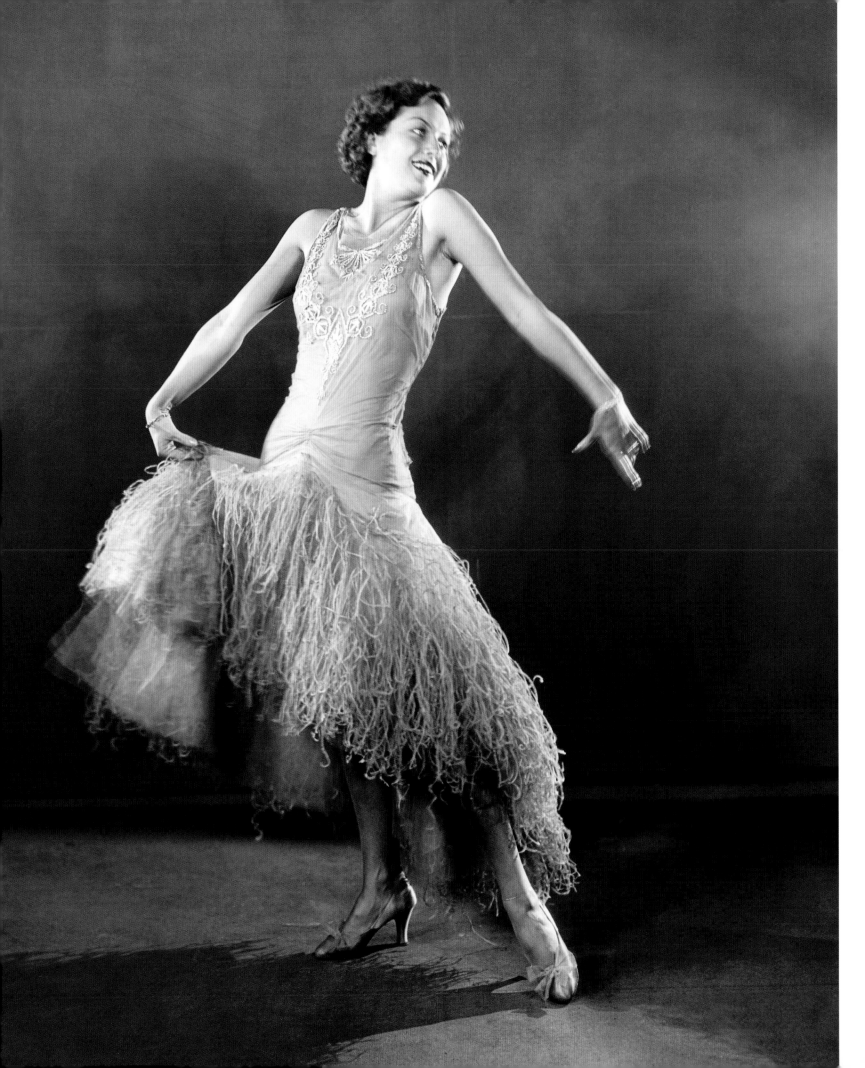

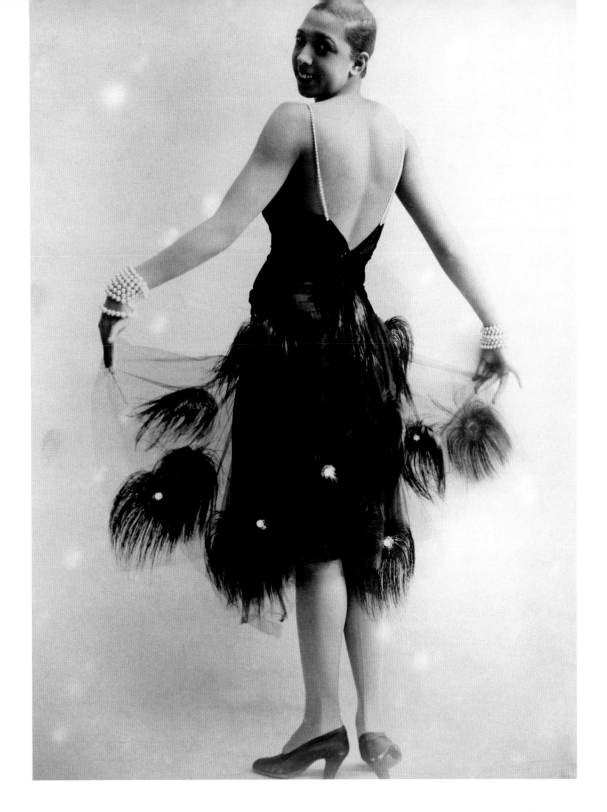

∞ *The dance culture of the 1920s was a fashion catalyst, inspiring designers to create formal dresses that would give a woman freedom of movement, while still appearing seductive. Here two celebrities of the day, Joan Crawford (opposite) and Josephine Baker (above) show how feathers were used to give a dress suppleness and a sense of panache. Fluttery chiffon layers achieve the same end in Karl Lagerfeld's designs for Chanel (overleaf).*

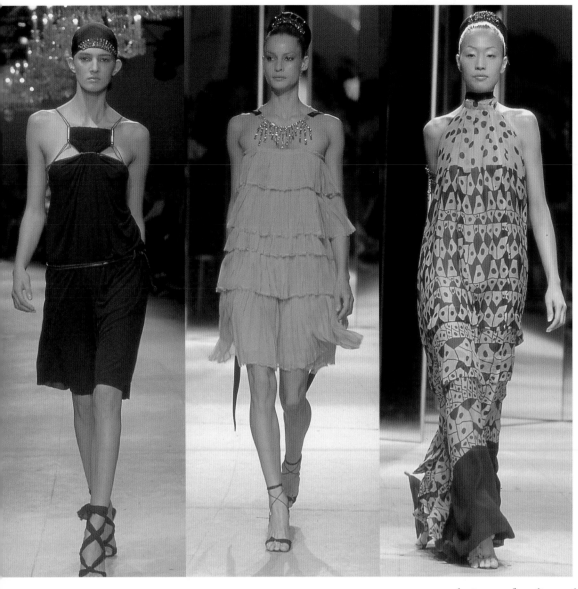

by society hostesses. Cecil Beaton described one such party in an article for British *Vogue*. There were "people literally overflowing into the street ... all the people one had ever known or even seen ... Lady Ashley shining in a glittering short coat of silver sequins over her white dress ... Gladys Cooper in a Chanel rhinestone necklace that reached to the knees of her black velvet frock."

In Paris, Paul Poiret returned from the war to open up his salon, and a nightclub, called L'Oasis, although it famously did not play jazz. Nevertheless, Poiret recognized that the focus of fashionable society was now dance-oriented.

By 1921, *Vogue* was ready to admit that: "Owing to this craze for dancing, dining in restaurants where dancing takes place either during or after dinner, has become very popular, and it is in such restaurants that one sees the newest clothes."

∞ *American dancer Irene Castle (opposite) was an enormously influential figure. Here, photographed in 1910, she wears a Lucile evening gown, designed by Lady Duff-Gordon, and holds a large feather fan. Her athletic body and bold stride captured the interest of Patou when she and her husband, Vernon Castle, performed in Paris in 1914, and he became aware that women were now going out in the evening to enjoy cafés and cabarets rather than entertaining at home. Capturing the mood of that time, contemporary evening dresses by Lanvin (above).*

The "newest clothes" for evening were straight and loose, with chiffon streamers and handkerchief hems, tasselled or feathered. Skirts were still longish, finishing just a few inches above the ankle, but in 1923 Chanel showed much shorter skirts, ten inches off the ground. The look worked, and it set a trend for shorter skirts for the next few years.

It is interesting that while 1920s women had more freedom than at almost any time previously, and their

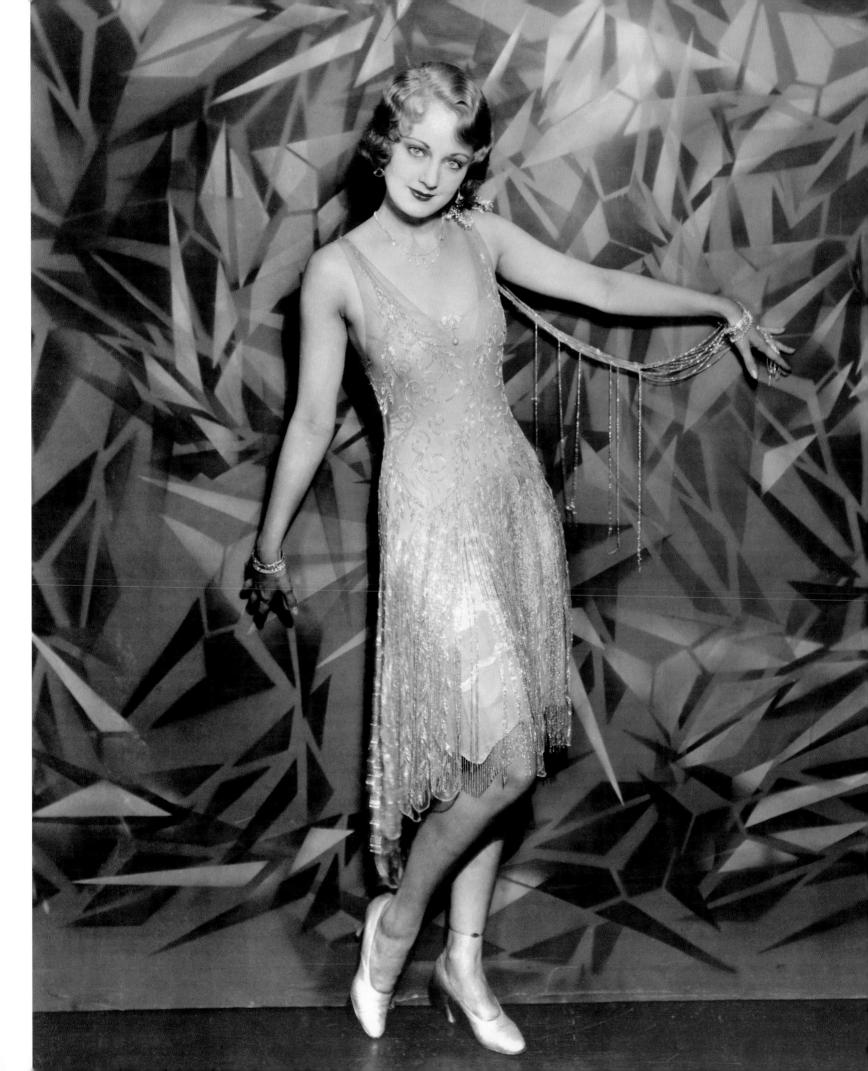

a red flapper dress to her husband's inauguration at the White House. And Mary Edna Sullivan, curator at Louisiana State Museum, has noted of 1920s youth in New Orleans, the home of jazz: "Even Carnival queens wore flapper-style gowns." By 1931, one New Orleanian would complain, 'Bare legs have lost their novelty.'

Concurrent with the emergence of the flapper was a huge array of new consumer goods, especially clothing. Department stores were well stocked with ready-to-wear dresses in the new artificial silk, as well as the real thing for those with bigger budgets. Machine processes meant that the working girl could afford an evening dress that was beaded and trimmed in the style of more expensive couture creations.

The flapper heroines were cinema stars, Gloria Swanson and Louise Brooks, with their chic cropped heads and designer clothes. The other female icon of the 1920s was Josephine Baker. In her revue of 1925 at the Folies Bergère in Paris, Josephine Baker made an enormous impact with her exotic costumes and striking appearance. *Vogue* described her arrival for an interview with the magazine dressed in "a full blue tulle frock with a bodice of blue snakeskin". On stage she wore "only a diamanté maillot of tulle and red gloves, with diamond balls hanging from the tips of her fingers". Neither Paris nor London had never seen anything quite like it, and the attention surrounding Josephine Baker, and of the music and dance of her show, injected a huge dose of energy into the fashion designer's realm.

∞ *The "little black dress" (opposite), at once sexy and versatile, originated in the 1920s. Karl Lagerfeld has suggested that it evolved from the mourning clothes worn by so many women during World War I. Black and white, another popular combination for evening (right), was associated with jazz music.*

The interest in African culture that Baker had helped to consolidate was coupled with the great archaeological discovery of the age, Tutankhamen's tomb, in 1922. Suddenly, Egyptian motifs were everywhere in fashion. These two influences were seen in evening dress in the form of geometric patterns, often rendered in beads and spangles, bold colors, and black and white. Following on from modern art and the costumes of the Ballets Russes, the themes of jazz, African cultures and Ancient Egypt gave added impetus to eveningwear designers. These varied sources of inspiration were interpreted as fashion by the

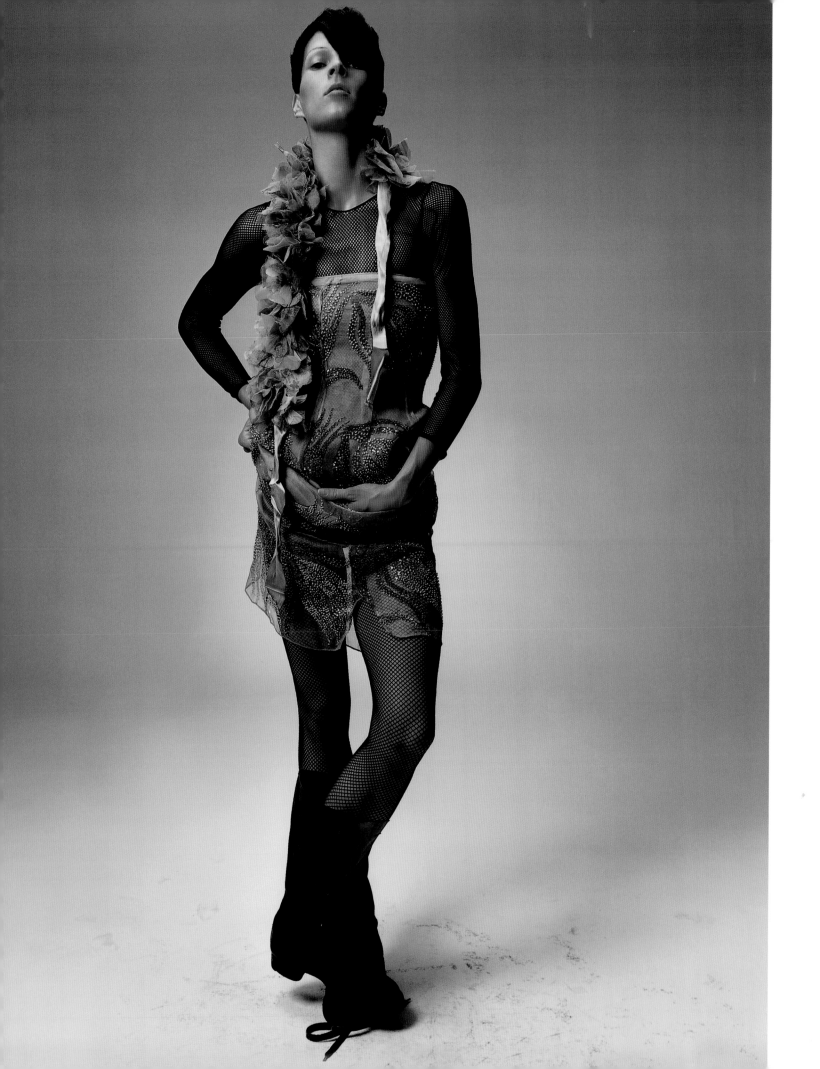

Paris designers, and copied in Europe and the United States. Fantasy elements were strong, especially in the first few years of the 1920s, when evening dresses were almost like costumes in their luxurious fabrics and theatrical details. Fabrics such as lamé, silver lace and shot tulle were formed into dresses with trails of chiffon, beading, feathers and fringes that moved with the wearer as she tried out one of the new dance steps. The fringed shawl was a very popular accessory for night, often in brilliant colors and featuring decorative embroidery or hand-painted motifs.

Perhaps most of all, the flapper loved the "little black dress", low in the front and at the back and hung from thin shoulder straps. Zelda Fitzgerald's heroine in *The Millionaire's Girl*, the sixteen-year-old Caroline, "dressed herself always in black dresses — dozens of them — falling away from her slim, perfect body like strips of clay from a sculptor's thumb".

Fashion doyenne Emily Post was also a great promotor of the flapper's beloved black, writing that "nothing really can compare with the utility and smartness of black. Take a black tulle dress, made in the simplest possible way; worn plain, it is a simple dinner dress. It can have a lace slip to go over it, and make another dress. With a jet harness — meaning merely trimming that can be added at will — it is still another dress. Or it can have a tunic of silver or of gold trimming; and fans, flowers and slippers in various colors, such as watermelon or emerald, change it again. In fact, a black tulle can be changed almost as easily as though done with a magician's wand."

∞ *Louise Brooks (right) portrayed the independent young flapper in her films, becoming a role model for women who cropped their hair accordingly. She endures as a symbol of the free-spirited female, as emulated by Armani's model (opposite).*

In 1925, British *Vogue* devoted what would be the first of many issues to "The Little Black Dress", but it is Coco Chanel who is officially credited with its invention in her collection of 1926. A slender, sleeveless dress of black crepe de Chine, it was scooped low at the back and finished at the knee, with a chiffon streamer trailing from the back of the waist to below the hem. American *Vogue* referred to it as "The Chanel 'Ford' — the frock that all the world will wear." It could have added "always with a rope of pearls", for that is how Chanel accessorized it, and how thousands of women subsequently did in the 1920s, and in almost

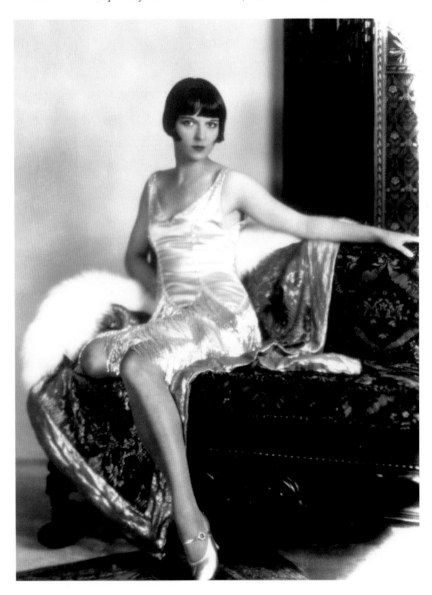

In the spirit of Louise Brooks, Anna Mouglalis (right) wears a gold lace dress by Chanel, based on a sketch by Karl Lagerfeld (left). Metallic lace dates from at least Elizabethan times and has remained one of the most precious fabrics for evening.

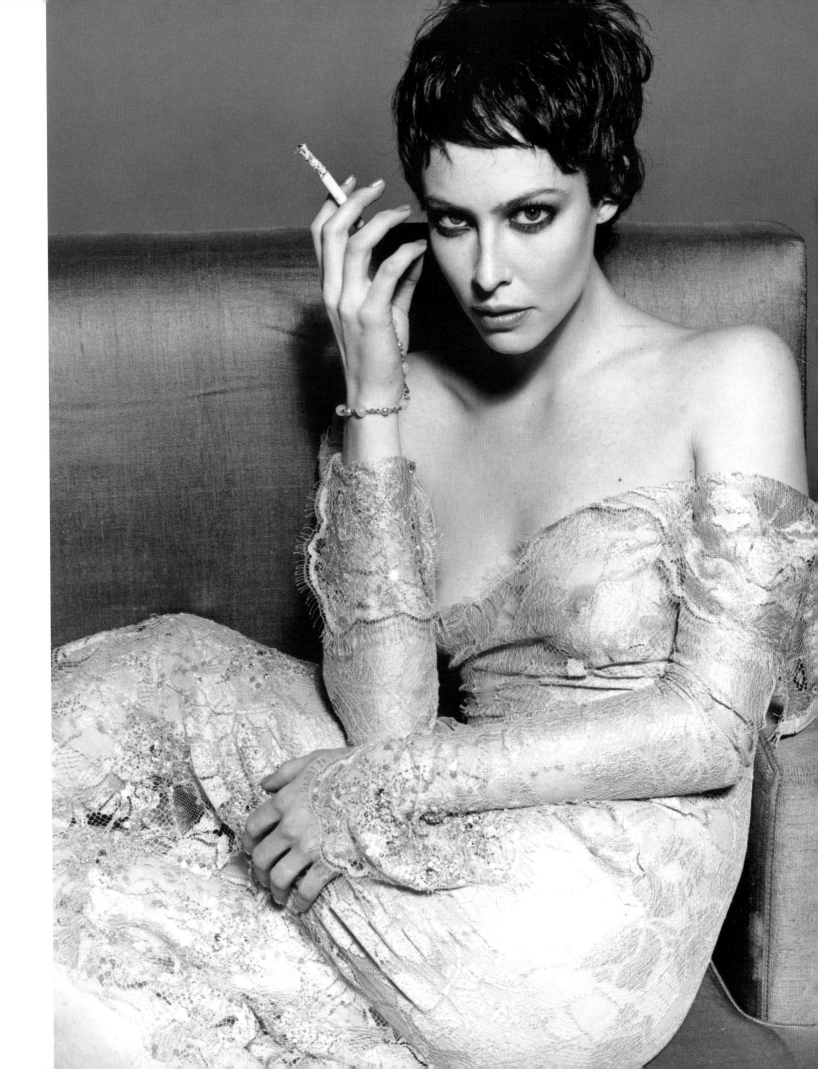

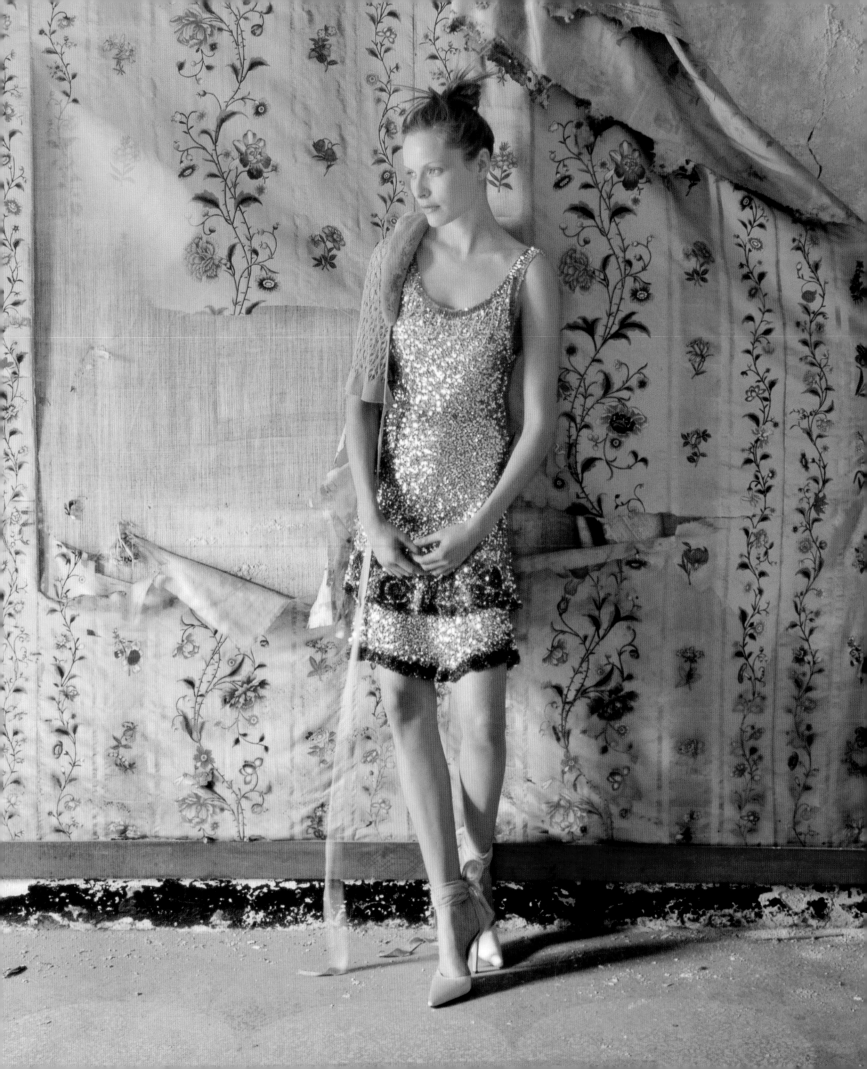

every decade since then. There were black dresses for day in wool and matt fabrics, but the black dress for night has proved the most enduring. Chanel designed the black evening dress in shiny fabrics such as silk and satin, which had first been used for eveningwear in 1924 in the form of Patou's evening pyjamas, often with a trim of diamanté.

Patou was Chanel's main rival in Paris. He had pioneered the idea of the fashion show, showing collections twice a year in his elegant salon on the rue Florentine. Champagne was served, cigarettes and fine cigars proffered, perfume samples presented. Models came out wearing sports and daywear first, and the show culminated with evening and bridal wear as is still customary today. Patou made his name with sportswear, influenced by key women such as the elegant tennis player Suzanne Lenglen. Like Chanel, he catered for the international café set, who during the summer months frequented the Riviera resorts, along with Deauville and Biarritz.

Sports had become all the rage among this fashionable set, and Patou was one of their favourite designers. His dresses and swimwear were chic and bore a prestigious label, yet were immensely practical and designed with physical activity in mind. His eveningwear was equally sought after for its freedom of movement. One evening dress of 1925 is designed just like a sleeveless tennis shift, but with a glittering pattern of multicolored sequins all over, announcing its use for parties and dinners.

Despite Patou's close association with sportswear, it was his evening-dress designs of the late 1920s that pointed the way to the next major change in fashion in the 1930s. The catalyst was his association with Hollywood's movie stars. Gloria Swanson was a favourite client, who is said to have spent much of her quarter-of-a-million-dollar wardrobe allowance in 1925 at Patou. Mary Pickford was another

client, as was Pola Negri. Designing stage costumes for the stars inspired Patou to try out more showy, glamorous evening dresses in his clothing range.

Among the stars he dressed was a new kind of professional ballroom dancer who danced in cabarets at Hollywood nightspots. Just as Irene Castle had inspired Patou some ten years earlier, this time it was the blonde El Ambrose. Patou set out to make dancing dresses for her that were not costumes as stage dancers had previously worn, yet were not as subtle as real-life dancing dresses. They needed to convey a heightened sense of reality and show off the dancer's graceful movements. These dresses were made from light gauzy materials, especially tulle, and they were distinct from Patou's other collections because they were long with fuller skirts and a defined waistline, sometimes emphasized with a diamanté belt.

In 1929 Patou transferred the lines of his dance dresses to the evening gowns of his Paris couture collection. The designs were hailed as a radical new look, and welcomed with open arms by the fashion set. While daywear continued to follow the same route for a few more years, Patou's evening dresses were pointing the way forward — to a new longer line that caressed and clung to the body, and to a new vision of femininity in the 1930s.

∞ *A simple sequinned shift by Anna Molinari for Blumarine has the flapper in mind in its straight lines, textured, light-reflecting surface and in the tiered hemline. Revealing the arms and the legs, the flapper dress was shocking in its time but has endured as one of the most flattering evening styles.*

CHAPTER TWO

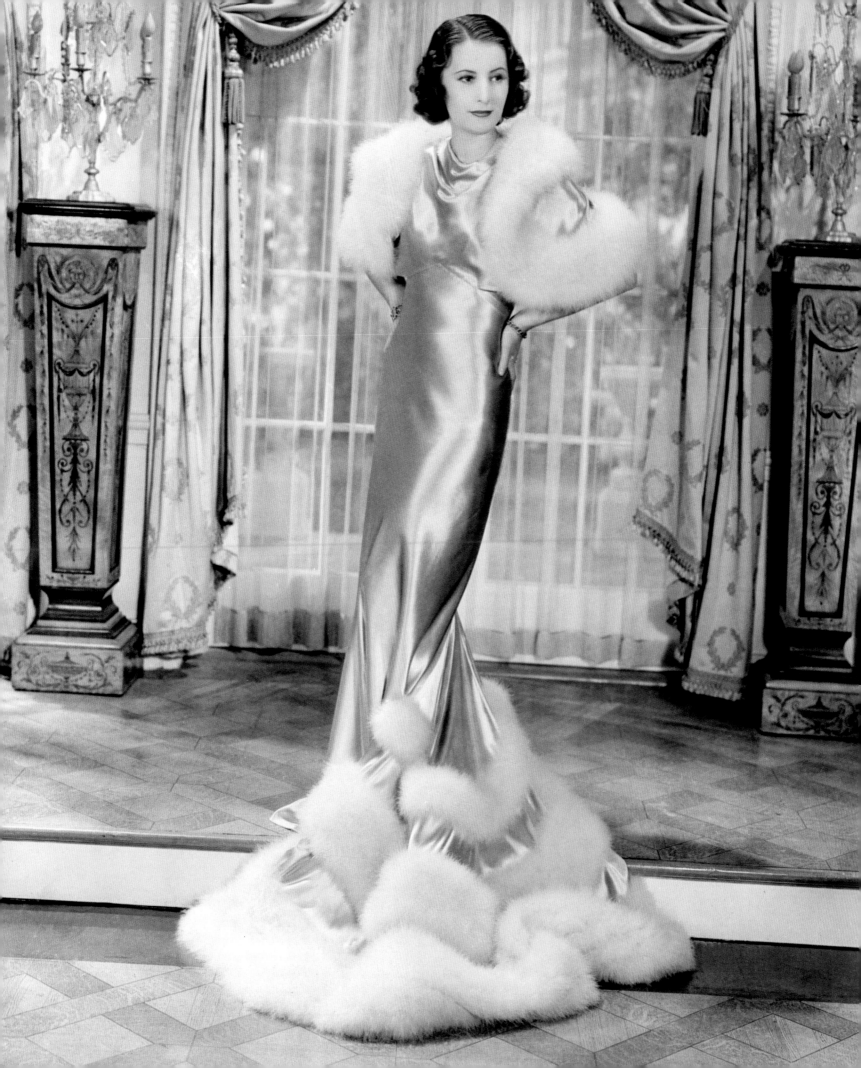

SATIN SIRENS

"Where's the man could ease a heart
Like a satin gown." DOROTHY PARKER, *THE SATIN DRESS*

The 1930s are famously characterized as a decade that began with Depression and ended in war. Despite the grim connotations, this era produced some of the most spectacular eveningwear of the twentieth century. Clinging, long lines, drapery, bias cutting and pleating distinguished gowns of the 1930s, a trend that continued through most of the following decade, and has been revived and reinterpreted by countless designers in the ensuing years. In recent times some of the most successful designers of eveningwear have drawn upon the legacy of the 1930s and 1940s. From American classicists Bill Blass and Carolina Herrera to fashion-forward names such as Narciso Rodriguez, Zac Posen and Miuccia Prada, all have been lauded for slinky satin gowns that cling beautifully thanks to bias cutting, pleating, panelling and drapery.

The mood created by these evening dresses is one of sultry sexuality, best embodied by the stars of the silver screen. The dresses they wore may have been long, cladding much of the skin, but they sat close to the body to emphasize its curves. In the interplay between covering and revealing to create sexual tension, the 1930s-style dress may well provide the ultimate combination. Typically this style of gown comes halter-necked, or with slim straps, but even versions that cover the arms and décolletage entirely manage to look incredibly sexy.

When fabric clings to the entire body, the viewer cannot help but think of everything that lies beneath. There is the pretence of modesty, yet a suggestion of the bare skin beneath. Of course, the effectiveness of the look depends on invisible underwear, removing any barrier, real or imagined, between the body and the fabric of the dress itself. And crucially, when the wearer turns away to reveal a bare back, the true beauty of the dress can be appreciated.

Evening dresses with low-cut backs were introduced in the 1920s, but as the legs and arms were on display as well, the impact of revealing the back was somewhat lessened.

∞ *Photographed in 1934, Barbara Stanwyck wears a silver satin gown trimmed with white maribou, a still for the film* Gambling Lady. *The costume designer was Orry Kelly and he obviously understood the relationship between black-and-white film and a woman's gown. Bette Davis, who relied on his costume designs, described him as her "right hand". He went on to win Oscars for costume design in color for* An American in Paris *(1951) and* Gypsy *(1962) and costume design in black and white for* Some Like It Hot *(1959).*

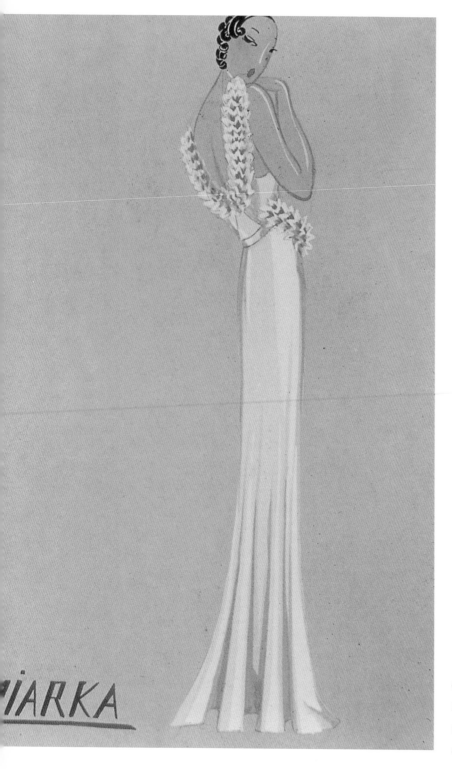

IARKA

By the 1930s, however, as hemlines came down to the floor and cleavage became more modest, the bare back became the focus of attention. As designers began to experiment with higher necklines for evening, such as cowl necks and halter necks, the back was confirmed as the decade's new erogenous zone.

The backless dress is deemed by most fashion historians to be an invention of the 1930s. Certainly in the history of fashion there seems no record of earlier clothing that reveals the back to the extent that has occurred since the 1930s. And where the low backs on dresses of the 1920s fell away into straight skirts, the backless dress of the next decade was shaped to hug the buttocks, heightening the sexual allure of the wearer.

According to the psychologist J. C. Flügel, the erotic focal point of women's fashion changes over time in order to keep males interested in the female body. In 1969 he proposed a theory of shifting erogenous zones, which holds that as one part of the female body is continually exposed, boredom and overfamiliarity with it leads to a change in fashion to reveal a different part of the body. Almost a century earlier, fashion writer Mrs M. R. Hawes had commented on the changing trends for revealing and covering certain parts of the body in her book *The Art of Dress* (1879):

"Costume vibrates perpetually in our country between the need of being seen and the need of being covered. Now one bit of the body's beauty is displayed, and the rest is sacrificed and covered up; it is invariably felt to be an

∞ *Clara Bow, in a silver lamé dress (opposite), demonstrates how black-and-white film dictated the use of shimmering, light-reflective fabrics for costumes. Her long, slim-fitting gown is typical of the 1930s, as is the low-backed gown by Lanvin (left).*

exit line. The bared back is the style of the season, whether that means spaghetti straps spanning the shoulder blades or a halter-neck dress plunging from nape to the base of the spine. Even if a dress is relatively covered up, it might have lacing down the backbone to suggest imminent exposure."

Menkes put the mid-1990s backless revival down to the fact that the slim silhouette of the moment, with minimal decoration, needed some dramatic element to make it exciting. In the silver-screen era, a similar idea applied. On dresses that were flat at the front and usually unadorned, the bare back was a discreet form of exposure that had great dramatic potential, enabling an actress to make a stunning departure from a scene. Or in the words of Menkes, "In the 1930s, the bared-back dress was ideal for passionate exits, seductive camera angles and shots reflected in shimmering mirrors for dramatic effect."

Apart from the surprise aspect of the backless dress, it also suggests a lack of underwear — no bra strap or slip is visible, and if cut low enough at the back, it precludes knickers as well. As Richard Martin and Harold Koda noted, "The spine's unerring course from neck to buttocks is an erotically charged path."

The pursuit of tanned skin is also a factor proffered for the popularity of the backless evening dress. What better way to show off a tan, which must be even, with no strap marks, denoting topless sunbathing. Coco Chanel is said to have made the tan fashionable. Unlike previous centuries in which tanned skin had been the mark of the peasant, in the twentieth century pallid skin indicated factory or office work, while those with money enjoyed sporting pursuits or sunbathing on the French Riviera and at other Mediterranean resorts. Thus the tan became the new physical indicator of privileged women who were part of the new international café society. The suntan also became synonymous with healthy living and a slim athletic body. By 1929 British *Vogue* was ready to declare: "This is a backless age! And there is no single smarter sunburn gesture than to have every low-backed costume cut on exactly the same lines, so that each one makes a perfect frame for a smooth brown back."

Costume historian James Laver goes one step further to suggest that the development of the backless evening dress was linked to design changes in the swimming costume. His reasoning goes that sunbathing became hugely popular during the early 1930s and was thought to be good for the health, so people wanted to expose more skin to the sun. Thus the swimsuit went from being really quite modest for most of the 1920s, to baring the décolletage, back and much more of the legs in the 1930s.

The backless evening dress was certainly a great way to flaunt a tan, but it also necessitated a different style of accessory. Capes, wraps, boleros and dinner jackets became all the rage, balancing the long, slim lines of a dress. Elsa Schiaparelli designed some of the most desirable styles. In 1930, Elsa herself modelled what would become an instant classic in the annals of evening dress history — a long, hip-hugging sheath in black crepe de Chine with a very low back, topped with a short white jacket, also in crepe de Chine, adorned with a cluster of white feathers. This outfit for evening would became one of the most successful of her

Gianfranco Ferre's starkly simple white gown recalls those worn by screen goddessess such as Jean Harlow in the black-and-white films of the 1930s. The dress gently skims the female form. Gianni Versace's backless dresses in electric blue (overleaf) also reference the glamour of 1930s Hollywood, albeit in a provocative contemporary fashion through zinging colors and stretch fabrics.

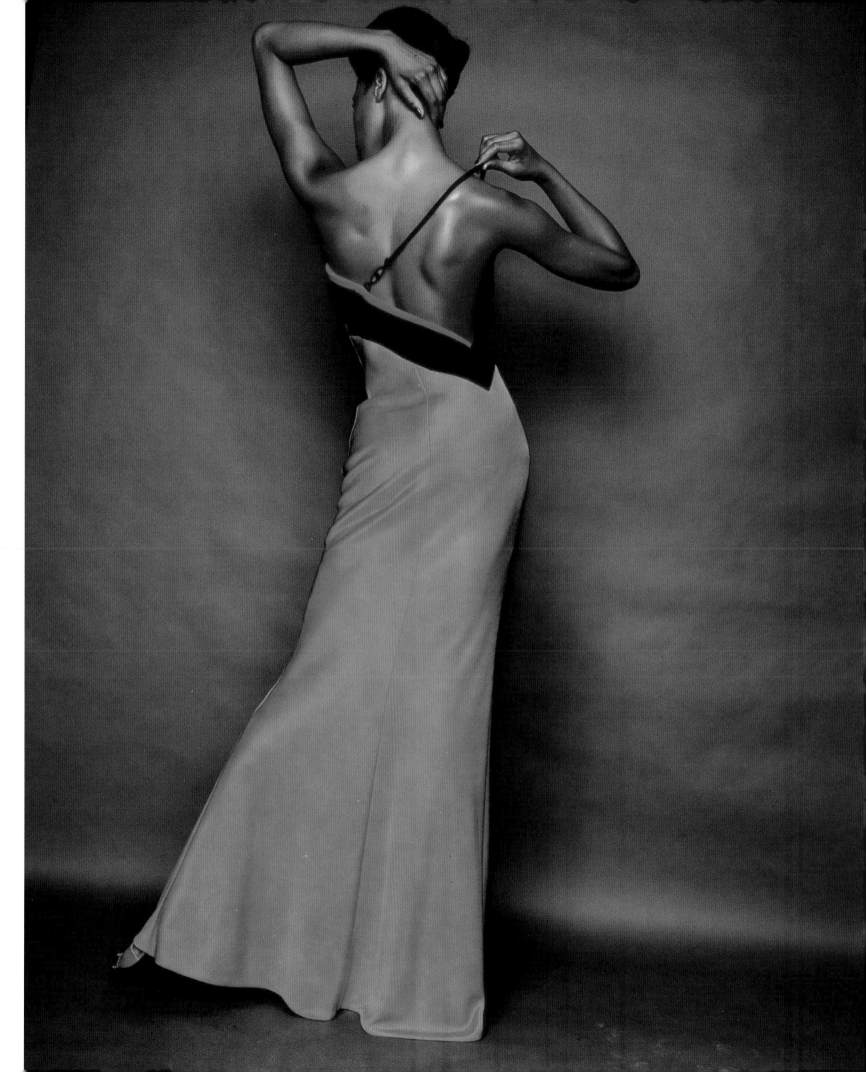

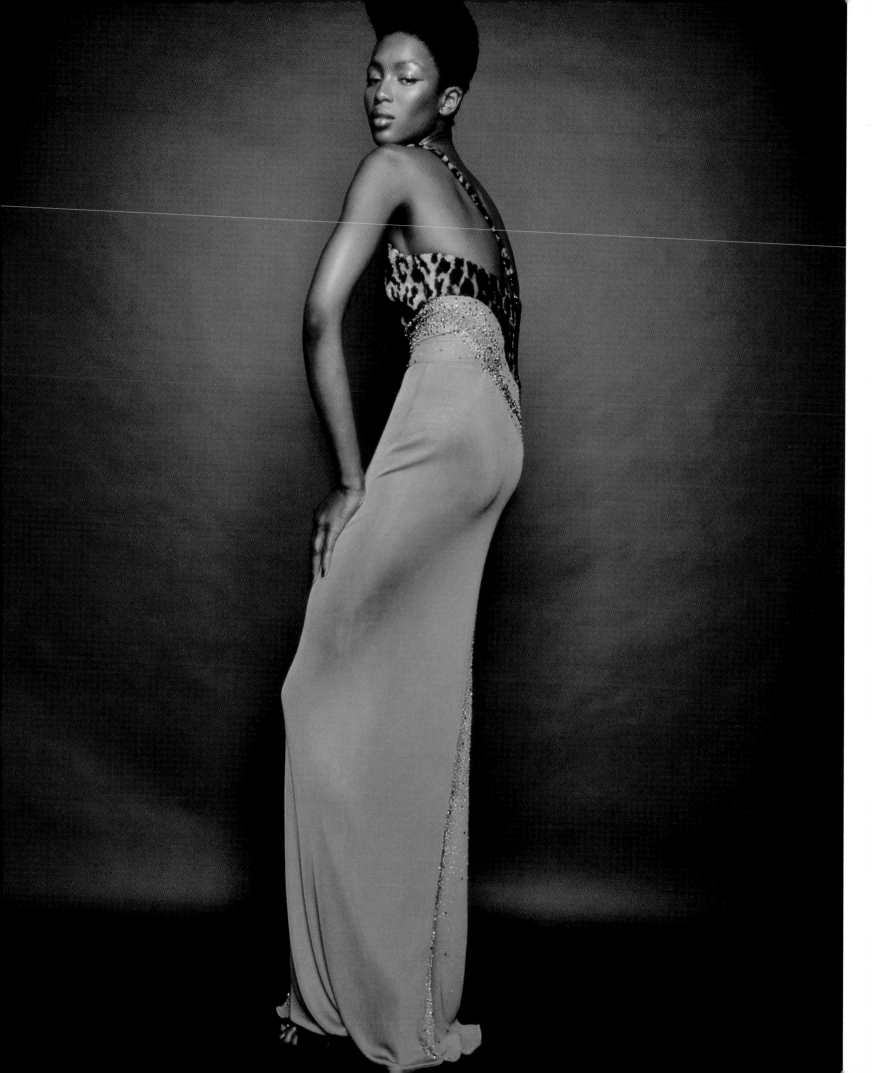

career, and kicked off a trend for short evening jackets, often in brocade or beautifully embroidered. The idea was revived again in the 1980s to great effect, with jackets and boleros covered in jewel-like encrustations or beaded all over to evoke the rich looks of that decade.

Schiaparelli's ensemble of evening jacket and dress became something of a uniform for dining out. In May 1931 American *Vogue* announced "Schiaparelli, once famous largely for sports clothes, hereby steps into the limelight as a great evening designer." It was a reputation Schiaparelli maintained throughout the decade. She introduced bright colors, especially "shocking" pink, and contrasted them with black. She experimented with shiny new fabrics such as Cellophane and Rhodophane, the latter derived from glass, and launched novel themes and silhouettes. One of these was the "Bird Silhouette", with shoulder wings on jackets, winged capes and plumage trim.

The craze for this and other fashion follies prompted British *Vogue* to warn its male readers "If you ask [a lady] to dinner she may arrive with a flight of blue birds doing vertically banked turns round the rim of her evening dress, or with a face obscured by a veil with real butterflies perched on top."

As new as they seemed when first launched in 1930, Schiaparelli's long dinner suits and backless dresses have now become standards for evening. Of course, not all evening dresses of the era bared the back. They did not really need to in order to elicit male attention. The beauty of the 1930s sheath is that although it conceals much of the body, the nature of concealment in itself is highly charged.

The fabric does not just fall straight; rather it clings and caresses, suggesting the other body parts that are hidden. In 1932 British *Vogue* famously described the fit of these slinky numbers as "poured in".

A common complaint of designers and fashion retailers is that 1930s dress styles do not sell well on the hanger. With no inner structure to give them shape, and with relatively little embellishment to sell them, these dresses need to be seen on the body. It is only when the clinging qualities are realized that the dress comes to life. Because bias cutting is designed for movement, such dresses also take on an entirely new look when seen in action. When the wearer is at rest, the dress falls straight and narrow, but when she moves there is no restriction. The skirt is revealed as full enough to allow a free range of movement, which of course is crucial for dancing.

Madeleine Vionnet was the pioneer of this style, and she continues to be cited as a major source of inspiration by contemporary designers. If not credited with actually inventing bias cutting, she is certainly believed to have popularized the technique. Vionnet cut fabric into panels at a 45° angle, as opposed to straight across the grain, and then stitched the panels together. In doing so she could stretch a dress beautifully around the body's contours, making it cling to the bust and hips and then flare out from the thighs to create a skirt that swung when the wearer moved. The stretch factor also enabled the wearer to step into a dress or pull it on over her head, with no need for additional openings.

Vionnet became particularly instrumental in setting the long lines and draped feel of the 1930s era gown, developing

This evening dress by Guy Laroche takes the idea of the backless gown one step further to almost reveal the top of the buttocks. Part of the erotic allure of the backless dress is that the wearer appears to have abandoned her underwear. In Hollywood, filmmakers used such devices to give their leading ladies sex appeal while fully upholding the Hays Code, which banned "undue" exposure.

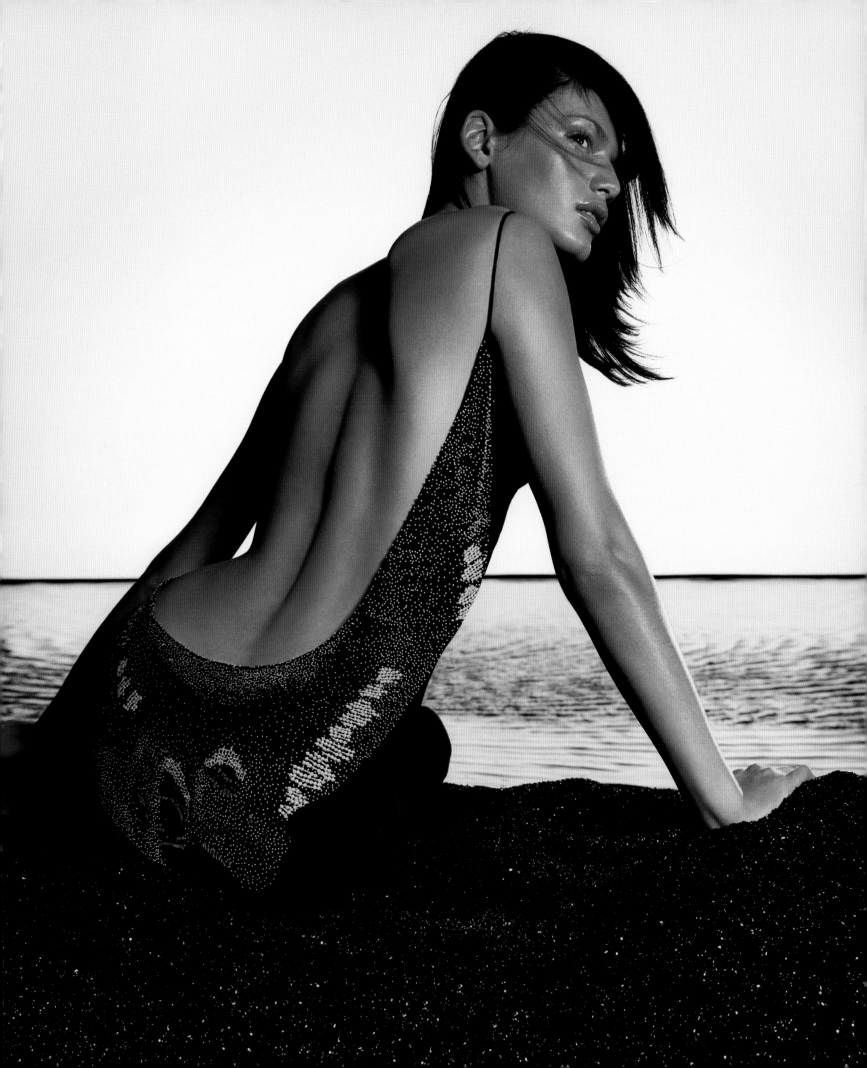

the cowl and halter necks that have become signature elements of evening dress.

The high priestess of draping was Alix, later known as Madame Grès. Like Vionnet she was inspired by Greek statuary, but instead of focusing on bias cutting and panelling as Vionnet did, she preferred to drape her clients in heavy folds of silk jersey to create the look of an ancient goddess. Other designers brought draping into their evening repertoire. Schiaparelli toyed with the idea in 1935 when she designed a range of Indian sari-style dresses. The draping aesthetic would gain even more currency during the 1940s as women sought a softer look, while still following the slim, body-conscious lines set in the 1930s.

Maverick American Charles James also designed long-line dresses but his were cut and constructed, rather than draped, to fit the body. His sculptural approach to evening clothes was reflected in a series of dresses he created during the 1940s, including the famous shrimp dress designed for the salon of Elizabeth Arden in New York.

Silk crepe, satin and silk jersey were the ideal fabrics for these long, fitted styles, with enough weight to hang well. They were also the most expensive fabrics. However, industrial advances had put a cheaper range of fabrics at the fingertips of designers. With a similar look and feel to silk, rayon, or "artificial silk" as it was dubbed, was widely used for evening dresses. Rayon meant that evening dresses could be produced relatively cheaply. First introduced for mainstream commercial clothing production in the mid 1920s, rayon was initially nothing like silk. By the 1930s, however, it had improved enough for even top designers to use it. But rayon was eclipsed in the late 1930s by nylon, which had a superior stretch and finish.

Lamé was a fashion innovation of the 1930s. Woven from flat metallic threads, lamé came in shimmering gold

Designer Toni Maticevski's contemporary take on the backless gowns of the 1930s (opposite) echoes a dress from Harrods News of 1938 (above), illustrated by artist Jean-Gabriel Domergue. In both gowns the line of the torso, waist and hips is emphasized by the soft drape and flare of the skirt.

and silver, and became hugely popular for eveningwear. The development of inexpensive plastic paillettes, sequins and beads meant that evening dresses could be lavishly covered in their entirety, while remaining reasonably priced.

Glass beading had been widely used for evening clothes in the 1920s but new manufacturing methods in the 1930s meant that plastic beads could be generously applied at relatively little cost. Ready-to-wear clothing firms began producing inexpensive beaded evening dresses. In an era marked by Depression, and later by war rationing, cheaper fabrics and embellishments were significant factors in helping women to dress fashionably.

The Wall Street crash in 1929 had marked the end of the "Roaring Twenties" and it led to what Groucho Marx would dub the "Threadbare Thirties". Economy was now an inevitable consideration for women planning their wardrobes. Even the well-off turned their backs on the decadent and frenzied good times of the 1920s, and their clothing reflected a new aesthetic: simple, elegant and not overtly showy.

In 1931, just two years after the crash, British fabric company Ferguson enlisted Chanel to promote its new range of cotton fabrics. To this end, she designed a range of extremely popular and much-copied evening dresses using organdie, lawn, muslin, piqué and net. The muslin evening dress had its antecedent in the flimsy cotton Directoire styles of the late eighteenth century but the Chanel dresses were altogether more modest, with charming full skirts to the ground and no hint of transparency. They exuded an innocent charm and were much loved by debutantes (perhaps not least because they cost less than satin). The cotton evening dress has reappeared in almost every decade since the 1930s and it has remained a stalwart item in the summer and resort collections of many designers.

∞ *The back as an erotic focus is key to the evening fashions of the 1930s. Edward Molyneux's gown of the time (opposite), photographed in his studio, further draws attention to the back with an extravagant feathered trim. In the twenty-first century Tom Ford for Gucci plunged backlines lower, combining a cheeky flash of buttock cleavage with corset-style lacing (above).*

∞ *The alternative to the backless gown was the evening suit, pioneered by Elsa Schiaparelli in 1930. Karl Lagerfeld's contemporary evening suit for Chanel (overleaf, left) covers the skin but the fluid skirt closely follows the lines of the body. Likewise Lagerfeld's sleeveless Chanel gown (overleaf, right) reveals the body in a subtle way through his use of clinging fabric and strategic cutting around the bodice.*

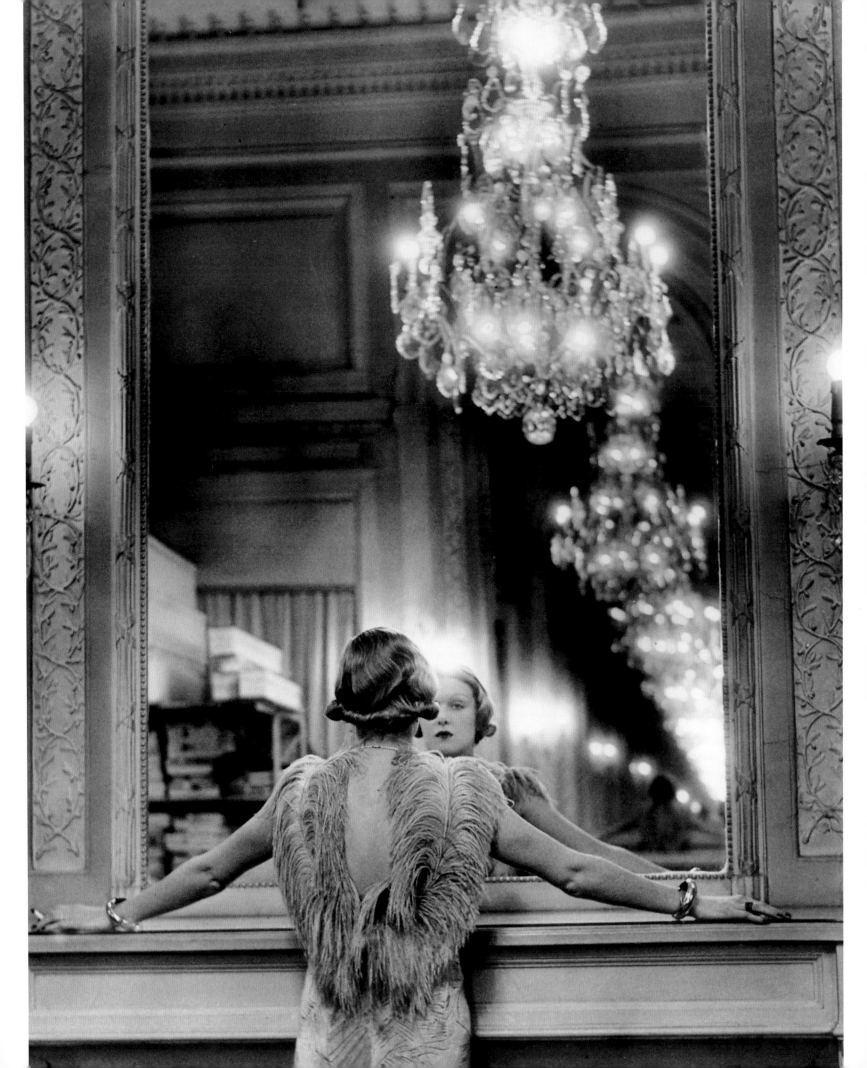

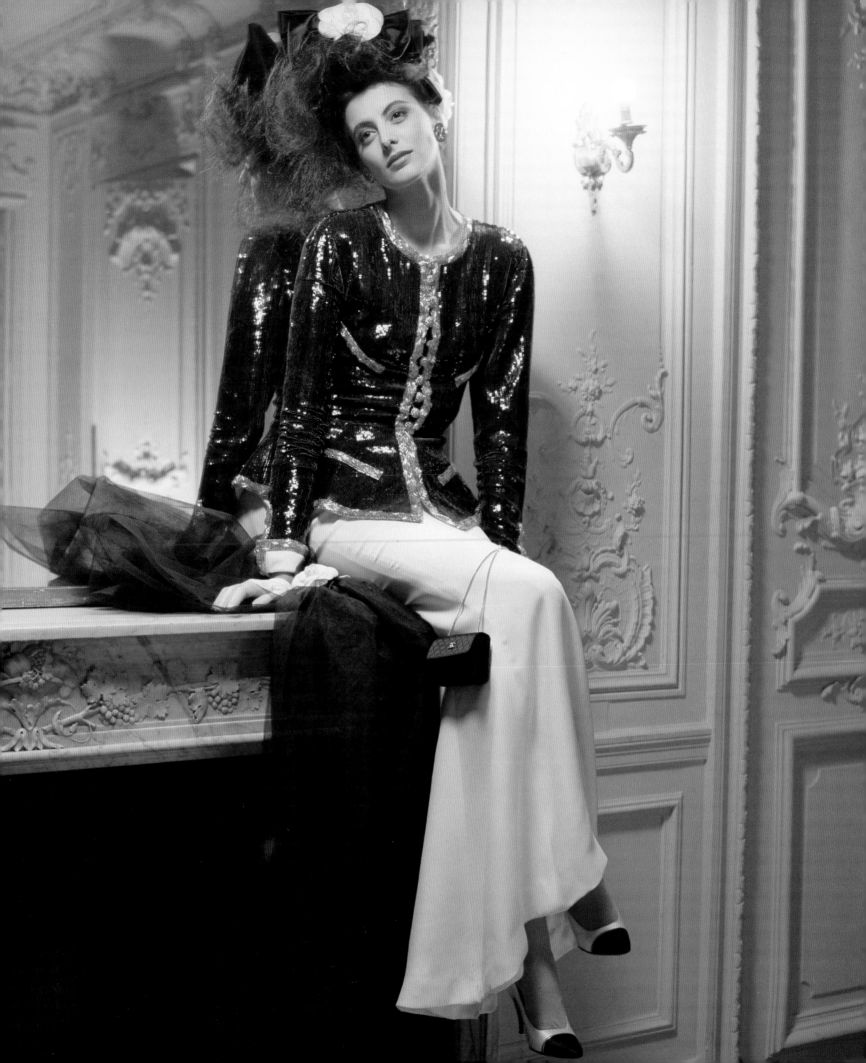

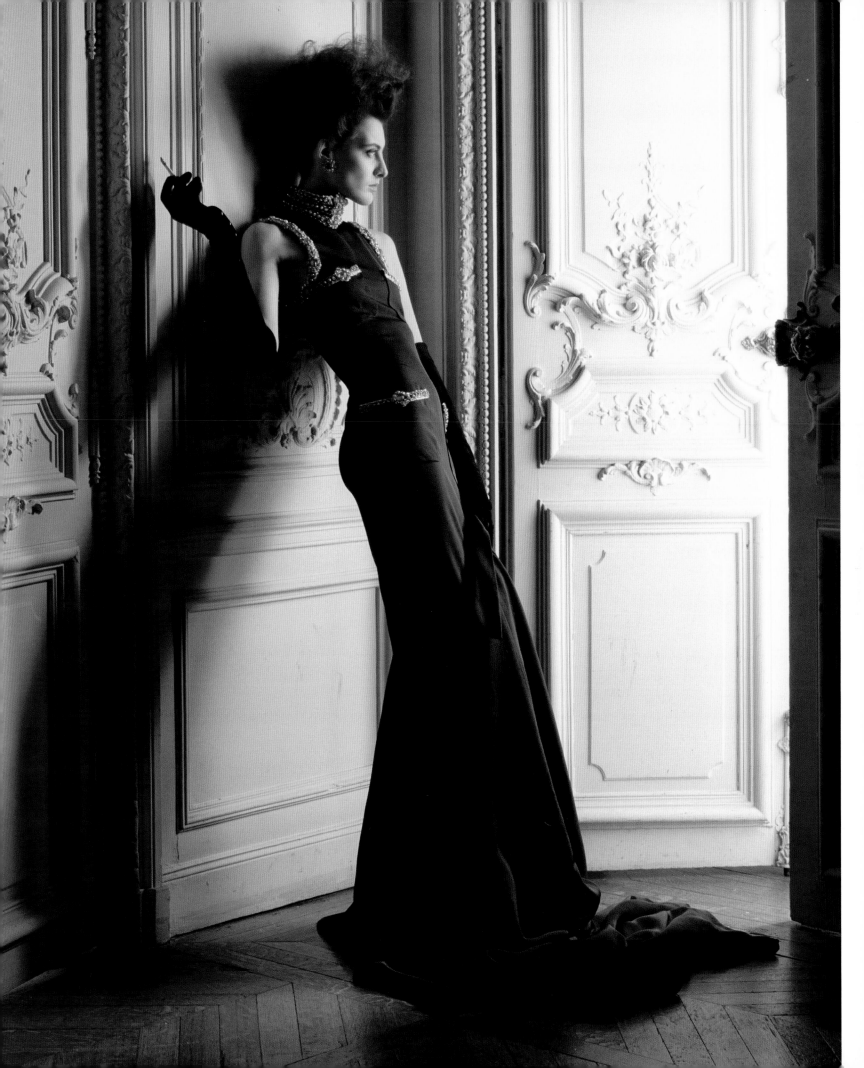

The idea of using simple fabrics for formal dress styles continues to exert its influence, and it seems especially relevant in the current age of casual dress. In the 1930s, as now, the worst fashion mistake a woman could make was to try too hard, to look overdone. A favoured device of *Vogue* was to deconstruct the evening ensemble of a woman who was wearing too much.

In 1931 the magazine demonstrated how a woman, dressed for evening in a simple long black sheath, with simple shoulder straps, "decides that the whole thing looks a little too plain. So she dresses it up with a few long strands of imitation pearls." When her beau sends her a huge corsage, "she pins that on too, pulling the décolletage regrettably askew." Finally she "buys long glittering earrings, a diadem of brilliants for her hair, and giant court shoe buckles. To all this splendour she adds a massive coral beaded bag, which swings from a long chain. One does not need to see to know that in due time she will produce from that bag a long chiffon handkerchief ... and a very long cigarette holder." *Vogue* concluded that "alone and unaided she has ruined a good dress." The solution, according to the magazine's fashion editor, was to accessorize with nothing more than a pair of white gardenias at the wrist, and a jewelled clip on the strap of the dress.

∞ *A Charles James dress from the late 1930s (left), illustrated by Antonio, uses bias cutting and drape but also looks ahead to the sculptural, heavily constructed styles of the 1950s. Draping was widely employed in evening dresses of the 1930s, drawing on the style of classical robes. A draped gown in violet crepe from Yves Saint Laurent Couture (opposite) revives the look, as does Hardy Amies' slender white dress (overleaf, left), photographed by Bryan Adams, and Giorgio Armani's jersey column, photographed by Paolo Roversi (overleaf, right).*

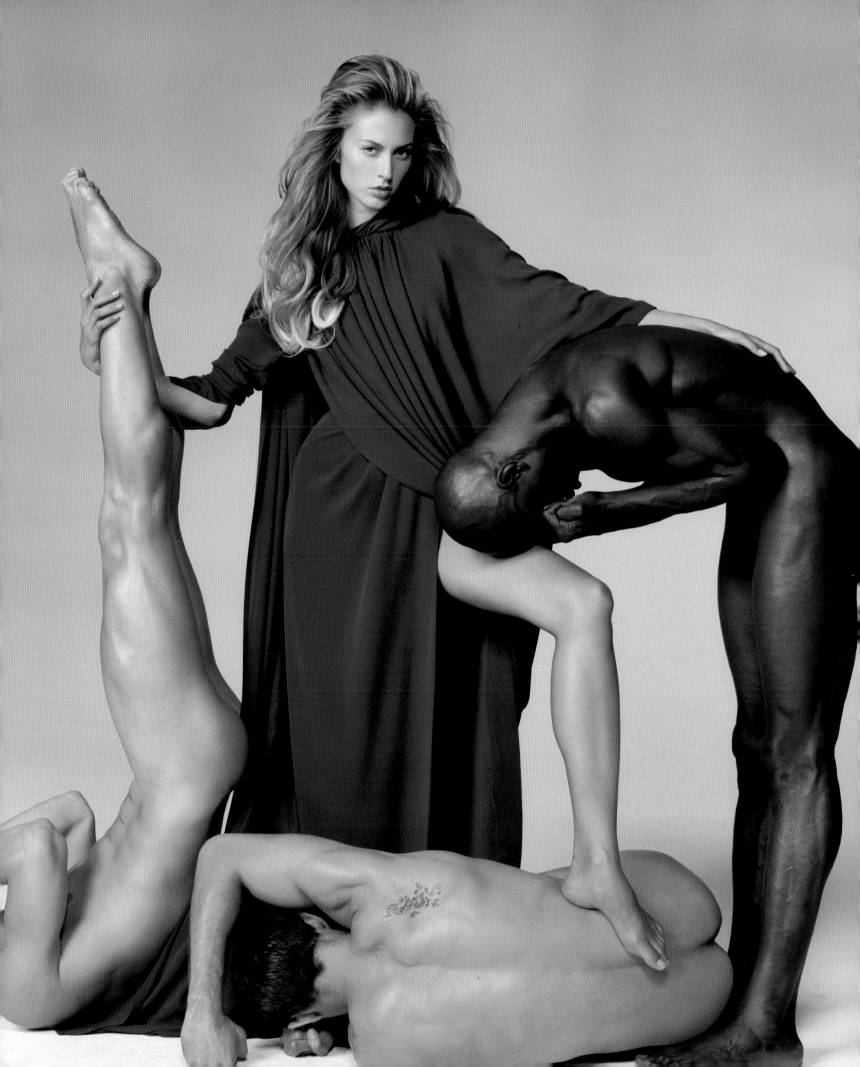

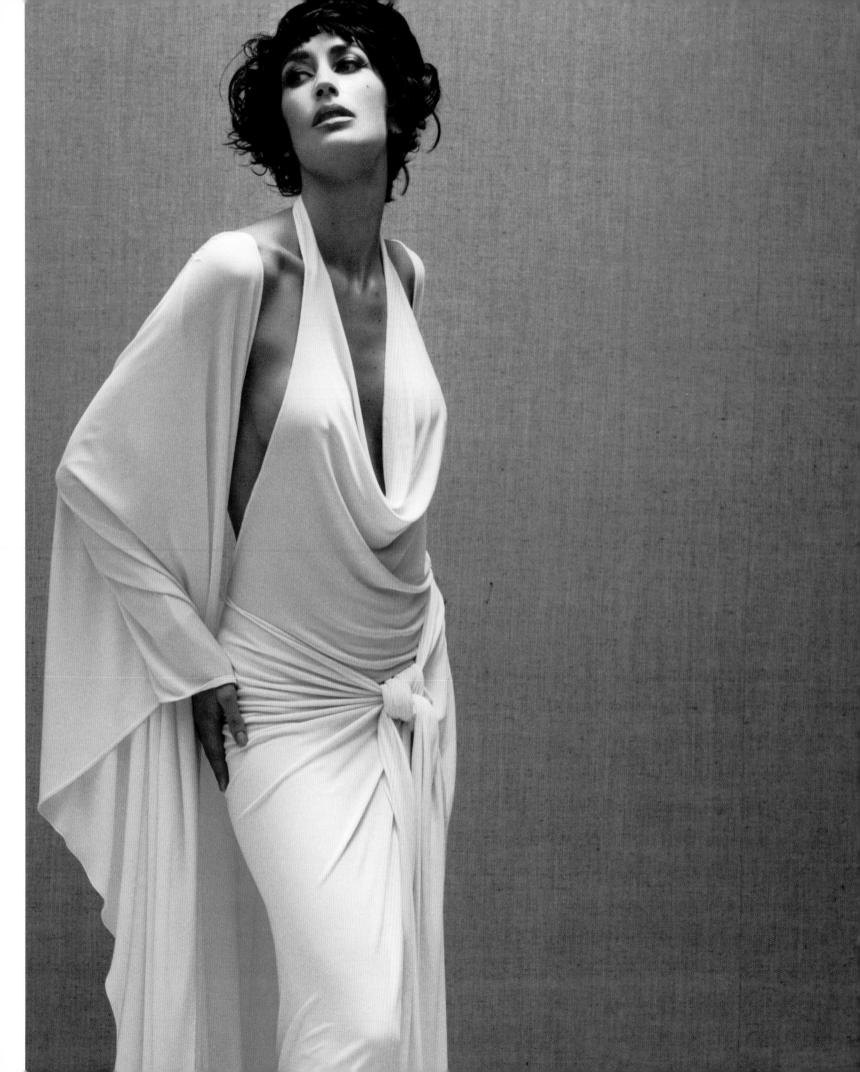

∞ *The dance team of Galante and Leonarda demonstrate a step of their own invention called the "rhumba whirl", circa 1935, in Hollywood. Dance dresses and dance shoes had a major impact on evening fashions in general at this time.*

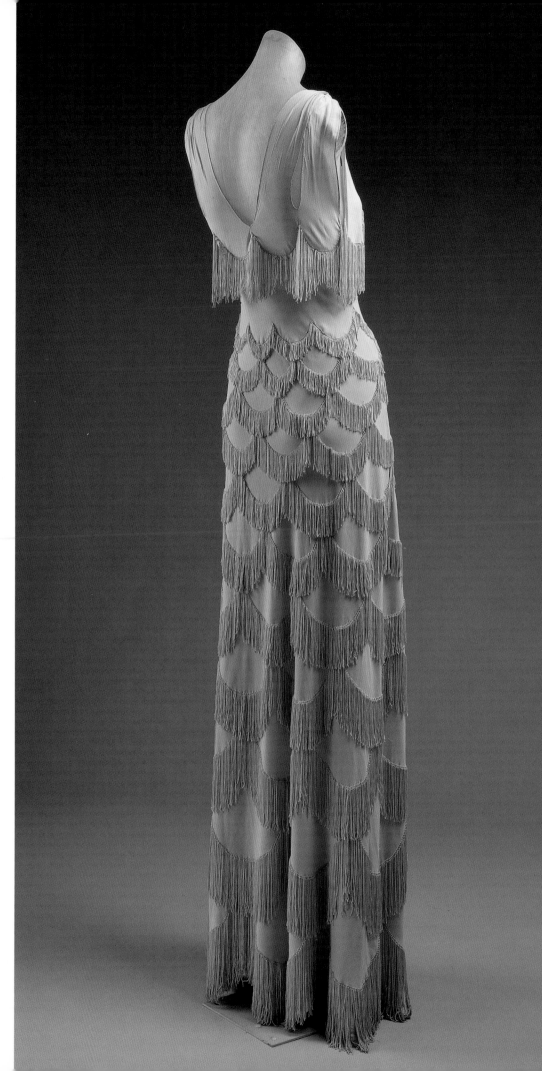

∞ *Madeleine Vionnet is generally credited with perfecting the bias cut, and she has since influenced generations of designers with her cutting technique. Her crepe summer evening dress from 1938, from the costume collection of The Metropolitan Museum of Art, is embroidered with rows of fringing. Each silk thread is individually attached to the fabric to create the scallop motif.*

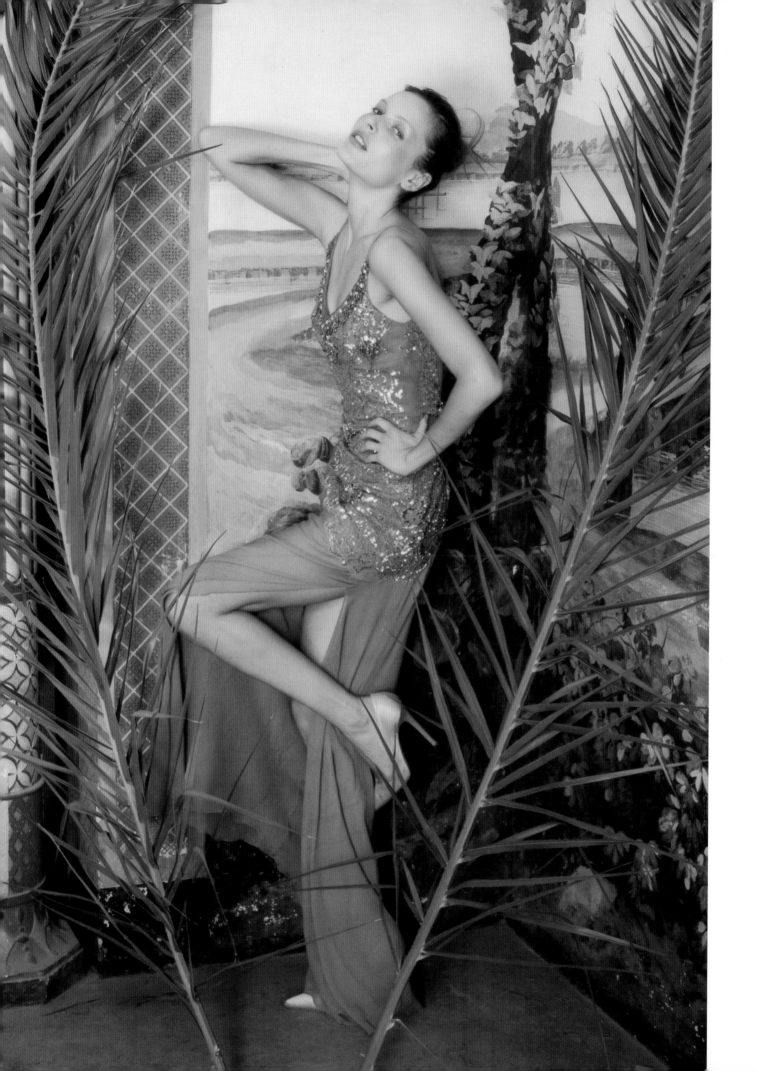

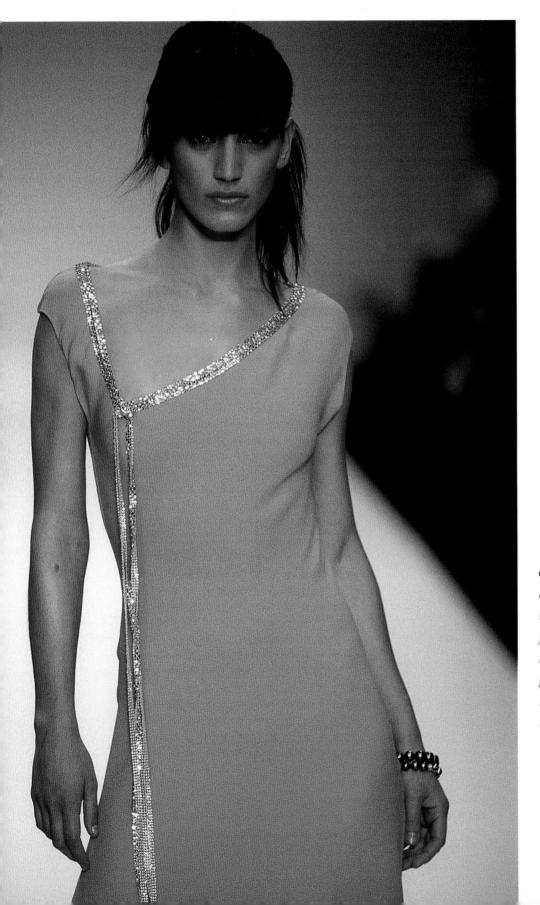

∞ *The smooth body-conscious lines of evening dress from the 1930s era make underwear a dilemma. Jean Harlow famously refused to wear any under her clinging gowns, so the film studios designed gowns to accommodate her. Dresses here by Blumarine (opposite) and Ben di Lisi (left) would no doubt have suited her.*

"As a young boy growing up in Milan I used to go into town to the movies. The actresses were really like creatures from another world." GIORGIO ARMANI

eye," said *Vogue*, "and kill their man at ten yards."

Interestingly, these colors also worked superbly in black-and-white movies. In fact, probably the single greatest influence on eveningwear, at this time and perhaps ever since, was Hollywood. Various film and fashion historians have noted that after the raunchiness and scantily clad heroines of many 1920s films, the 1930s saw a reaction in favour of modesty, especially when it came to the dress of female stars.

The Hays Code of 1930 is often cited as a factor in the styles of eveningwear developed for the silver screen. This strict censorship code was self-enforced by the big Los Angeles movie studios. Of particular relevance to evening dress, the Hays Code restricted the amount of cleavage shown by dictating that no more than two inches was to be visible between the breasts. Under no circumstances was the belly button to be revealed. Thus when midriff-baring styles became popular later in the decade, the waist on the skirt was always high, or else a wide

cummerbund would cover the offending part.

The Hays Code also warned that "transparent or translucent materials and silhouette are frequently more suggestive than actual exposure." Producers may have heeded the call to avoid transparent costumes but they seem to have skipped over the reference to "silhouette".

Designers worked around the Hays Code strictures, or selectively ignored parts of them, to create the fabulous gowns that became such a prominent feature of many movies. They might have covered up more cleavage but they did away with underwear and swathed the body in clinging satin — so much so that today the idea of the femme fatale is inseparable from visions of Rita Hayworth as Gilda in her black satin strapless sheath; or of Jean Harlow with her platinum blonde hair slinking around under a halo of cigarette smoke and wearing a sinuous white satin halter-necked gown.

Images of the backlit sirens of the silver screen permeate our consciousness of the 1930s era. Those carefully

Sequins, especially in combinations of black and silver or gold, were an elegant choice for evening in the Art Deco age, and they have remained a mainstay of fashion, as Giorgio Armani's sequinned ensemble attests (opposite). In contrast, designs by Bill Blass (overleaf) are free of all but a minimum of surface decoration, relying instead on drapery and cut for effect.

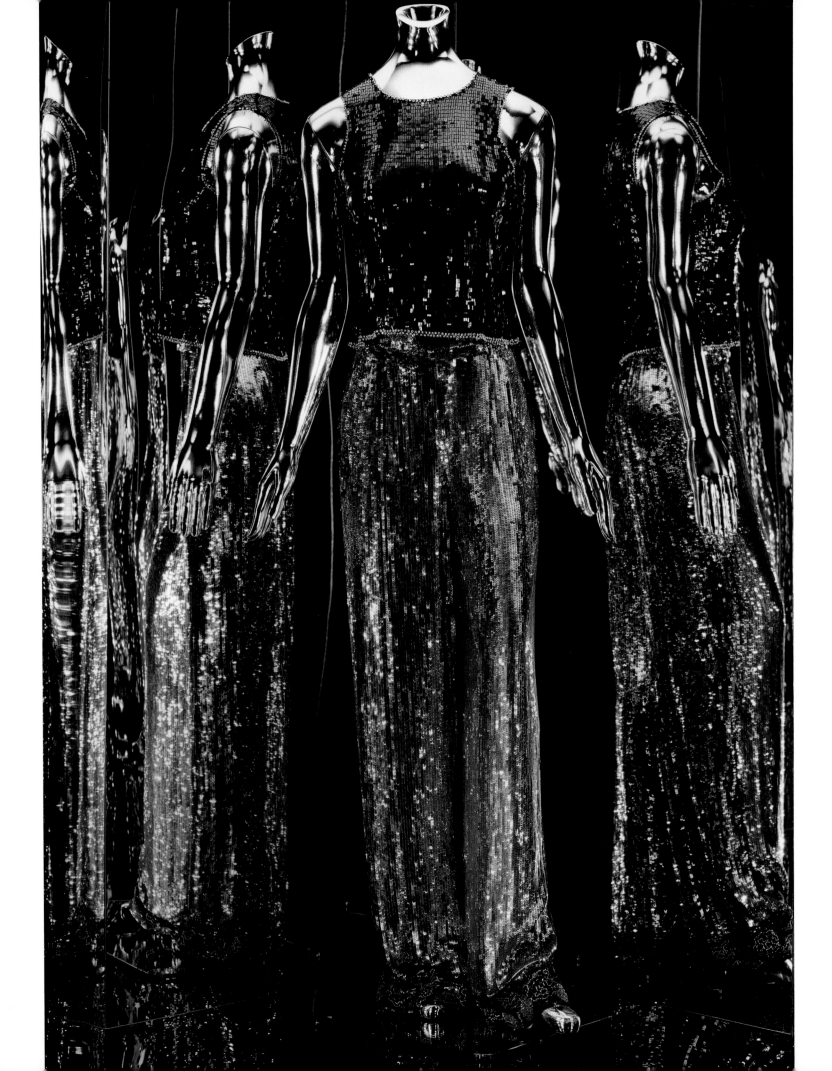

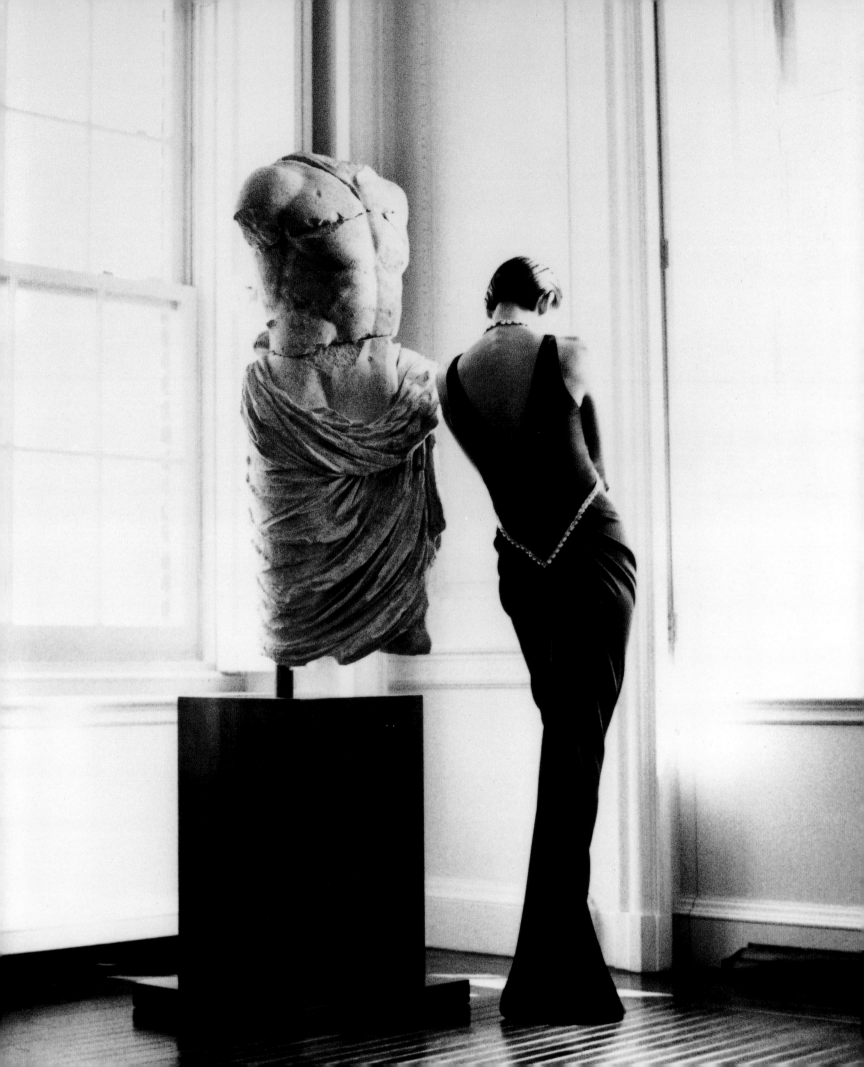

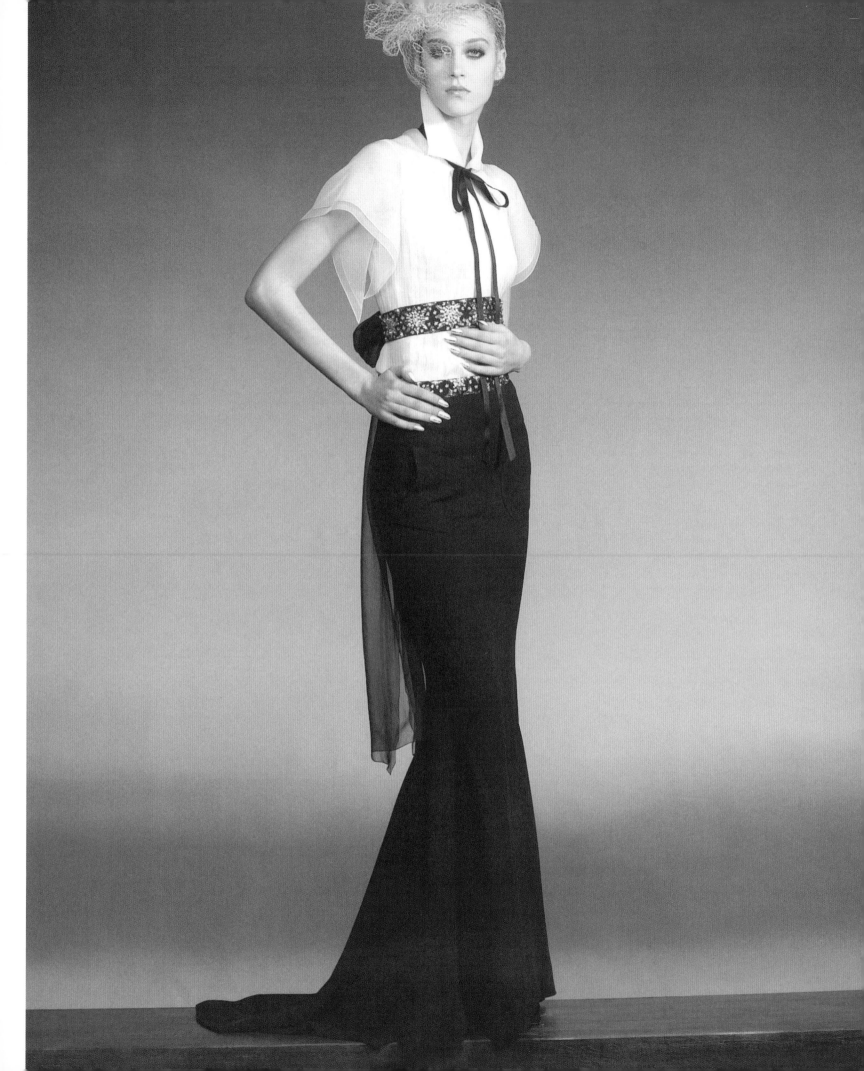

∞ *The long skirt with contrasting blouse for evening was an innovation of the 1930s, partly in response to tough economic times. It is a look that has endured, as in this ensemble designed by Karl Lagerfeld for the House of Chanel. The raised, cinched waist and high collar are indicative of evening styles of the 1930s. A wide shoulder line helps to emphasize the waist.*

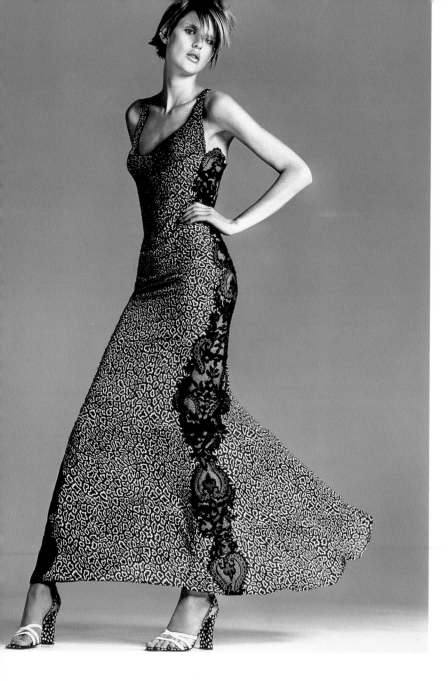

∞ *The simpilicty and relaxed look of the long bias-cut dress saw it revived in the 1970s and again in the late twentieth century as one of the most popular, and flattering, forms of evening dress. Nearly every designer of the past decade has used the style, from Versace (above) to Jasper Conran (opposite).*

manufactured photographs convey glamour in a way that has subsequently been hard to match — perhaps because the stars of the 1930s were projected as femme fatales: cool, clever and elegant, and oozing sex appeal. To modern eyes they seem more appealing than their cute, ultra-feminine and utterly respectable counterparts of the 1950s, whose general onscreen instincts tended towards homemaking and marriage. The 1950s stars smiled; 1930s screen sirens rarely did. Theirs was a tough, detached persona, which was emphasized by the gowns they wore on screen. The elements making up the 1930s Hollywood femme fatale combine to provide an extraordinarily successful recipe for eveningwear, one that has been consistently copied.

These extreme projections of glamour came at a time when despair and poverty were widespread across Europe and the United States. The Wall Street Crash of 1929 and the Depression had made conditions tough for the average person. Things would become even tougher from 1940 onwards when World War II was under way. In Europe, rationing was put in place, and governments issued guidelines for both men's and women's clothing, offering ideas for practical and "appropriate" modes of dress given the circumstances. Magazines like British *Vogue*, which at that time was a powerful fashion advocate, took up the cause, championing what it termed "The New Economy" in women's clothing. Even after the war, it took years for society to recover, particularly in Europe.

Yet it is fascinating that while such conditions prevailed, Hollywood continued to emphasize the potency of glamorous dress, embodied in the evening gown. In Billy Wilder's 1948 comedy, *A Foreign Affair*, set in postwar Berlin, a dowdy Iowa congresswoman vies with a nightclub singer, played by Marlene Dietrich, for the attentions of an army captain. Dietrich is as glamorous on screen as was feasible

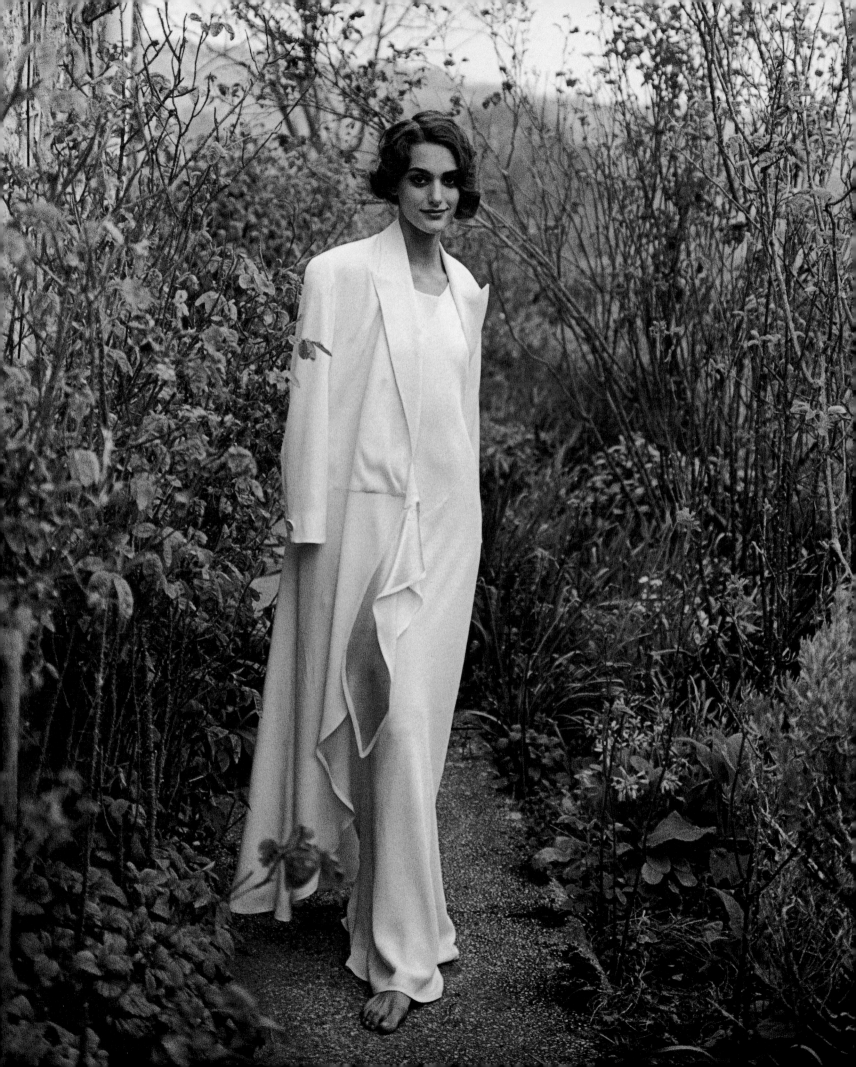

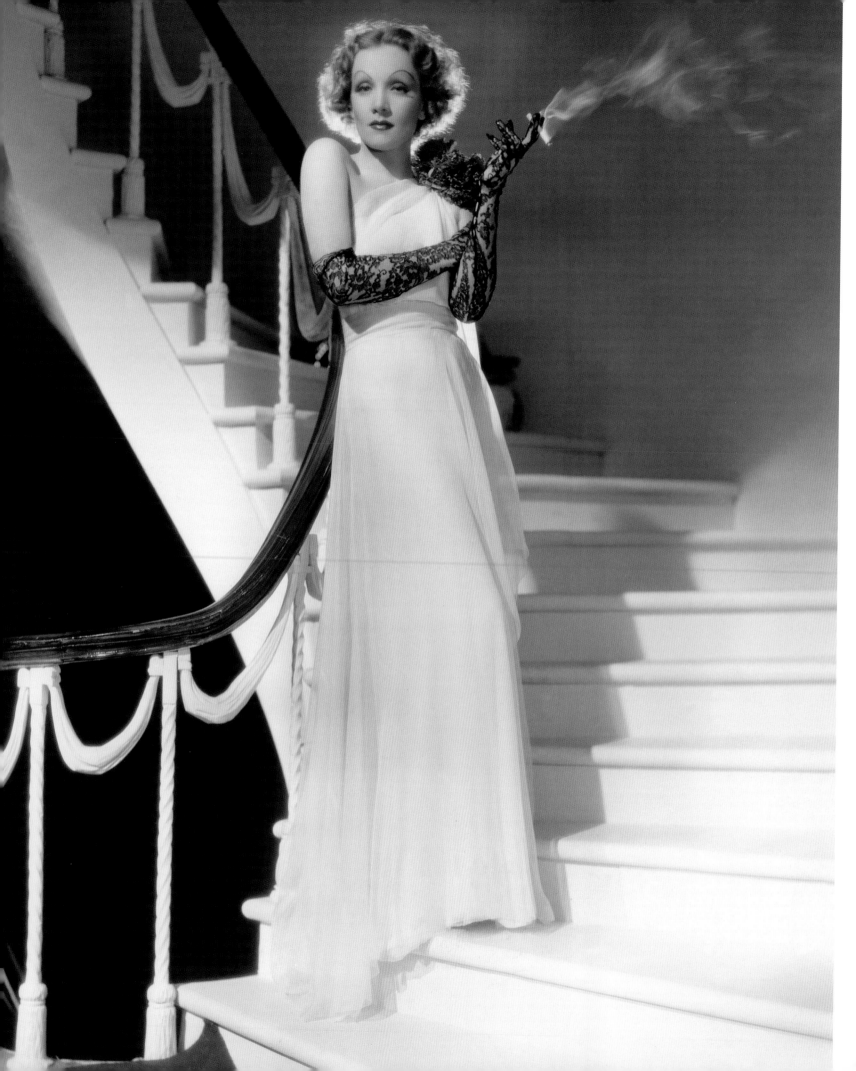

given the dire conditions for Berliners portrayed in the film, and has a gorgeous wardrobe of sequinned dresses for her nightclub act. The turning point in the contest comes when the plain congresswoman sets aside her principles to buy a fabulous evening dress on the black market. She descends the stairs of her hotel in the black dress with its plunging back and diamanté-spangled straps to the admiring whistles of the captain. Having thus proved her desirability, she goes on to win the captain's heart.

This presentation of the evening dress as desirable and powerful coincides with a great divergence between day and eveningwear. Almost without exception during the 1930s, evening dresses were floor length, while day dresses hovered between mid-calf and the knee. Day outfits were fairly tailored and plain, with decoration commonly in the form of trim around collars, cuffs and pockets. The evening dress was relatively undecorated; rather it showed off cut and fabric drapery. And it is interesting that while day clothes succumbed to rationing, requiring minimal fabric, eveningwear made no such concession. An evening dress in the 1920s required around 2 yards of fabric, while by the 1930s an evening dress used up more than 5 yards.

The lure of designing for Hollywood saw most of the Paris couturiers head for California at one stage or other during the 1930s. Chanel, Schiaparelli and Rochas were among those who designed the stars' onscreen wardrobes. But the problem with enlisting a fashion designer was that by the time the movie made it to the screen, the clothes could look out of date, superseded by the latest wave of seasonal trends from Paris. Instead, Hollywood fostered its own costume designers, who created clothes that would look good on screen, and would complement the personalities and physical attributes of the various stars.

In the era of silent movies, Gilbert Adrian had designed

The designs of Hollywood costumier Travis Banton were typically softer than those of his rival Adrian. They worked particularly well on Marlene Dietrich, pictured in 1935 wearing a white chiffon gown (opposite). The slightly raised waistline is echoed in a 1932 Lanvin dress of blue and gold lamé (above).

Chanel favoured luxurious fabrics and sparkling highlights for eveningwear, as is evident in the dress sketched by her friend Jean Cocteau (overleaf, left) in 1937. More than sixty years later, the Chanel spirit is captured by Karl Lagerfeld (overleaf, right).

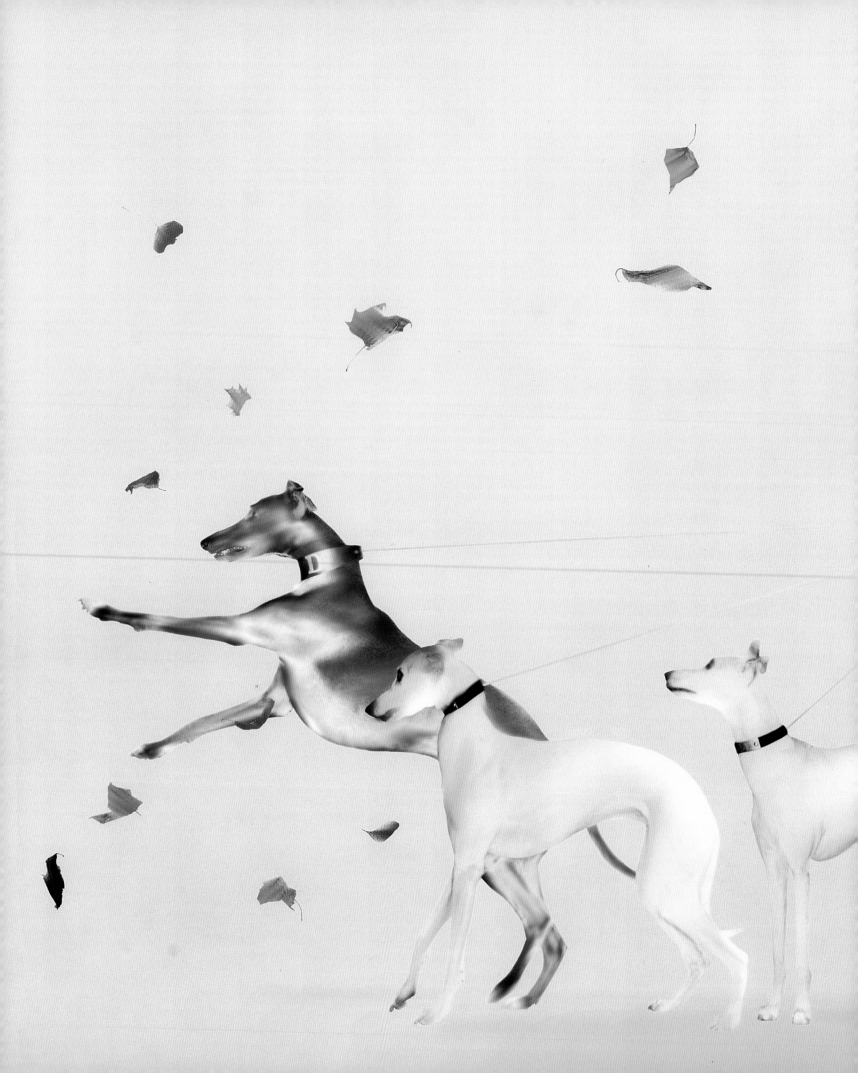

CHAPTER THREE

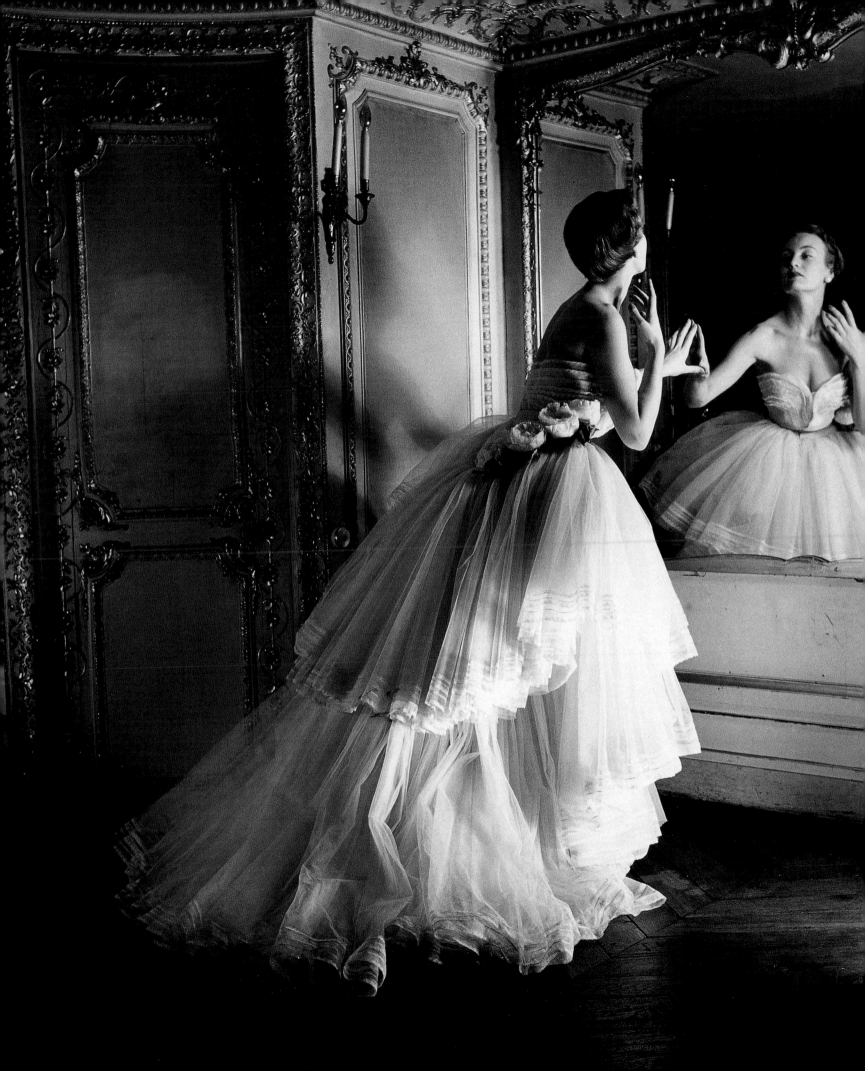

FEMININE IDEALS

"A ball dress is your dream dress, and it must make you magical." CHRISTIAN DIOR

Only a few words are needed to summarize the great mid-century era of the evening dress: Dior and the New Look. The lavish first collection by Christian Dior, launched in Paris two years after the end of World War II, set the tone for the next decade and continues to exert a major influence on eveningwear. The fairytale beauty, exaggerated form and stylized presentation of the New Look has made it one of the most recognizable, and desirable, evening looks of all time.

To a world disillusioned and exhausted by war, and to women who had worn fairly plain, square-shouldered dresses for the previous ten years, the New Look of February 1947 captured the imagination. Some critics hated it, for its very extravagance, but most in the fashion world loved it, and women in general embraced the ultra-feminine style. British *Vogue* gushed with praise: "His ideas were fresh, and put over with great authority, his clothes were beautifully made, essentially Parisian, deeply feminine. Dior uses fabric

lavishly in skirts — 15 yards in a woollen day dress, 25 yards in a short taffeta evening dress ... Fashion has moved decisively. Here are the inescapable changes. Always there is something prominent about the hips: in a shelf of peplum or a ledge of tucking; in bunched pleats or a bustle. The waist is breathtaking..."

The waist was the focus of this new highly stylized way of dressing. Christian Dior described his female ideal thus: "I designed clothes for flower-like women, with rounded shoulders, full, feminine busts, and hand-spun waists above enormous spreading skirts." It was a world away from the lean, athletic figure that had been prevalent through the war years, when "women looked and dressed like Amazons" according to Dior. He called the shape of his 1947 collection the Corolle line, after the tight petal formation of a flower just before it blooms.

Carmel Snow, *Harper's Bazaar* editor at the time, is generally accepted as being the catalyst for the immense

∝ *Halfway through the twentieth century, the change in the silhouette of evening clothes was dramatic. This dress by Christian Dior, photographed by Louise Dahl-Wolfe in 1950, is indicative of the new mood for nighttime. It represented a decisive move away from the slim lines that had dominated the previous five decades. Some commentators have suggested that the return to very romantic, historical gowns was partly a reaction to the combined rigours and austerity of the two World Wars and the Depression.*

popularity of that first Dior collection. One of the sales staff at Dior in 1947 recalled how Snow returned to the salon after the show and asked to see ten specific dresses of the 200 or so that had been presented. She studied each one very carefully before returning to her hotel to telephone her fashion report to the magazine, announcing: "It's really a New Look." She reportedly expressed this in person to Dior as well, saying, "Your dresses have such a new look, my dear Christian, it's a revolution."

Harper's Bazaar's Ernestine Carter described the moment when Dior's models entered the salon "arrogantly swinging their vast skirts, the soft shoulders, the tight bodices, the wasp-waists, the tiny hats bound on by veils under the chin, they swirled on, contemptuously bowling over the ashtray stands like ninepins. This new softness and soundness was positively voluptuous."

Part of the softness and "soundness" of the evening dresses was due to the fabrics used by Dior, who despite the wartime shortages in Paris had no trouble sourcing material because his backer was a textile magnate named Marcel Boussac. Silk tulle was used for those first evening-dress skirts in 1947 and organza the following summer. Lace was also a favoured fabric for evening, and Dior often used transparent, floral-patterned lace for entire ball gowns. Decoration in the form of beading and embroidery was also liberally used. It is not hard to believe that a single Dior evening dress could take up to 300 hours to create.

The look of softness was enhanced by a color palette in which white and pastel pink were predominant. At the other end of the spectrum, black, or "glorious black" as Dior referred to it, was a favourite color for elegant evening creations. He loved gardens and nature, and incorporated floral motifs or shapes into his gowns.

Everything that had gone before suddenly looked drab and hard-edged. Women were swept off their feet by the New Look, especially the fairytale fashions for evening. "Women were starved for luxury," Diana Vreeland noted, "and Dior gave them plenty."

The New Look Dior skirt took up 25 yards of fabric, a phenomenal amount to a generation of British women who had adhered to the slogan "Make do and mend" throughout the war years. Their fabric ration for a skirt had been three yards. Despite the outrageous quantity of material required for the Dior dress, women wanted it — badly.

In Britain, Queen Elizabeth and her sister Princess Margaret arranged a special viewing of the Dior collection and became firm converts. There is no doubt that the formal and luxurious lines of the Dior gown gelled with the royal need for clothes with strong presence, dignity and a sense of exclusivity. Princess Margaret chose to wear a Dior gown for her twenty-first birthday portrait, which was photographed by Cecil Beaton.

The historical look of Dior's long evening dresses was something that appealed greatly to the queen, whose favoured British couturier Norman Hartnell specialized in precisely this type of clothing. A portrait taken of Princess Elizabeth on the occasion of her nineteenth birthday shows a radiant young woman, soft light silhouetting her chestnut

∞ *Princess Margaret Rose wears an evening dress in the new full style, photographed in August 1949. Christian Dior had given the princess, her sister Queen Elizabeth and the Duchess of Kent a private showing of his New Look collection in the autumn of 1947. Princess Margaret embraced the New Look and wore it everywhere. Queen Elizabeth and the Duchess of Kent were also won over to the new styles, helping to popularize the Dior look among British women and influencing British couturiers.*

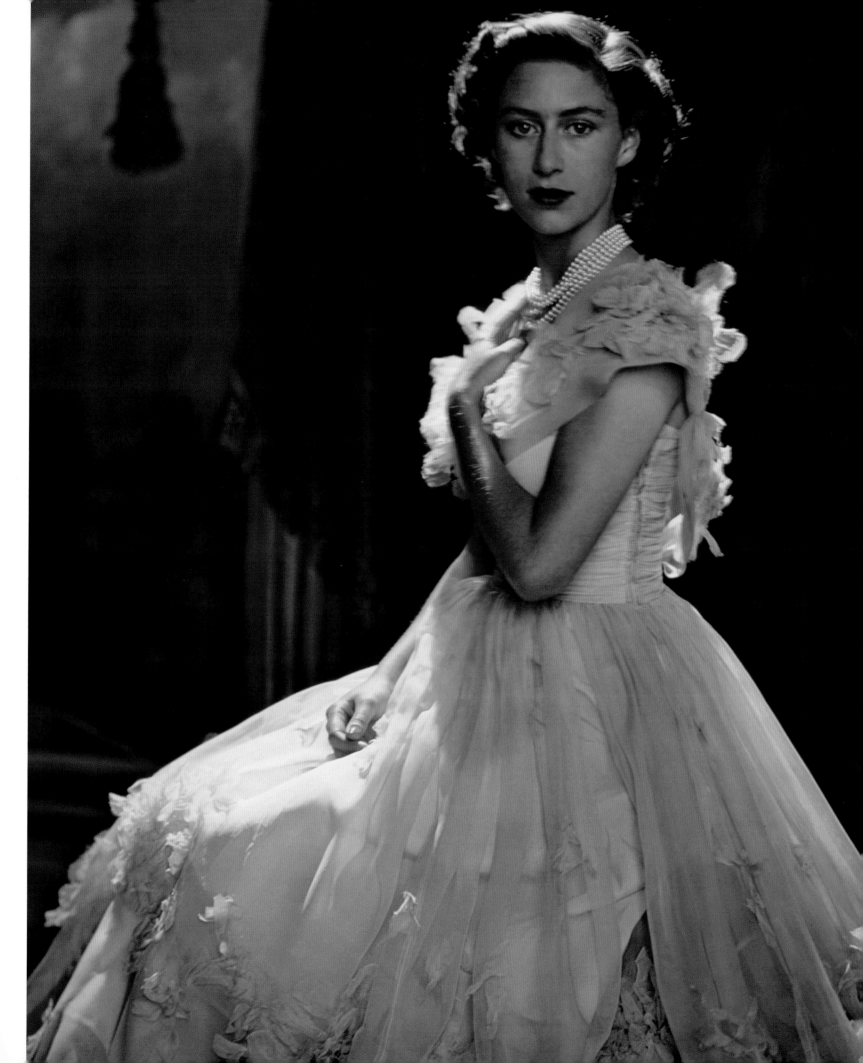

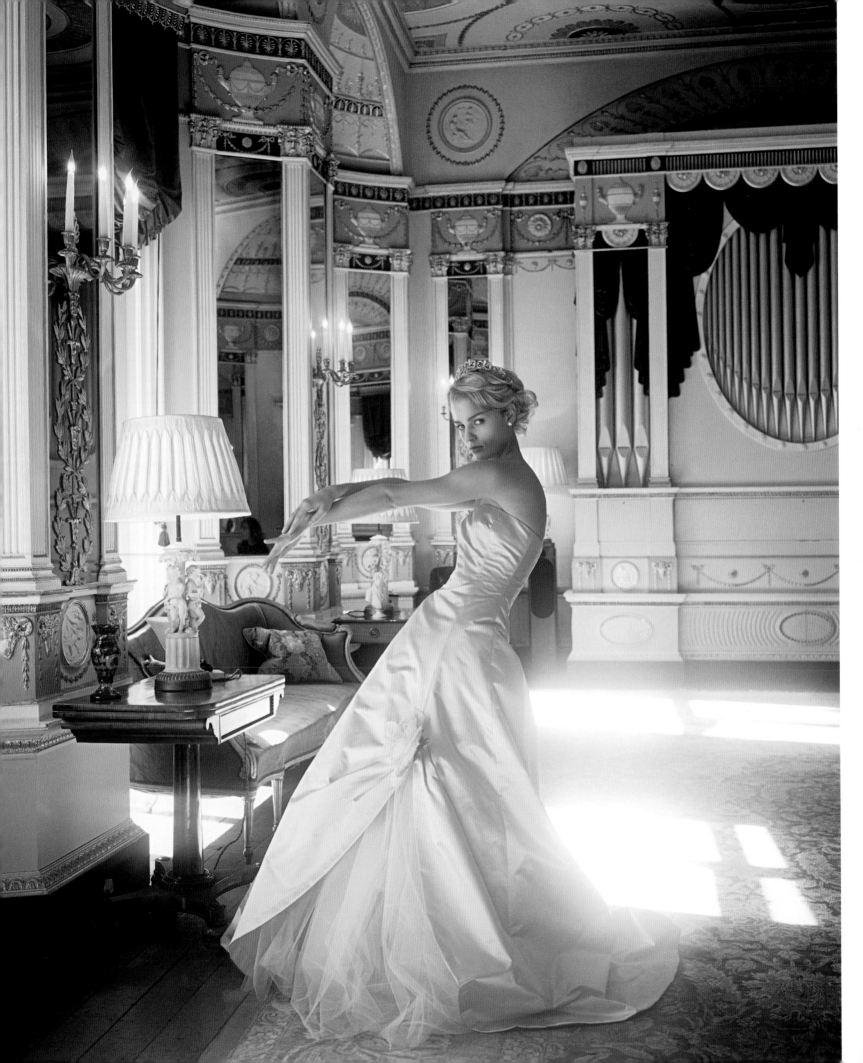

George VI, had shown Hartnell some nineteenth-century paintings by Franz Xavier Winterhalter that were hanging in Buckingham Palace. Winterhalter had excelled at portraits of women, painting them in court dress or evening dresses that had sleeveless bodices draped in gossamer tulle and full skirts. Floral corsages and jewels at the neck or wrist added to the prettiness of his pictures. Hartnell recounted: "His Majesty made it clear in his quiet way that I should attempt to capture this picturesque grace in the dresses I was to design for the Queen. Thus it is to the King and Winterhalter that are owed the fine praises I later received for the regal renaissance of the romantic crinoline."

The crinoline of the mid-twentieth century, or what would become known in the industry as a "Winterhalter", was softer in line than its nineteenth-century prototype. In place of the hoop that had traditionally supported the skirt and given it a characteristic bell shape, the big skirts of the 1950s, and those that have followed in their wake, generally relied on layers upon layers of net or tulle to give them fullness and eliminate hard lines. Expensive couture gowns would use cotton or silk tulle, while cheaper ready-to-wear versions could employ nylon net to support bouffant skirts.

Several of Dior's contemporaries also excelled at adapting the historical style of the crinoline, with dresses featuring tight bodices, small waists and lavish skirts. Jacques Fath's brief career saw him producing some of the prettiest gowns of the early 1950s. In Carmel Snow's words,

This famous photograph by Dean Loomis (opposite) showcases the Christian Dior collection of 1957. Alongside the classic, full-skirted white gown are chic cocktail outfits including the black strapless style with long gloves and neck scarf. Also underlining the importance of accessories is Pauline Trigere's strapless golden-brown cocktail dress (right) with fur stole.

Two designs by Valentino prove the enduring popularity of the traditional ball gown. The black-and-white dress (opposite) was designed by Valentino in 1954 while working for Jean Desses. The floral dress (right) is from Valentino's collection of 1986.

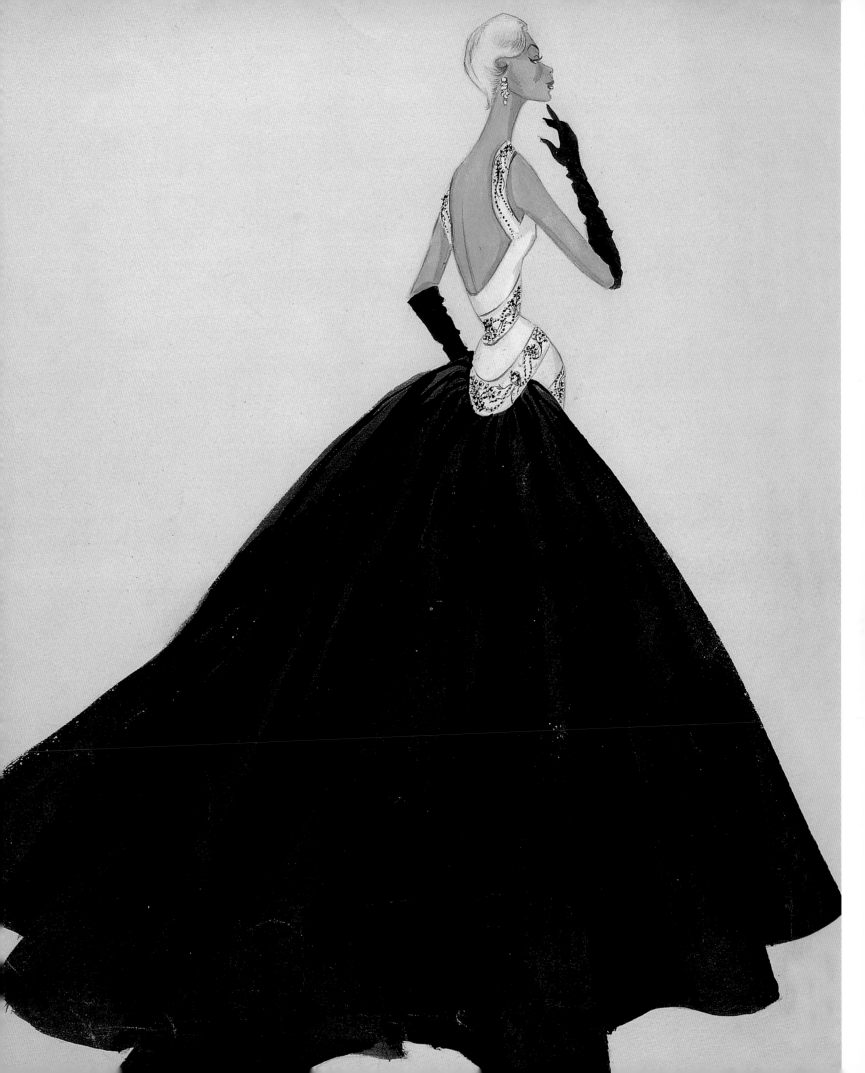

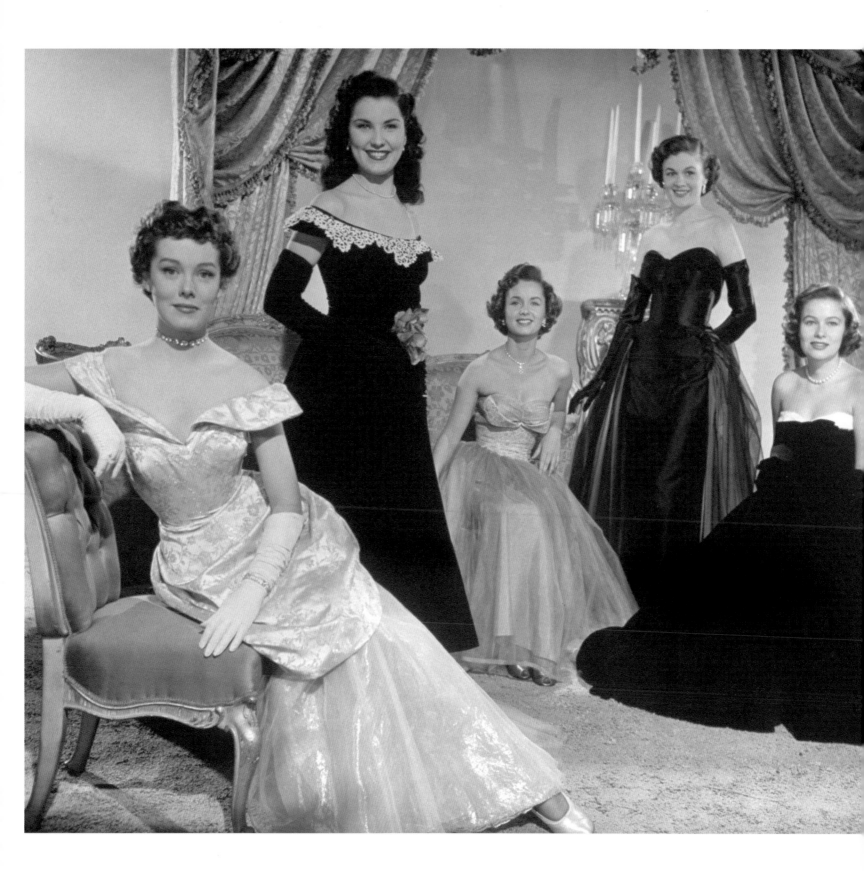

"Your dresses should be tight enough to show you're a woman and loose enough to show you're a lady." EDITH HEAD

∞ *Film and television stars of the day played an important role in showing off the latest designer evening gowns. Here movie starlets (from left) Phyllis Kirk, Debra Paget, Debbie Reynolds, Jean Hagen and Nancy Olsen wear the fashionable evening styles, strapless or off the shoulder, of 1950.*

"He makes you look like you have sex appeal." His trick was to combine ultra-feminine cuts and glamorous details. And while Dior went on to experiment with a whole range of new shapes, and sometimes radical looks, Fath continued simply to design with the same end in mind — to make women look beautiful. This meant skirts fitted from the waist and either swirling out over tulle petticoats or draping softly over the hips.

Hardy Amies established himself on Savile Row from 1946, developing both couture and ready-to-wear lines. One of his specialities was eveningwear. Amies maintained that there were two basic types of evening gowns that recurred through history: those with wide hems and those with narrow hems. Given the choice, women would invariably choose the style with a wide hem as their fantasy dress. "Where a woman can give full rein to her desires and let her taste be untrammelled by practical considerations, such as when wearing an evening dress, there is no doubt about it that the straight silhouette loses heavily."

From Amies' point of view, the "Winterhalter" dress had become even more appealing in the 1950s because it was no longer attached to Victorian sexual attitudes. By the end of the 1950s, more than half of married women in Britain were going out to work. Women had become more liberated and wore neat, practical outfits by day. Despite Dior's full skirts for daywear, most women wore the pencil skirt, especially for work, so were happy to indulge in the feminine fantasy of a strapless, full-skirted gown in the evening.

Fashion historians note Dior's chief rival as Christobal Balenciaga. Some have hailed him as the greatest fashion designer of the twentieth century. The Spanish genius had come to international prominence in 1937 when he opened a salon in Paris. Earlier in the century he had enjoyed a thriving business in San Sebastian supplying elegant ensembles to the Spanish court, so he had certainly gained vast experience in how to make aristocratic gowns. His new customers were mostly wealthy Americans, who were taken with the majestic, sculptural line of his dresses.

Like his designs, Balenciaga's color palette for evening was bold, often using black combined with a solid color. Lace was a favoured material for evening gowns, usually in black or white and combined with a plain silk.

Fabric was everything to Balenciaga, and one of his lasting legacies to evening dress was the development of a new type of silk called gazar. Pioneered in Switzerland by Gustave Zumsetg, gazar had the stiffness that Balenciaga craved for his evening creations, yet it also imparted an impression of softness. Balenciaga's use of gazar has been emulated by later designers, most notably Gianfranco Ferre and Isaac Mizrahi.

Testament to the quality of Balenciaga's fabrics and craftsmanship is found in an anecdote told by the actress Zsa Zsa Gabor. One of her ex-husbands was sure she had been cheating on him and in a fit of rage dangled her by the straps of her dress from the window of a hotel bedroom. "Dahling, it was made by Balenciaga," she later recalled. "Anything cheaper and I wouldn't have survived."

Diana Vreeland was devoted to Balenciaga. "He was the greatest dressmaker who ever lived," she once wrote. "Those were the days when people dressed for dinner, and I mean

Christian Dior's "Mozart" dress, photographed by Norman Parkinson in 1950. Dior used the vast skirts of his gowns as canvases for the artisans of haute couture. Rebé Embroidery was a favourite workshop with the skills and sensibility to produce the most delicate finishes. Thus Dior revived not only the grand dress silhouette of the eighteenth century, but also the luxury of rich decoration.

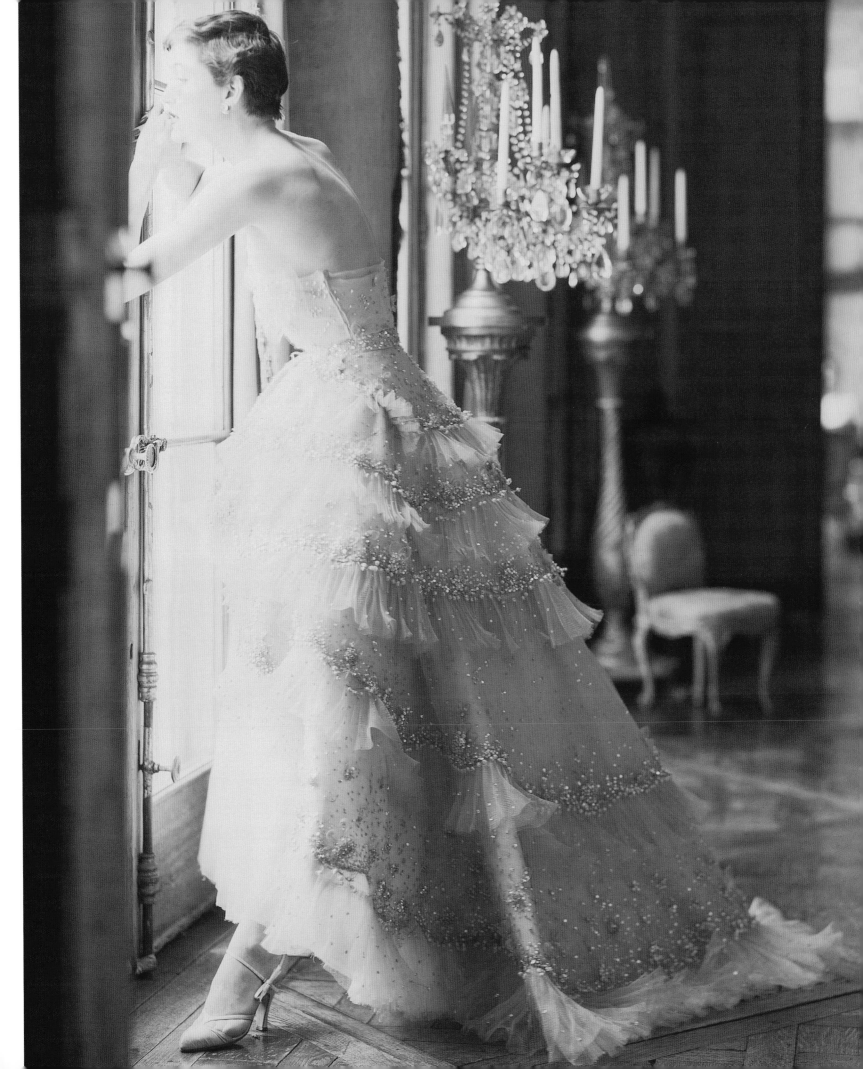

"Fashion is at once both caterpillar and butterfly. Be a caterpillar by day and a butterfly at night ... there must be dresses that crawl and dresses that fly."
Coco Chanel

∞ *This Chanel gown by Karl Lagerfeld combines an ultra-feminine, ballerina-like shape with contemporary materials and approach. The strapless line of the bodice, demure veiling of the décolletage and extensive use of the camellia motif create a particularly pretty effect, balanced by the plastic overlay that is resolutely modern. The combination is very appropriate given Chanel's own experiments with form and fabric – in 1920 she made fashion headlines when she presented a tulle bell worn over a slim crepe de Chine dress for evening.*

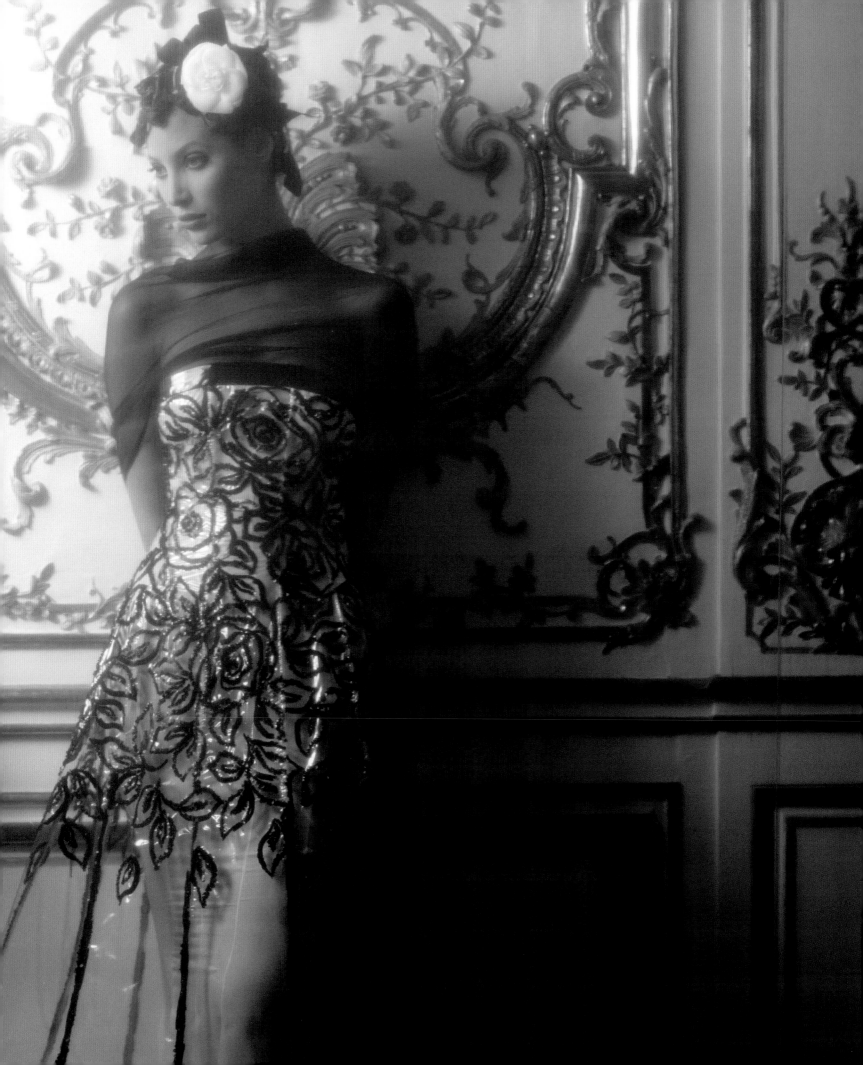

dressed, not just changed their clothes. If a woman came in in a Balenciaga dress, no other woman in the room existed."

Even so, it is Dior's achievement that was popularized. Although Dior followed up the New Look with a flurry of "new looks" every season, his first collection had the strongest impact on eveningwear. After all, it relied on the age-old art of female attraction, emphasizing womanly curves. Much of the body was disguised in vast swathes of skirt, often with padded hips. The parts that were now exposed — the décolletage and shoulders — attained new importance. *Vogue* advised how to show off bare skin to best advantage: "Choose the lightest shade of Elizabeth Arden's Leg Film ... Shake the bottle thoroughly, slather the make-up over shoulders and back; then let it set for a good five minutes. Next, buff well with a big cloud of absorbent cotton; powder if you like with pure white talcum powder — especially if you like the look at night of very fair skin. More buffing, after powder."

Needless to say, it was a high-maintenance evening look, and the antithesis of the previous three decades when it was considered vulgar to be overdressed, or at least look as if one was trying too hard. In dress, this was an era of high style. It also saw a return to formality in fashion and to prescribed looks that altered season by season. In fashion magazines it was the era of fashion instruction: How to dress for cocktails, How to dress for dinners at home, What to wear for what. "What, for instance, to wear to the biggest ball of the season?" asked American *Vogue*. "What to wear: to a biggish party that you could also wear to a dinner party at a private house; to an opening (this is a real question in

New York with so many theatre evenings); and what can you choose to wear in both North and South when the time comes? ... Next question: What, without getting too complicated and expensive about it, to wear to cocktails, dinner, and from there, say, on to the Mitropoulos Concert to see 'Till Eulenspiegel', or to a reading by the First Drama Quartette? The answer most likely to be taken out of the closet night after night: the short dinner dress, often black, sometimes red, with a skirt that is anywhere from wide to bouffant; a little waist; and unquestionably becoming neckline."

It seemed that women's social lives had never been so full, and that the intricacies of fashion had never been so avidly discussed and followed. One of the big debates on evening dress that arose in the early 1950s concerned hemlines. Whereas in the 1920s hemlines for evening had generally been short, or at least above the ankle, and in the 1930s they had been uniformly long, in the 1950s both options were available. American *Vogue* discussed the matter in its "New York Season Notes" of 1951:

"At every big evening party this winter in New York, the controversy over long or short evening dresses continued. The Duchess of Windsor nearly always chose ankle-length dresses; she was in the minority. But the Duchess, who has such a good figure, superb carriage, and superb jewels, manages to make her short-skirted dresses seem important ... Mrs Byron Foy and Mrs Walter Hoving have both been seen in Dior's orange-gold faille, strapless, short bouffant dress, with black net underskirt, but they usually wear full length for very formal evenings, reserving their short dresses

∞ *Two of the greatest fashion plates of the mid-century period display the poise that made them famous. Audrey Hepburn and Grace Kelly wait backstage at the RKO Pantages Theatre in Hollywood, 1956, ready to present awards, for Best Picture and Best Actor respectively, at the 28th Annual Academy Awards. The Oscars have remained the year's most important night for eveningwear.*

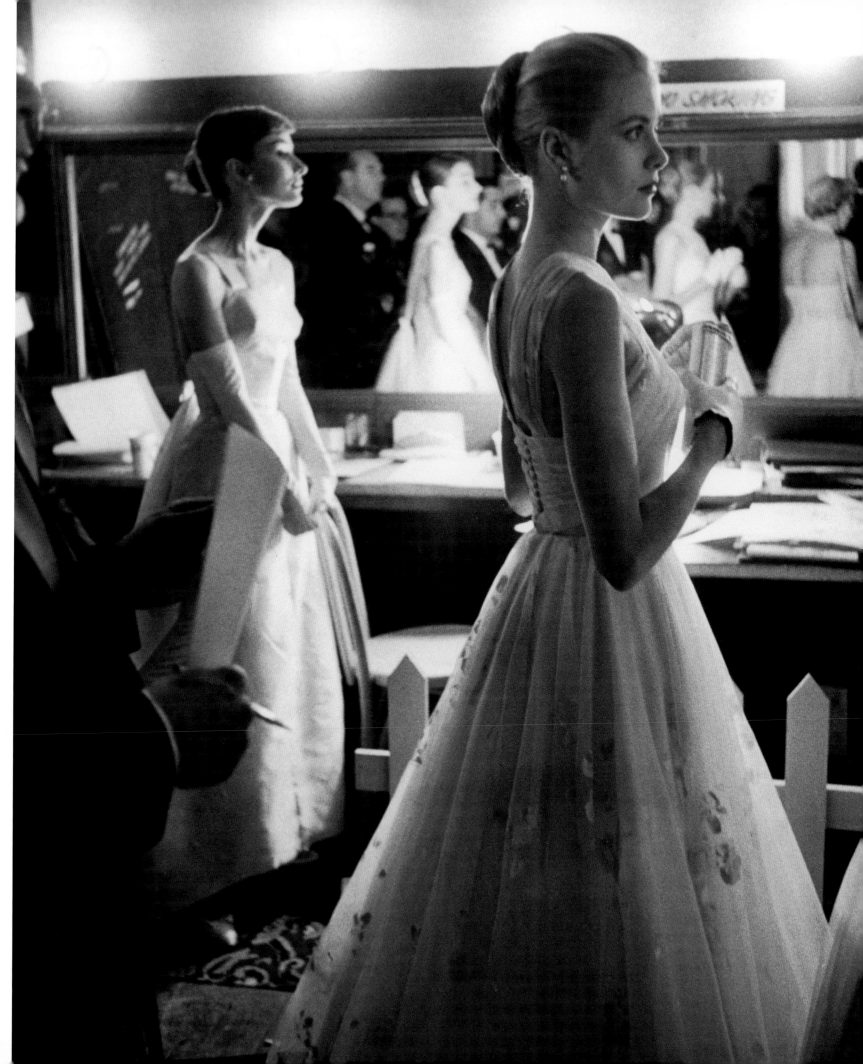

for theatres, restaurants, and small dinners." And so the column continued.

By the following fashion season, *Vogue* had made up its mind after viewing the Paris collections: "As for the short vs long question. Very few, almost no day-length décolleté dresses were shown. Full evening dresses were floor length, or ankle length. When short, the dress was for late-day-into dinner; had a full skirt, often with balloon hems stemming from Balenciaga; was usually worn with a hat."

Given the nature of 1950s fashion, though, such slavish pronouncements were often old news by the time the next season came round. The *Vogue* debate partly reflected a new formality in the wardrobes of women, with expectations that certain dress requirements be filled for certain occasions, much like the dress codes that had prevailed for women's dress in previous centuries.

Dinner parties, cocktails, restaurant dinners, dinner and the theatre, gala dinners, balls — each event offered new sartorial checklists. For dinner parties at home, "dinner culottes of apricot satin, ruby jewelling, slippers of Turkish brocade. Or for small dinners chez eux or chez vous, a close floor-length cardigan, knit of Roman striped wool with a gold mesh belt, a dazzle of crystal-in-gold earrings. Brocades of great golden beauty are everywhere, for the gala dinners, and there's cloth-of-gold itself ..." and so on in the pages of American *Vogue*.

The decade was indeed full of opportunities for extravagant dress. Fashion writer Nicholas Drake has noted

∞ *Tulle, a lightweight silk mesh, is one of the most romantic fabrics for evening. Its transparency and airiness means it can be layered to create full skirts without excessive bulk or weight. Two beautiful examples are Elsa Schiaparelli's 1950s dress (right) and John Galliano's exaggerated ballerina style (opposite).*

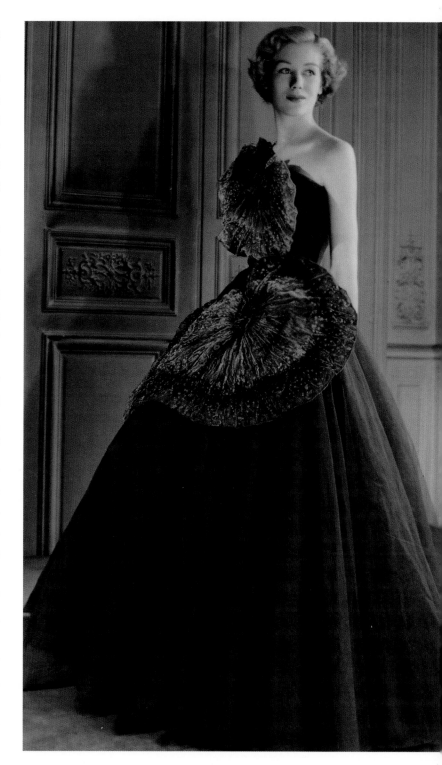

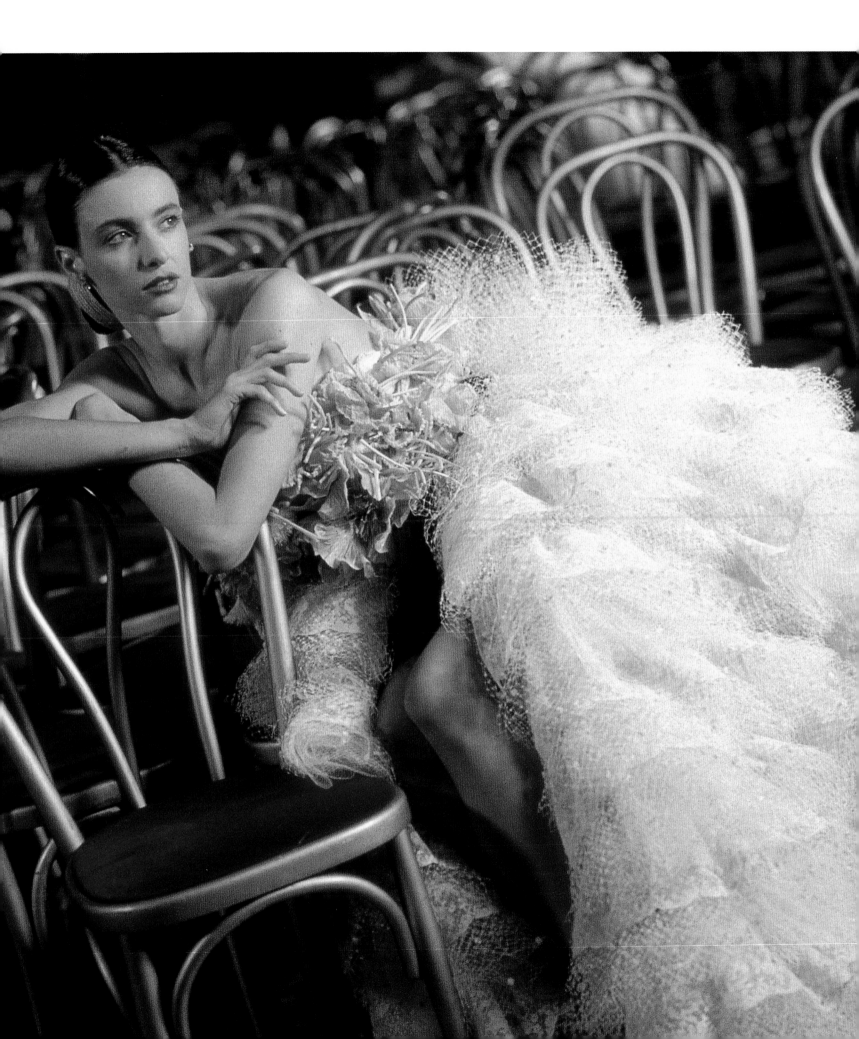

∞ *Two perennial fabrics and colors for evening dress: Gianfranco Ferre's off-white tulle gown (left) from his spring/summer 1989 haute couture collection, and a one-shouldered black velvet dress with a matching choker and black velvet cocktail hat (below) from Christian Dior's collection of 1947.*

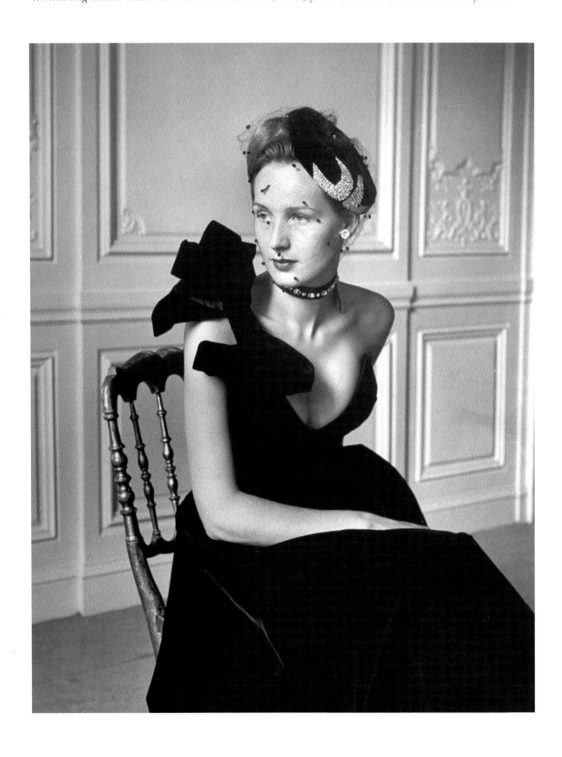

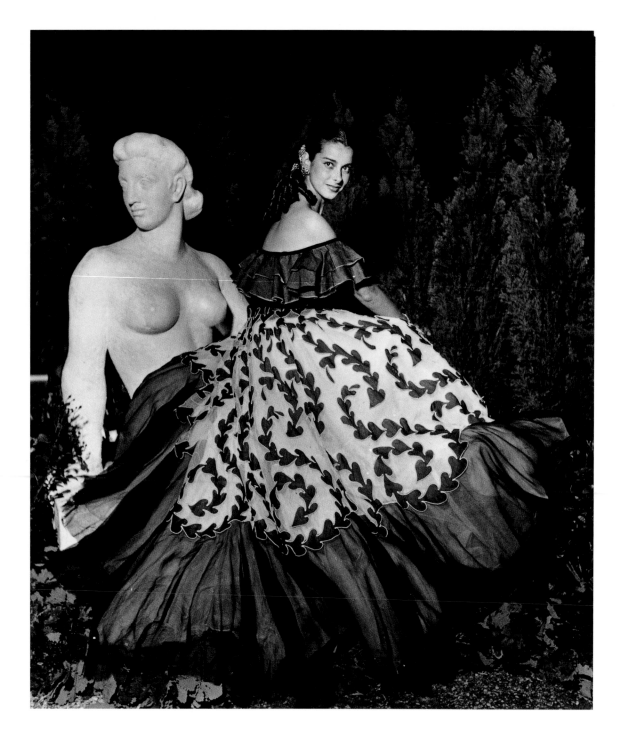

✂ *Off-the-shoulder styles, which had been so popular in the mid-nineteenth century, were revived in the 1950s and again in the 1980s. The beauty of this feature is its power of suggestion: the bodice appears to be falling down, as if to reveal the breasts. Both Madame Carven's dress from the early 1950s (above) and Belville Sassoon's design for Diana, Princess of Wales (opposite) are demure yet hint at the naked body by exposing the shoulders. The rest is left to the imagination.*

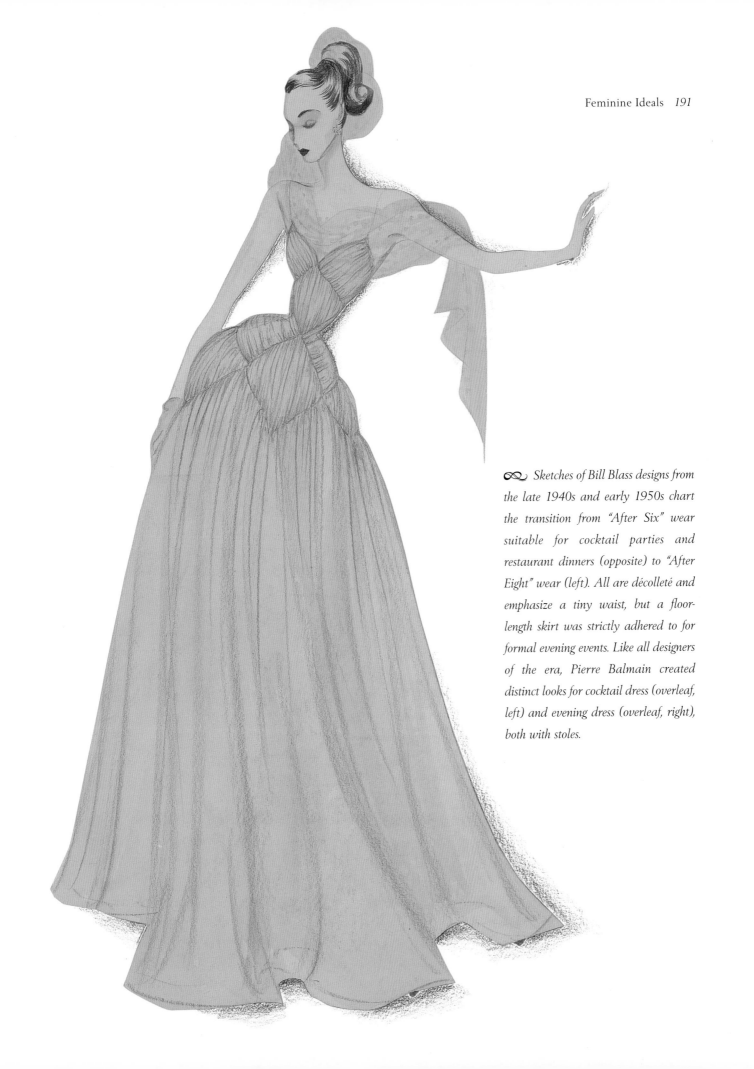

※ *Sketches of Bill Blass designs from the late 1940s and early 1950s chart the transition from "After Six" wear suitable for cocktail parties and restaurant dinners (opposite) to "After Eight" wear (left). All are décolleté and emphasize a tiny waist, but a floor-length skirt was strictly adhered to for formal evening events. Like all designers of the era, Pierre Balmain created distinct looks for cocktail dress (overleaf, left) and evening dress (overleaf, right), both with stoles.*

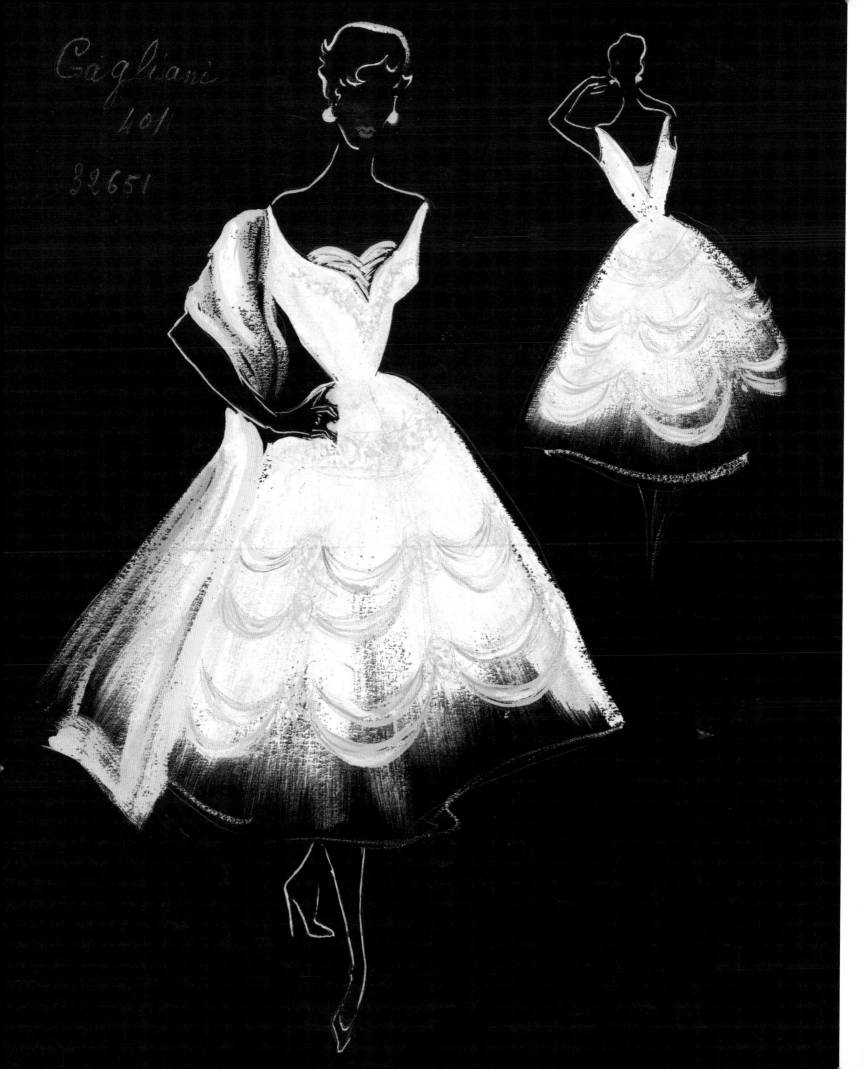

meant for the drawing room as well as the coat closet; meant to create a certain silhouette, a certain effect."

Like the typesetting of its editorial mantras, the evening looks advocated in *Vogue* were precisely calculated for a particular, stylized effect. The narrowly constructed evening gowns of the latter part of the decade were a popular choice of the film stars of the day, above all Marilyn Monroe.

What remained an almost constant feature throughout the 1950s was the small bodice. Whether skirts were large and full, as in the years immediately after the New Look, or narrower and draped as they were by the late 1950s,

More than any other style of clothing, the evening dress is purposely designed for making dramatic entrances and exits. Hence both form and color are essential considerations. The black Chanel sheath (opposite) is so sleekly fitted to the body, with no extraneous detail, that it succeeds brilliantly in attracting attention – purely through its silhouette. Gianfranco Ferre's ball gown (below) is eyecatching for other reasons – firstly its brilliant color, and secondly its revealing, open-weave fabric.

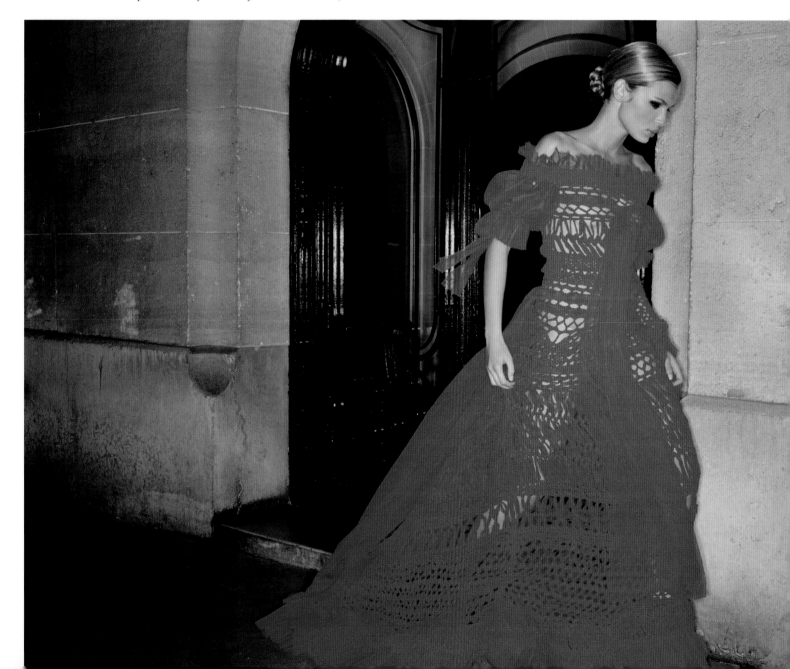

"It was through my grandmother that I learnt that clothes carried a message, that you could be more seductive by dressing a certain way." JEAN PAUL GAULTIER

∞ *Jean Paul Gaultier's spectacular couture dress of 1999, worn by Devon Aoki and photographed by Patrick Demarchelier for American* Harper's Bazaar, *reinvents the glamour of the fishtail skirt for a new generation. When Gaultier opened his couture house in 1997, Pierre Bergé, head of Yves Saint Laurent declared him the most brilliant couturier since Yves Saint Laurent. Gaultier's first couture customers included Nicole Kidman and Catherine Deneuve.*

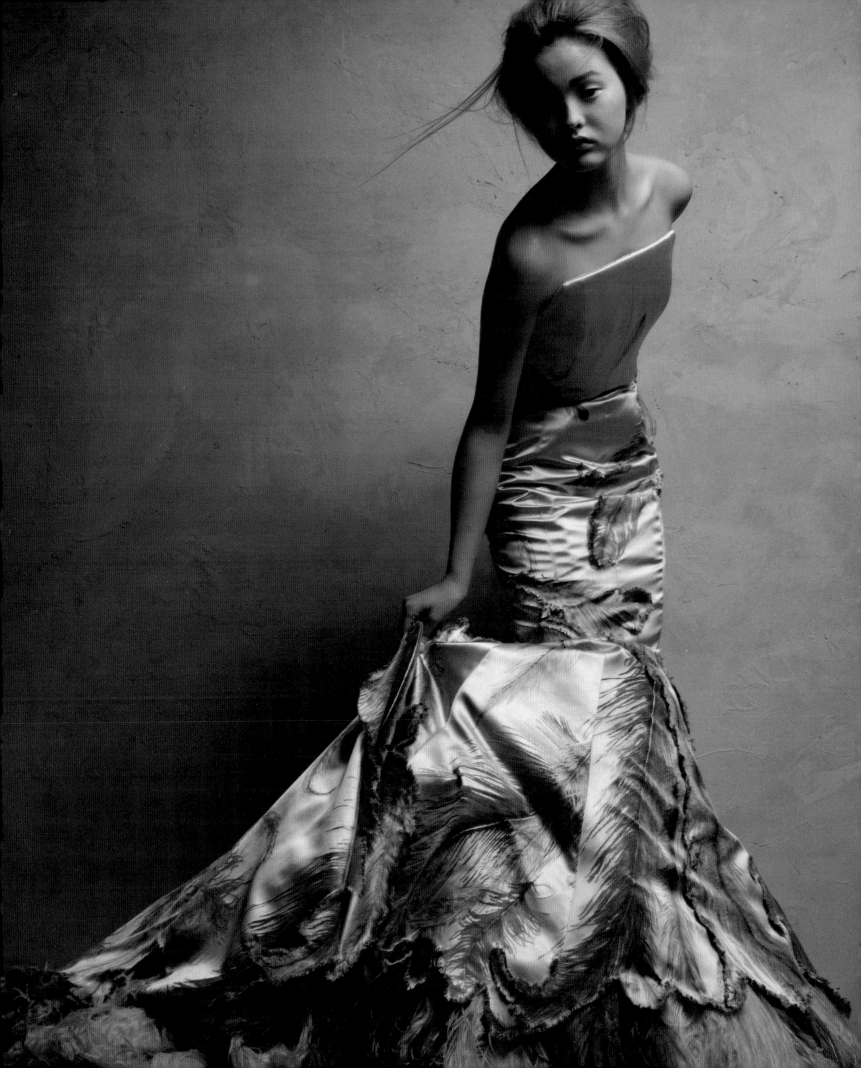

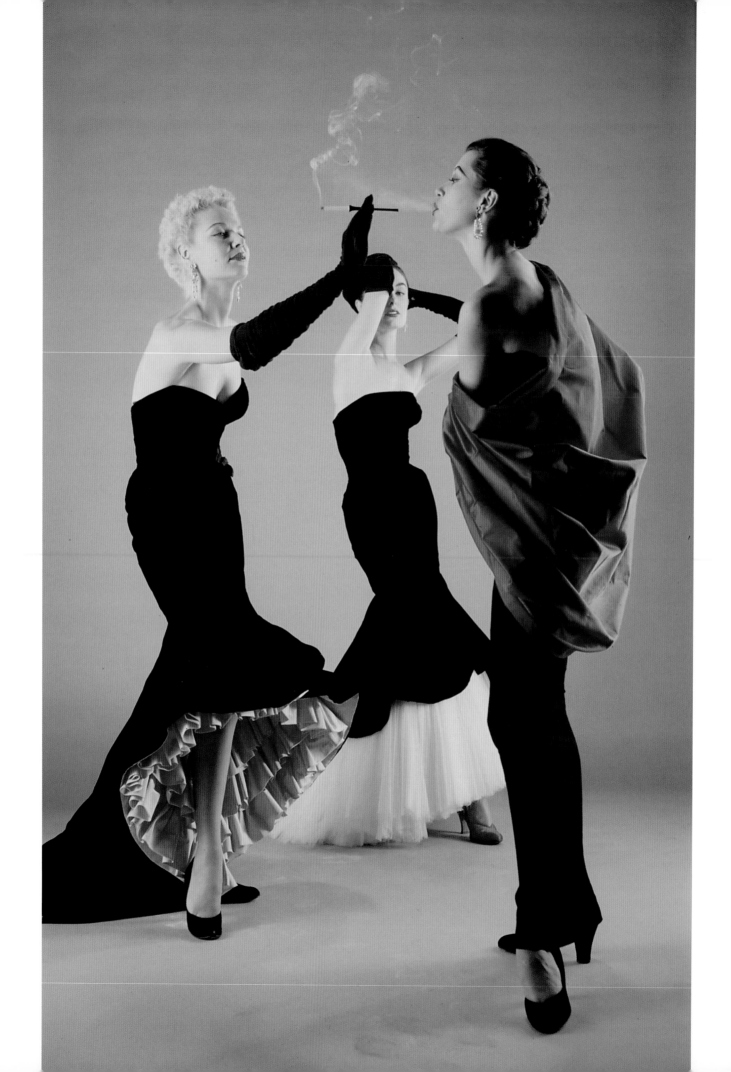

gown with white tulle overskirt and white violets covering the bust. It became one of the most copied styles of the year, prompting one fashion editor to remark, "Go to any prom this season, and you'll see dozens of them." In the 1950s Head produced some of the most memorable gowns in film history, and for two of fashion's great icons: Grace Kelly and Audrey Hepburn.

Grace Kelly was the perfect clothes-horse for beautiful evening gowns. Like the popular models of the day, such as Suzy Parker and Jean Patchett, she exuded high style, rather than sex appeal. For Kelly's role in *To Catch a Thief,* Head designed three evening dresses: the first two are draped chiffon and appear early on in the film, one in white, the other in shades of blue to help to project an icy demeanour. The costume colors intensify as the film builds to a climax, and Kelly steals the show in the final sequences wearing a gold lamé dress, its enormous skirt trimmed with gold birds.

While Head considered Kelly the perfect clothes-horse in every way, she found Audrey Hepburn more of a challenge. She considered the actress's collarbones to be too prominent, her neck sinewy, and her legs too heavy in proportion with her frail arms and shoulders, so many of her costumes were conceived to conceal them. For Hepburn's Oscar-winning role in *Roman Holiday* in 1953, she designed two evening dresses, adding a diamond necklace to one to detract from those collarbones.

Hepburn posed problems for Head in other ways, suggesting that some "real" Paris dresses be used in *Sabrina.* Hepburn went to visit Balenciaga but was instead referred to Hubert de Givenchy, who fitted her for several couture gowns for the movie. For *Funny Face,* regarded as one of the most influential fashion movies ever, Givenchy again stepped in to design a wardrobe of chic evening dresses as well as daywear for Hepburn's character. Countless women

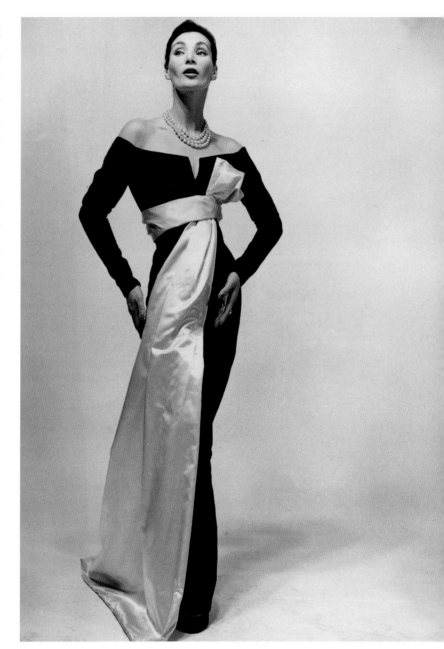

∞ *The New Look triggered a multitude of exaggerated and geometrical dress styles, exemplified in Dior's 1955 "Soireé de Paris" (above). Ian Garlant's design for Hardy Amies (opposite) embodies the 1950s obsession with sculptural, stylized form.*

were inspired by her onscreen outfits and gamine style. Writing in *Vogue*, Cecil Beaton summed up the Hepburn phenomenon: "Nobody ever looked like her before World War II ... now thousands of imitations have appeared. The woods are full of emaciated young ladies with rat-nibbled hair and moon-pale faces."

A more elevated description comes from Hepburn's favourite designer Hubert de Givenchy: "My first impression was of some extremely delicate animal. She had such beautiful eyes, and she was so extremely slender, so thin ... In film after film, Audrey wore clothes with such talent and flair that she created a style, which in turn had a major impact on fashion. Her chic, her youth, her bearing and her silhouette grew ever more celebrated, enveloping me in a kind of aura or radiance that I could never have hoped for."

The antithesis of sex kittens Marilyn Monroe and Brigitte Bardot, Hepburn represented a charming new brand of femininity. In the words of Billy Wilder, who directed *Sabrina*, "After so many drive-in waitresses, here is class."

Hepburn and Kelly have remained the role models for aspiring actresses, and are invariably held up by fashion commentators and journalists as the yardsticks by which others are measured, especially on the red carpet.

For Samantha Critchell who covers the Oscars for the Associated Press, "Ask today's A-listers who inspired their look and they'll likely say Grace Kelly, proving that elegance — and, yes, grace — is always in style. The blue silk spaghetti-strap gown and evening coat by costume designer Edith Head that Kelly wore to the Oscars in 1955 remains a classic." The Academy Awards ceremony is, more than ever, the glamorous highlight of the year when it comes to evening dress.

John Galliano, before he became the designer for Dior, had spent long hours in the vaults of the Victoria and Albert Museum's costume department, studying the fabric and seams from the couture house. Of the sumptuous Dior tradition he said: "Our generation has been denied that kind of beauty — the delicious etiquette of dressing up."

Although that "delicious etiquette" is no longer, and perhaps never will be, such an important part of women's lives, the urge to dress up is as strong as ever. In the twenty-first century, many retailers have noted a boom in sales of evening dress. Thus while modern lifestyles are dominated by casual dress, it seems that women do miss the feeling of being "dressed", and are prepared to splash out on a gown they may only ever wear a few times.

The show-stopping evening dress, in the grand style of the 1950s, has itself acquired a kind of star status that often eclipses that of the wearer. The irony is, of course, that the stars are dressing solely for the cameras, to ensure a high profile in the media. The more fabulous the dress, the better the chances of securing a page in the glossies. In the words of Kate Winslet, commenting on the 2001 Academy Awards, "From now on, it's all about the dress."

Zac Posen's high-voltage cocktail dress updates the classic New Look silhouette. The designer draws attention to the bust and waist with a corseted torso, but this is balanced by the full and fanciful skirt trimmed with feathers. "Sexy clothes are always relevant, because they are empowering," he maintains. "Intelligent, adventurous women ... are always attracted to strong, sexually charged clothes."

CHAPTER FOUR

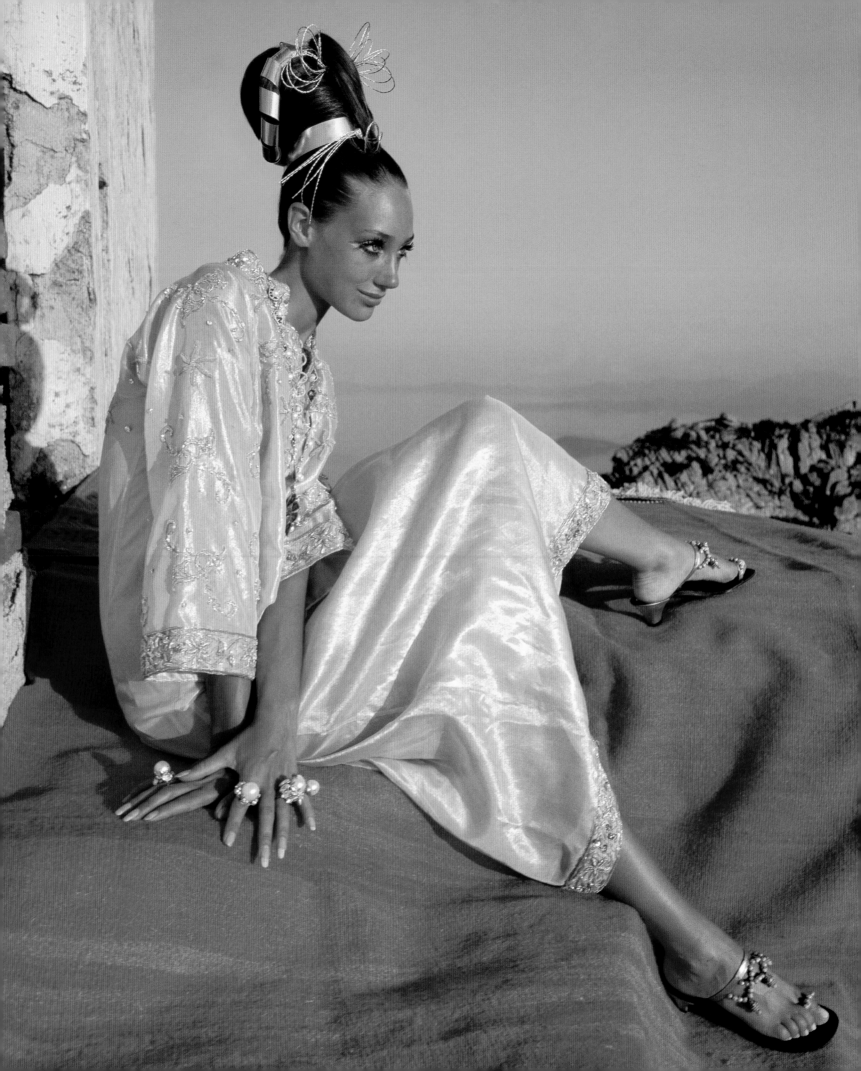

FREEDOM AND FANTASY

"Saint Laurent designs for women with double lives. His day clothes help a woman confront the world of strangers ... in the evening when a woman chooses to be with those she is fond of, he makes her seductive." CATHERINE DENEUVE

After the formalized eveningwear and grand gestures of the 1950s, a new mood took hold for nights in the subsequent two decades. Eveningwear followed daywear in loosening up. The change was in large part driven by the cultural emphasis on youth. Where the structured styles of the 1950s suited the figure of the mature woman, the new evening looks were designed with a younger model in mind.

Demographics were a powerful force in dictating the way in which evening fashion — indeed all fashion — was to develop. By the 1960s one third of the population of England was under twenty, and half of the population of the United States was under twenty-five.

Thus the young played a pivotal role in setting trends, simply by sheer force of their numbers and buying power. They disregarded convention, including the separate categories of day and eveningwear, formal and casual clothes that had defined fashion for so long. Formal dinners, balls

and theatre occasions were no longer the main domains for eveningwear. There were nightclubs, bars, pop concerts and parties just for the young, and these venues dictated a more relaxed mode of dress.

The disco was one of the new youth destinations that had a significant impact on eveningwear, in the 1960s and again in the late 1970s. In her book *The Changing Face of Fashion*, Ernestine Carter explains the phenomenon: "At the beginning of the sixties Paris had invented a new kind of boite, with canned, instead of real, music. These discothèques, small, dark, mini-nightclubs, upgraded the jukebox. To the jive and swing was added the Twist. The Couture responded to the discothèques by designing swinging little dance dresses, usually black, Guy Laroche scoring the most instantaneous success. In 1961 discos flew across the Channel to England, and their darkness encouraged, but did not inspire, the anything-goes attitude of the young who wore their hot pants and jeans with

Marisa Berenson wears a gold kaftan by American designer Tina Leser in 1967. She was nineteen. Berenson, the granddaughter of Elsa Schiaparelli, was a top model by the age of sixteen and graced the covers of Vogue *and* Harper's Bazaar. *A 1960s "It Girl" she personified the new spirit in fashion, perfecting the luxurious yet effortless look of a rich bohemian, wearing the dresses of her designer friends Valentino and Yves Saint Laurent among others. "It's impossible to overdress," she once wrote, "more is always more."*

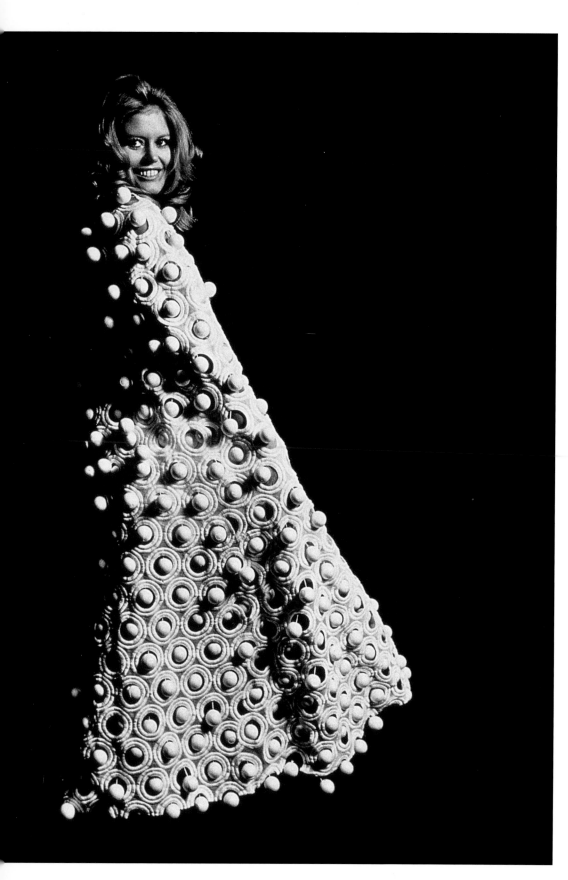

∞ *Designers in the 1960s threw away many previously held convictions about the nature of eveningwear, producing new shapes and using heavier fabrics such as felt and wool to give them a stronger line, as is evident in these dresses from the archives of Ungaro (left), adorned with ping pong balls, and Mila Schön (opposite).*

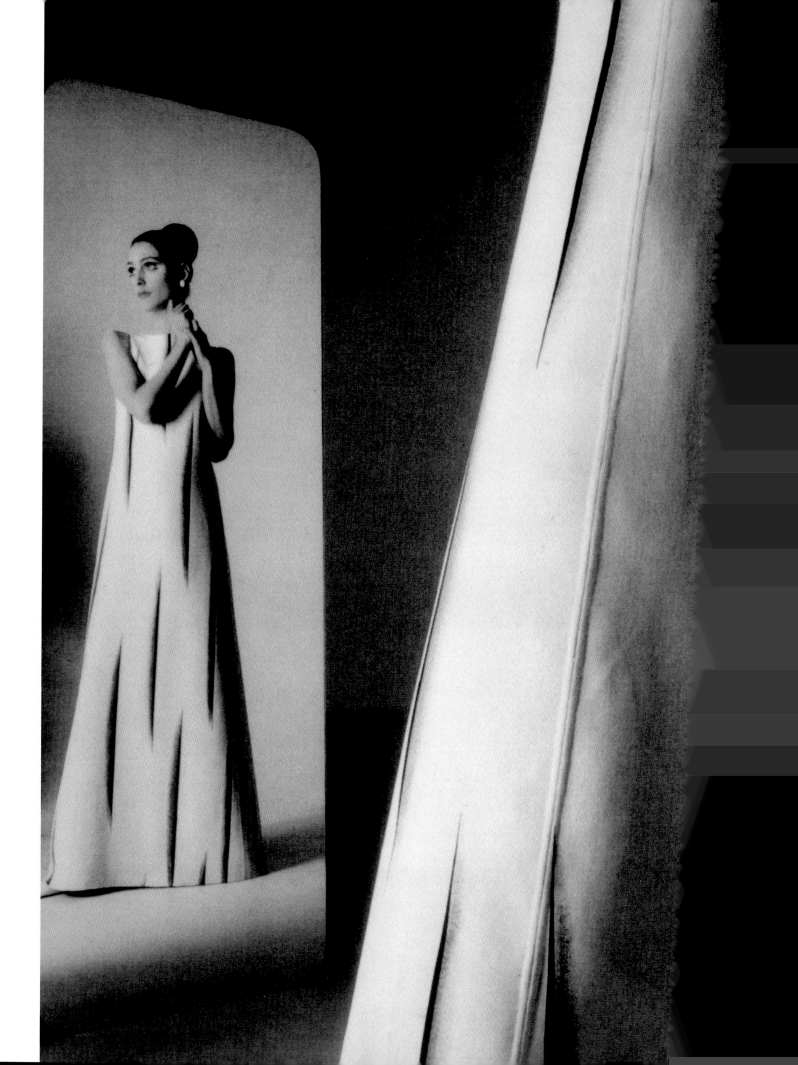

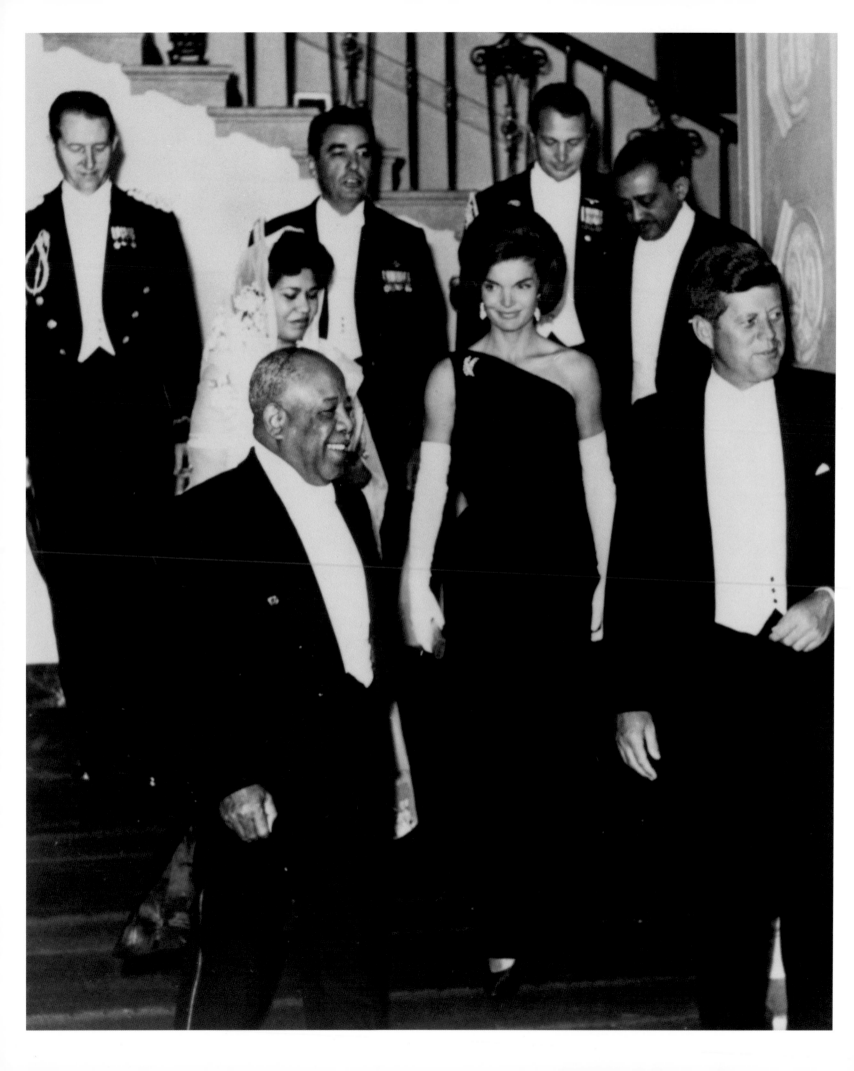

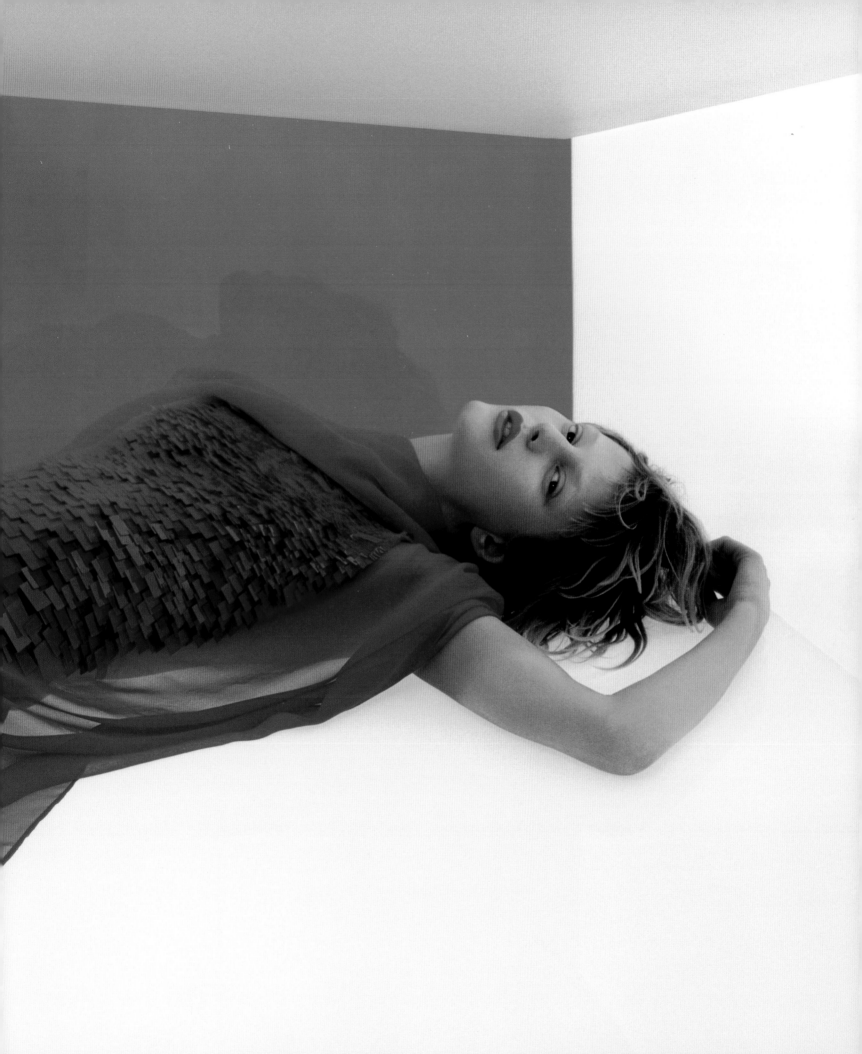

Washington was doing more than anyone to revolutionize evening looks, with a resolutely modern approach.

In 1960 John F. Kennedy became president of the United States, taking his wife Jacqueline Bouvier Kennedy with him to the White House. Unlike the mature women who had previously served as First Ladies, Jackie, as she became known, was young and fashion conscious. As was traditional, all eyes were on her at the inauguration ball of 1961, which would send a message to the nation about the style of their new president's wife. Would the critics, and the people, applaud her or reject her?

That night Jackie Kennedy made the right choice. She wore an off-white sleeveless silk gown of silk chiffon over peau d'ange, designed together with Oleg Cassini who

would become her favoured couturier, especially for public events. She helped to turn him into a household name, and he in turn gave her a clean contemporary look that was copied the world over.

It is no wonder so many women emulated Jackie O's evening style. She had the knack of looking modern while retaining enough formal elements to appear polished and neat. The First Lady remained an emblem of good taste and modern elegance, but other women were turning in droves to the youth styles of the counterculture. In this respect, London was the fashion capital of the world.

There was one significant figure on the London scene who helped to define the wardrobes of young Londoners and influenced many more around the world – fashion designer Mary Quant. With her finger on the pulse of what was happening on the streets, she helped to change the accepted thinking about eveningwear, and the result was a new ambivalence between night and day. Her idea of going out at night might have involved a black moiré halter-neck dress that stopped a few inches above the knee, or a plain sleeveless shift teamed with gold tights and a pair of low-heeled Mary Janes.

The main difference between day and evening styles for the young was solely the amount of flesh on show. Quant's short pinafore dress, for example, appeared in the pages of *Vogue* in 1960, worn with a tight black poloneck underneath for day and on its own for night with patent purse and stilettos. On the streets, in London especially, young women wore their minis from day on into night, with simply a change of accessories. This was a major shift in evening

Along with Courrèges, Pierre Cardin embodied the utopian fashion feeling of the mid 1960s. His dresses for evening (above) were short and shift-like in sparkly or shiny fabrics. Cardin's penchant for geometric shapes and graphic style is clear in Paula Ka's chartreuse dress (opposite). Gradually eveningwear became more nostalgic; Sonia Rykiel's black mini (overleaf) captures the late 1960s mood.

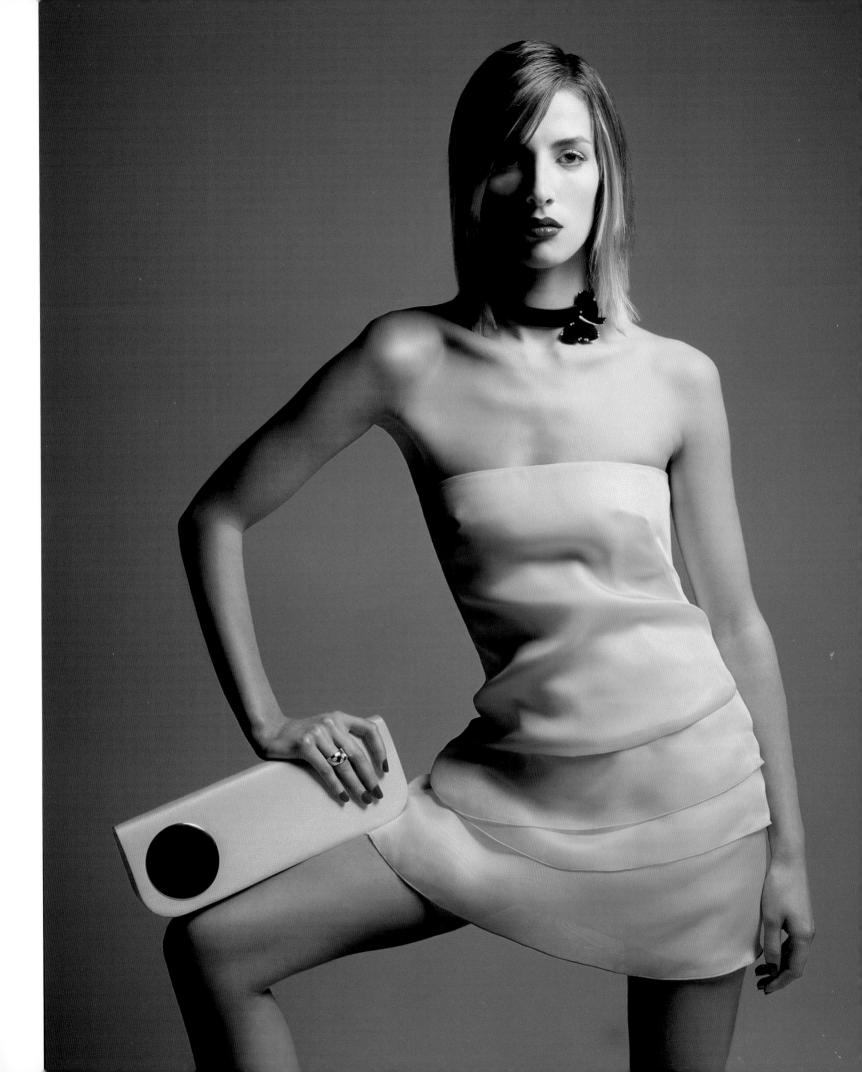

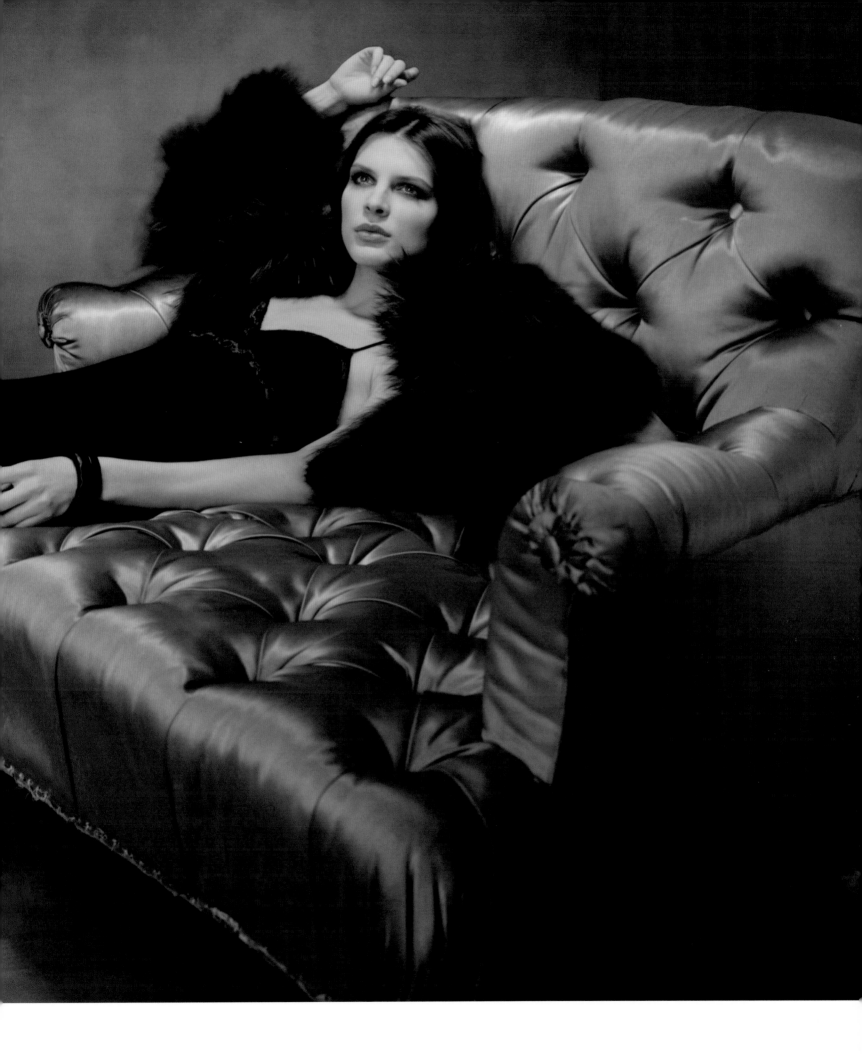

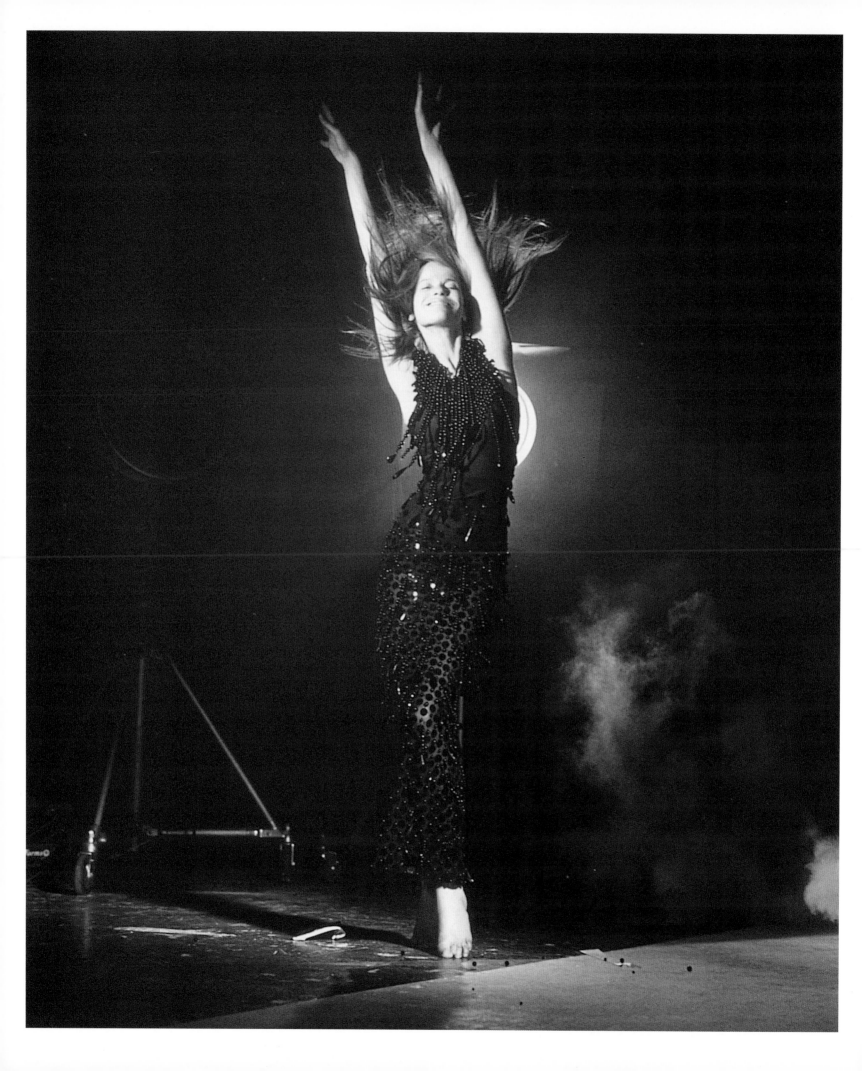

fashion and laid the basis for how many women now dress for going out, from the office to dinner, theatre or a party, switching practical flats for a pair of heels, changing a sweater for a pretty silk top, adding sparkly earrings.

Looks were changing constantly in the 1960s, with fashionable young things turning to the next new trend at a great pace. One reason for this was the incredible cheapness of clothes, made possible by manufacturing advances, new synthetic fabrics and the huge volumes of clothes that could be sold. Teenagers were buying about half the womenswear in England, and their mothers were also being drawn into the young styles, not wanting to look dowdy.

Designers of high fashion realized they could not ignore the influence of this huge and energetic demographic. Yves Saint Laurent had shown the way in 1960 with his "Beat" collection, referencing the beatnik generation and rebellious youth. He drew on the street culture of the times to create youthful, hip designs such as motorbike jackets and fur-trimmed hems. However, his mastery lay in using couture techniques to produce his collection.

As fashion historian Valerie Steele has pointed out, "the 'Beat' collection was a significant development both in Saint Laurent's career and in the subsequent history of fashion, because it demonstrated that street fashion could be made elegant for an older and more sophisticated clientele."

At the time, however, the collection was poorly received by the fashion press both in France and abroad. American *Vogue* complained bitterly that the collection was "designed for very young women … who expect to change the line with frequency and rapidity, and who are possessed of superb legs and slim, young goddess figures".

Remarkably, the youth-driven style of the little shift remained unchallenged over the next few years as the main

∞ *Dolce & Gabbana, in a 1960s frame of mind, play with paillettes, beads and transparency (opposite). Their ruby-red sheath (below), covered in jewel-like beads, references the 1960s, when surface texture brought streamlined shapes to life. Both dresses are modelled by Veruschka, who American* Vogue *heralded in the mid-1960s "as one of the great wonders of our time."*

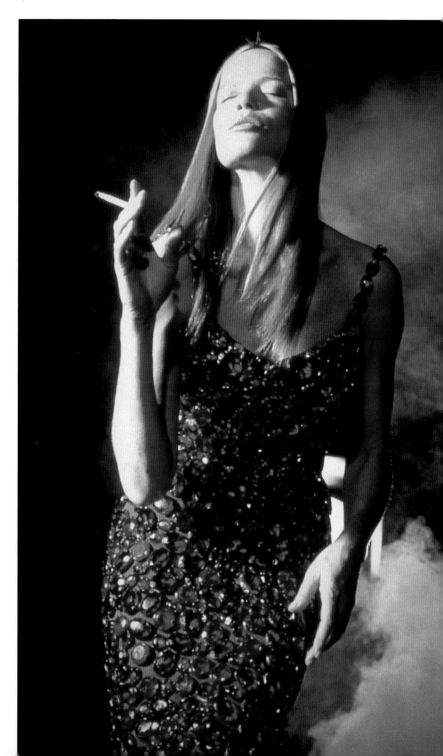

form of fashionable dress. It was worn for both night and day. One popular incarnation was the "Little Girl Look", which might have meant a little smock dress in piqué cotton for day, and in lace or velvet for night. Certainly, compared with the ladylike evening attire of the 1950s, these seemed like children's clothes.

Writing in *Vogue: History of 20th Century Fashion*, Jane Mulvagh notes that in 1963: "The fashionable dress was still the childlike shift, occasionally cut out at the sides or back ... Culottes and pinafores, which could be worn from dawn to dusk with a simple change of hairstyle and accessories, remained very popular with the young. 'N'oubliez pas la femme,' admonished [Marc] Bohan at Dior amid all the little girl looks. He made his point by presenting short and long two-piece evening gowns full of ruffles coquetry, and the return of the décolleté, framed by seductive Chantilly lace."

Like Bohan, other French designers were also trying to capture evening looks that chimed with the times. There was some experimentation — Yves Saint Laurent's "brassière" dress of 1962 with its cutout back and bra-like straps, for example — but the simple dress with a lean silhouette prevailed in both long and short versions. Despite the uncomplicated structure of these dresses, haute couture designers went to great lengths to make them dazzling for evening through surface embellishment.

For his autumn/winter collection of 1960, Givenchy presented a long, shift-like dress in midnight blue, covered all over with a layer of iridescent greenish-black cockerel feathers, each one attached to the dress by its quill and

Contemporary designs for Paco Rabanne pay homage to the designer who made chainmail the choice for fashionable evening dress in the mid-1960s. Rabanne, a former architect, was the first designer to use plastic and metal in clothes manufacture.

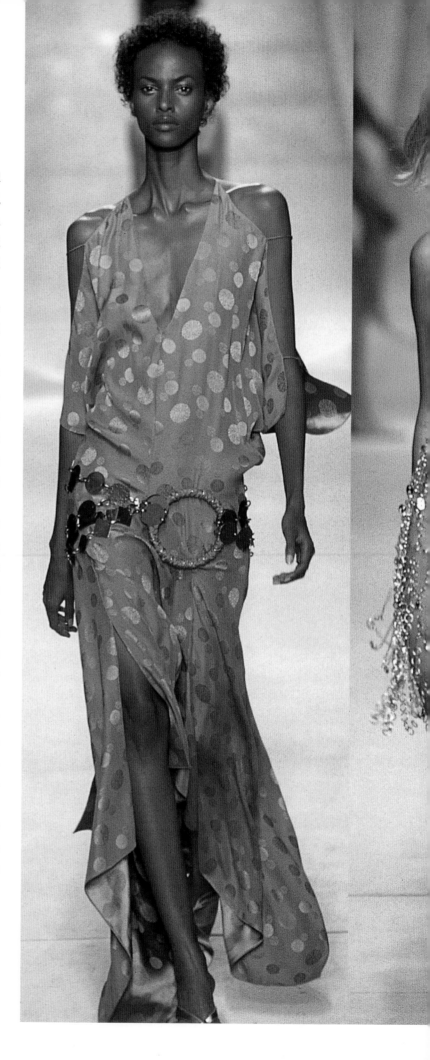

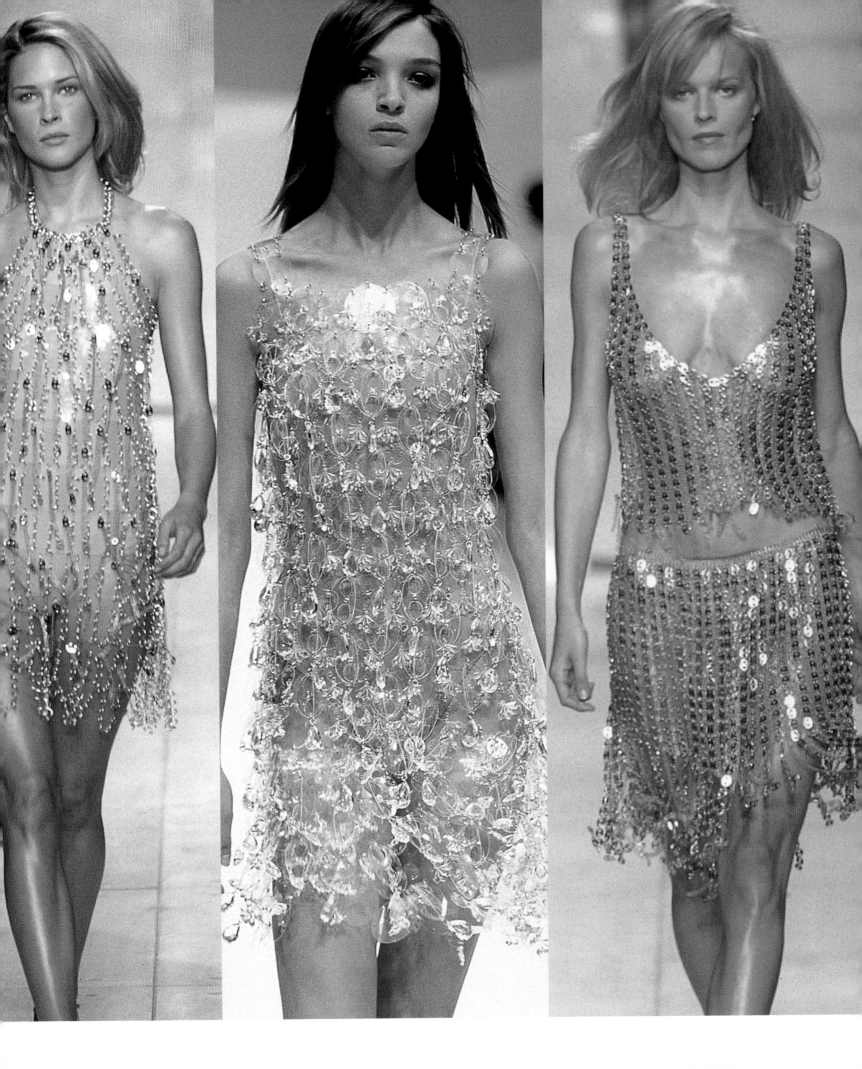

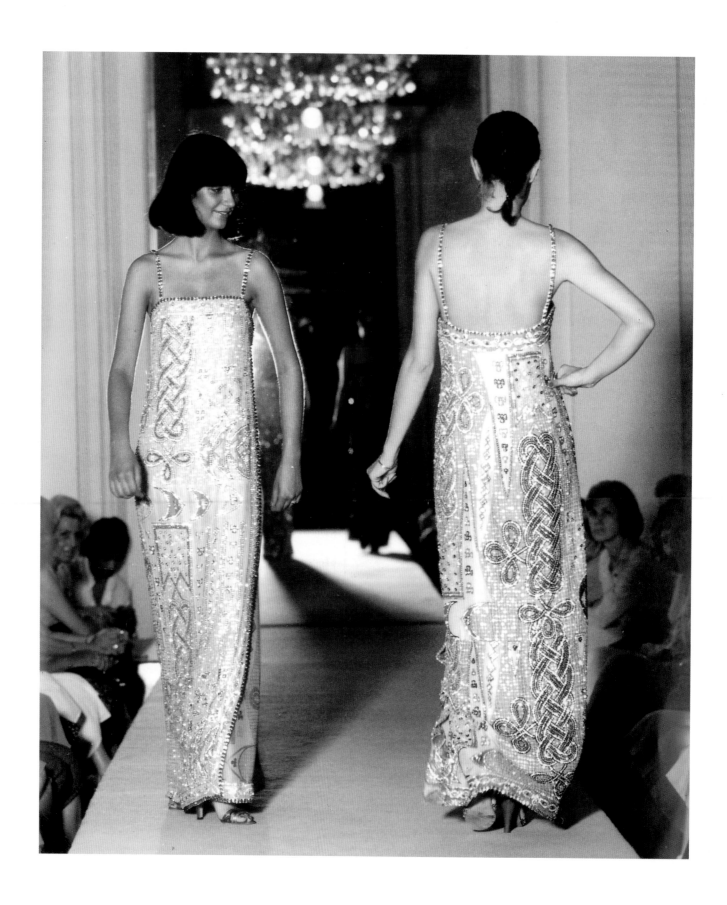

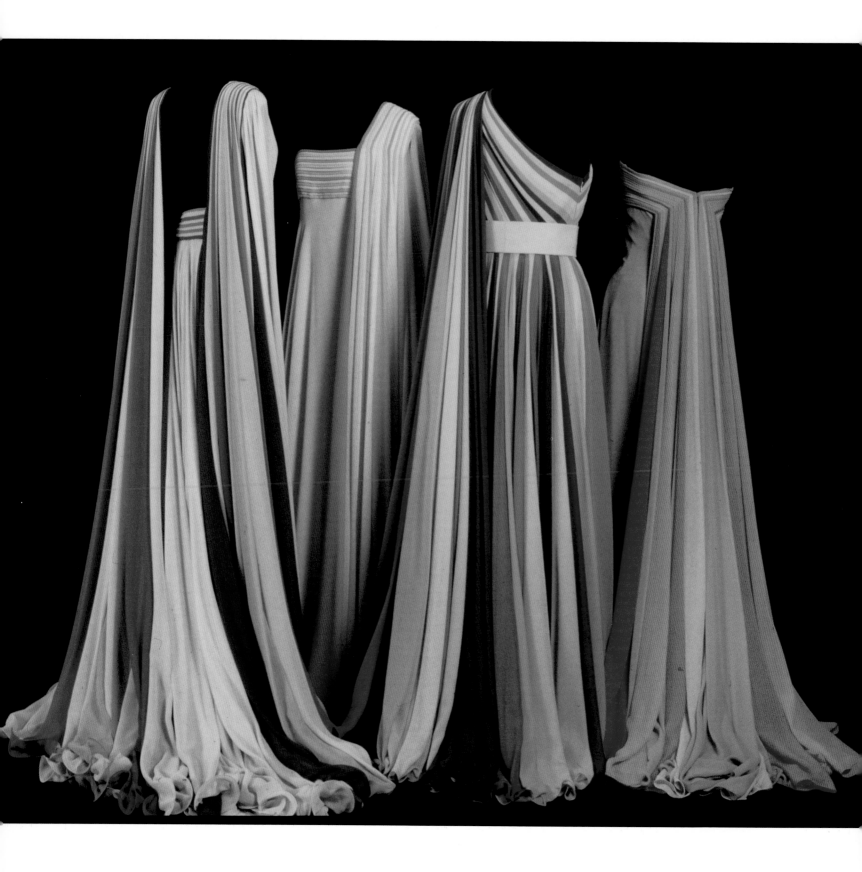

of plastic chainmail or suspended from plastic discs and almost anything in silver leather. But there was also a hint of change in the air. Yves Saint Laurent was presenting gypsy style shifts as an alternative to the stiff space age dress. And in the chic boutiques of London, women were buying embellished kaftans from Morocco.

By the following year the kaftan had become the fashionable attire for evening and was well on its way to becoming a classic. Women on a budget could buy a cheap version from one of the many youth-oriented boutiques such as Biba in London. At the other end of the scale was Hubert de Givenchy's one-shouldered peach-colored silk dress, inspired by the loose lines of the kaftan and luxuriously trimmed with matching feathers.

As the decade wore on, the sharp shifts and futuristic looks for evening were increasingly replaced by a yearning for nostalgia, with evening clothes put on like costumes. James Laver sums up the transition in his book *Costume & Fashion: A Concise History*. "By the late Sixties the teenagers who had drawn attention to the problems and needs of their generation, were in their early twenties. As their rebellion lost its bite, the mood was beginning to change. Paco Rabanne's crazy chainmail collection of 1967 had taken this quasi space age and the whole extreme phase of fashion to its limits. The new mood which arrived to replace it was other-worldly too ... a dreamy, summer-afternoon idyll, seen in soft focus." British *Vogue* heralded the change in its editorial: "On gusts of balalaike music from the Balkans, from hurdy-gurdy camps in Varna and the Ukraine, from straw-roofed Chechen villages, comes pure theatre for evening fashion. Give full rein to instincts for display and munificence with tinselled finery, brilliant skirts, silk embroidery, gold lace, tall boots, pattern used with pattern." The fashion editor declared that "Ossie Clark's satin dresses with fabric prints by Celia Birtwell make the most revealing evening dresses in London, slashed or flowing against the body to show every line."

Across the Atlantic American *Vogue* saw things the same way. "When evening comes around, the brash is past ... '67 nights know the luxury of kaftans and djellabas, the full excitement of subtle fabrics and embroidery, the gentler allure that's come to fashion from the seraglios of the East." At the couture level Yves Saint Laurent became a master at interpreting this mood for evening. "The evening is the time for folklore," he declared.

Inevitably, hemlines came down, shapes became freer and fabrics lighter. To compensate for longer skirts and dresses, designers added slits and used transparent fabrics to add an element of sexual allure. Again Yves Saint Laurent was at the forefront of this trend, showing a long see-through black chiffon dress with a band of ostrich feathers around the hips. In his 1968 collection he used another technique for making eveningwear sexy — the laced bodice. He explained his reasoning thus: "First of all I think one should want to undo something that a woman is wearing. From the point of view of seduction, it can be a dress that's laced up the front or something knotted on one shoulder so that one thinks: if I pull there, the whole dress will fall down. The laced corset is, of course, the very emblem of sexuality." It seemed as if the exposure of legs so dominant

∞ *In the 1960s, Rome attracted international attention for the eveningwear being designed by a handful of talented couturiers of whom Roberto Capucci was one. He became renowned for his sculptural approach and for never repeating an idea. Capucci used brilliant colors, often juxtaposing different shades to enhance the linear effect he was after, as these draped, one-shouldered gowns show.*

One of the most photographed evening dresses of 1968 was Yves Saint Laurent's sheer black gown (opposite). As hemlines began coming down, transparency was one technique that designers used to give dresses sex appeal. Like Yves Saint Laurent, Sonia Rykiel pioneered "ready-to-wear" in Paris, opening her boutique on the rue Grenelle, in the heart of Saint Germain, in 1968. Since then she has rarely strayed from her chic Parisienne signature look (left).

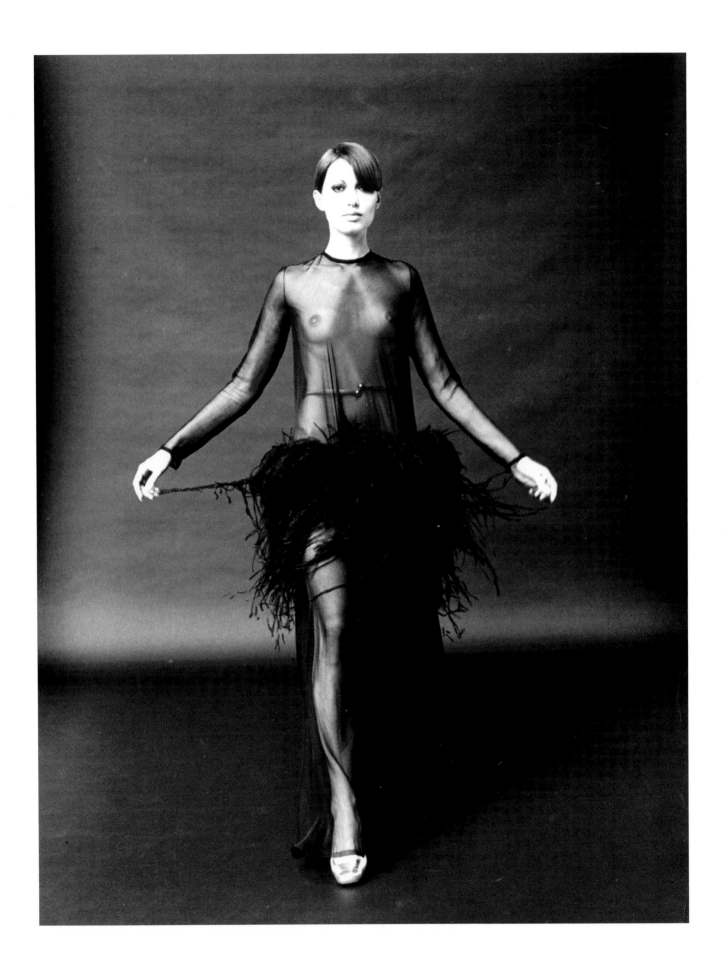

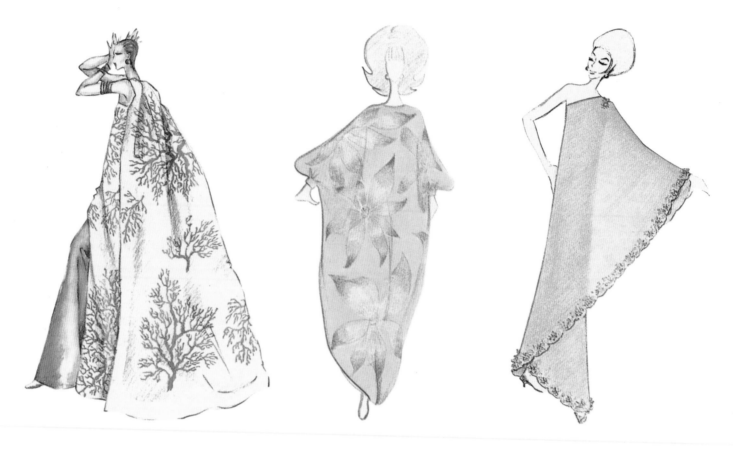

until now had come to an end. Legs no longer seemed exciting. Mini styles had been so pervasive, for so long, that legs were no longer fashion's favourite erogenous zone.

While designers toyed with hemlines on skirts and dresses, transparency and slashed skirts, they hit upon the trouser suit. In 1969 Yves Saint Laurent launched his tuxedo for women – "Le Smoking", now a fashion classic for evening. Eastern-style pant suits with wide trousers and tunic tops also became immensely popular for both day and night, especially when cut in Eastern style. This posed

problems for some formal venues. The Ritz Hotel in London, with a long-standing policy of no trousers for women, decided that so long as they could not tell you were wearing pants they would allow you to dine. Floaty culottes were a much safer bet than slim trousers for securing a table.

By 1970 there was not a short skirt in sight within the pages of British *Vogue*, and by the following year the fashion editor felt confident to print the following: "There are no rules in the fashion game now. You're playing it as you go … you write your own etiquette, make up your face

∞ The kaftan made its fashion debut in the 1960s. As the cocktail wear of the 1950s segued into "lounge wear", the kaftan became the ultimate hostess gown. It was certainly comfortable, but it also had an exotic cachet, and both men and women wore it for parties and entertaining at home. By using sheer fabrics and adding slits to show off the legs, the kaftan of the Arab world was reinvented for the fashionable West. Even couture designers have presented kaftans, including Valentino (above) and Ungaro (opposite).

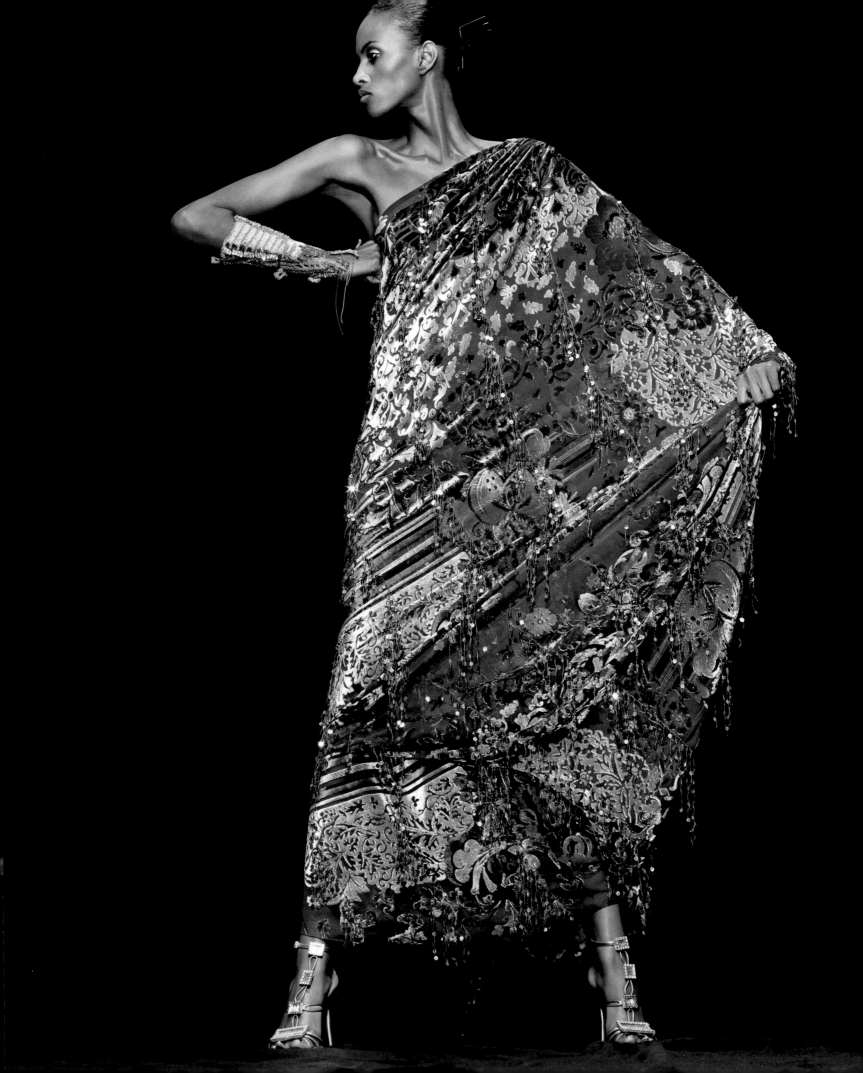

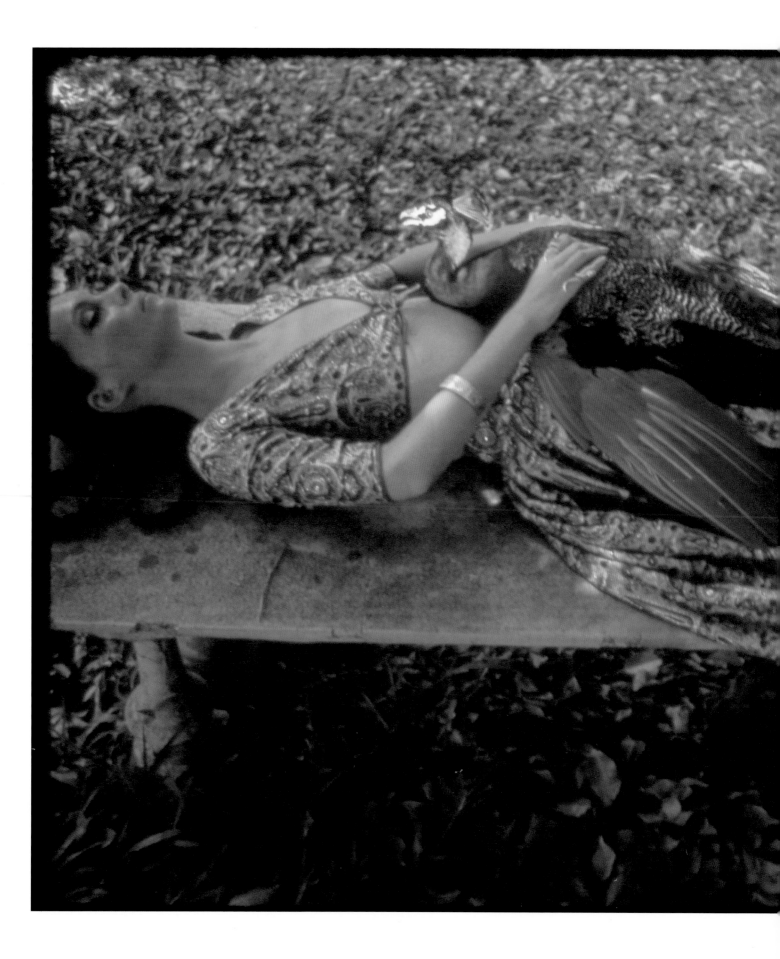

From Vogue 1968, Norman Parkinson's image demonstrates how eveningwear had become more relaxed, but also how fantasy played a bigger role than ever before. Getting dressed became like putting on a costume. In the same way that Asia had influenced designers in the 1920s, fashion in the 1960s, especially eveningwear, drew heavily on the exoticism of Asia, Africa and the Middle East.

your own way, choose your own decorations, express yourself ... *faites vos jeux*."

In the United States fashion both for evening and day was also becoming more body conscious. Designers left behind the architectural shapes of the 1960s and created a softer silhouette. Lightweight silk and cotton jersey draped and gently caressed the body. Interestingly, the demand for day and evening fashions among wealthy Americans became highly differentiated. Customers now wanted classic and sporty separates for day, but very glamorous dresses for evening. Designers such as Bill Blass, Oscar de la Renta and

James Galanos became expert at delivering these styles to their rich, well-groomed customers.

A similar divergence was happening in Paris. The haute couture industry focused on exclusive evening gowns and formal daywear while the prêt-à-porter concentrated on mainstream fashion. Much as it works today, the couture gowns became showpieces designed to grab attention, generating publicity for the ready-to-wear lines of the house.

In 1974, British *Vogue* profiled the leading couturiers in an article entitled "The Perfectionists". Along with Emanuel Ungaro, Hubert de Givenchy, Karl Lagerfeld and Marc Bohan,

∞ *As the 1960s gave way to the 1970s, eveningwear lost some of its fantasy element and focused instead on the body. Retro influences were strong, but the overall line was lean and body conscious. Valentino showed relaxed shapes in his couture designs (above) while Yves Saint Laurent embellished a simple tunic shape with gold lacing (opposite) in this image from 1975 by Norman Parkinson.*

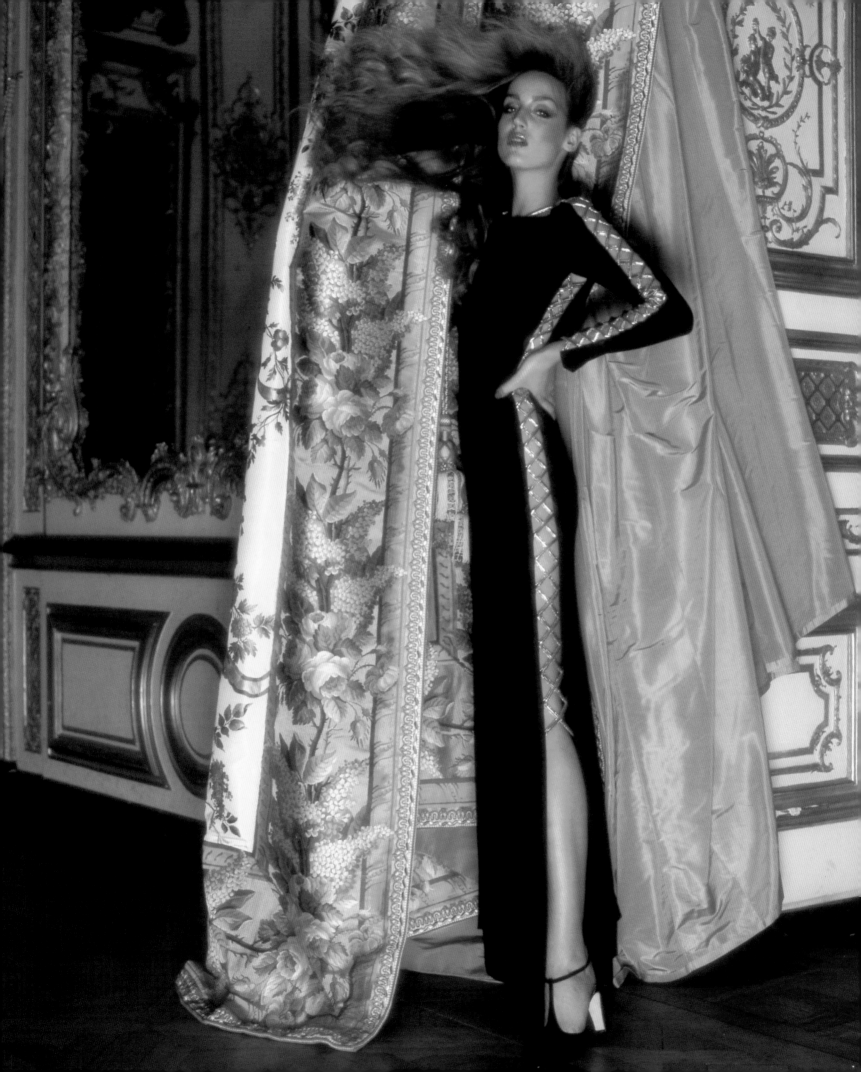

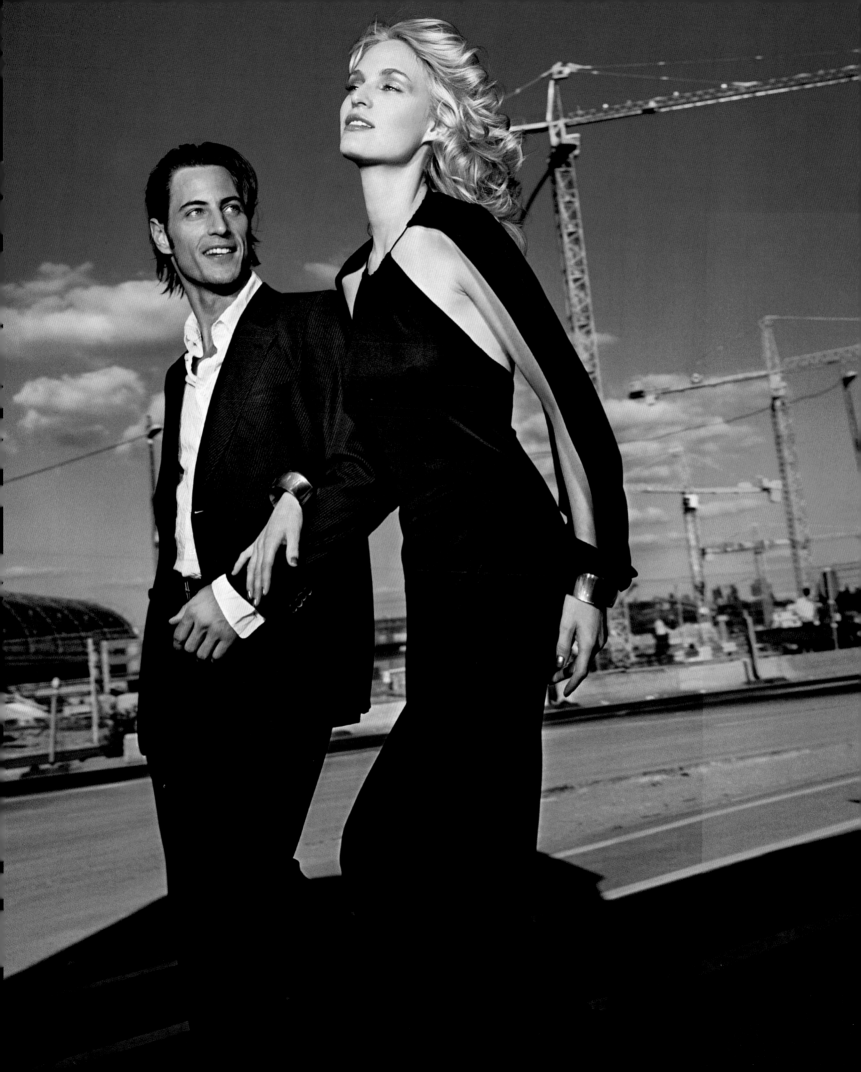

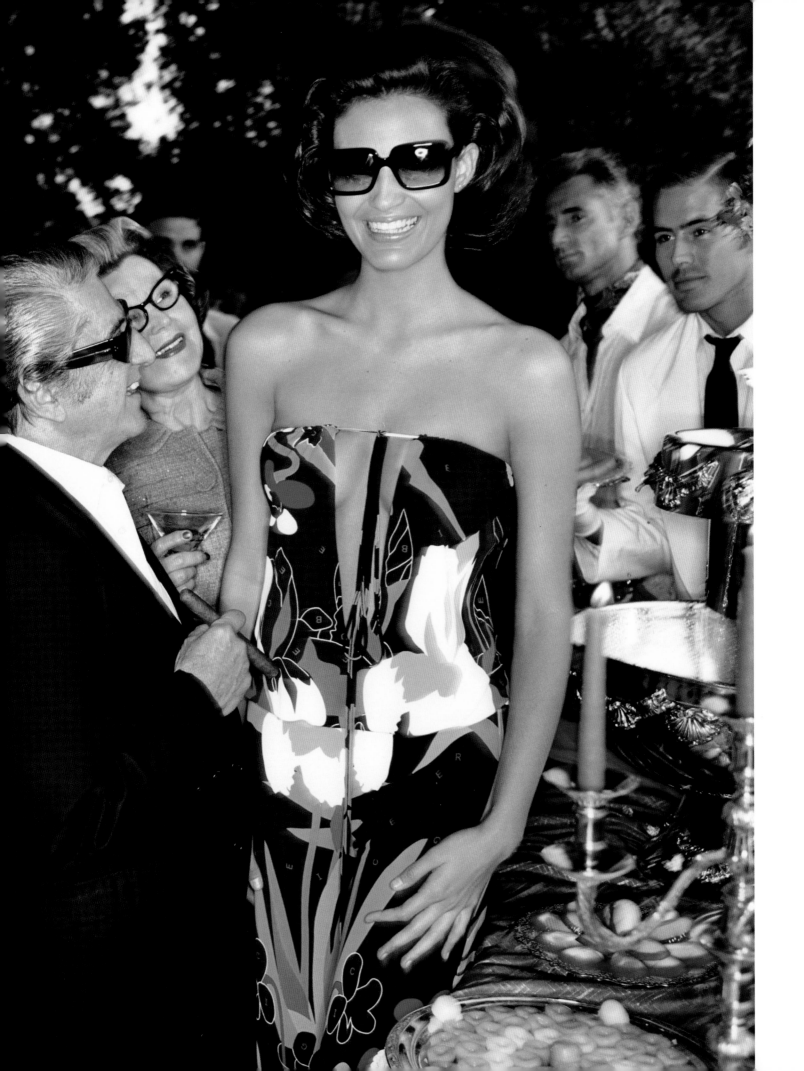

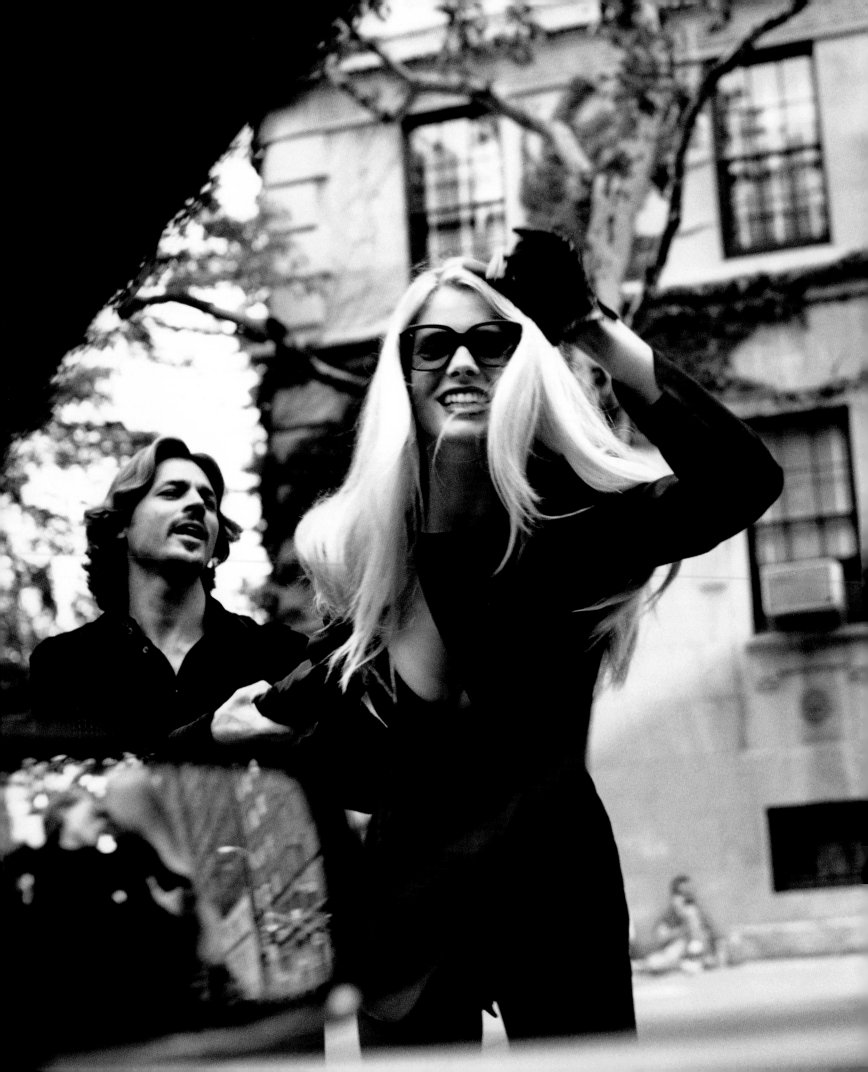

 The 1970s are notoriously characterized as the decade of "anything goes" and certainly dress codes were very relaxed, often bordering on bad taste. Such diversity of looks and choice of clothing was virtually unprecedented in the history of fashion. For evening women could choose a bright, strapless sheath with cheeky cutout such as Iceberg's modern interpretation (preceding pages); a minimalist halter-neck dress or a pantsuit worn with nothing under the jacket. Here Giorgio Armani reworks these ideas for the independent woman.

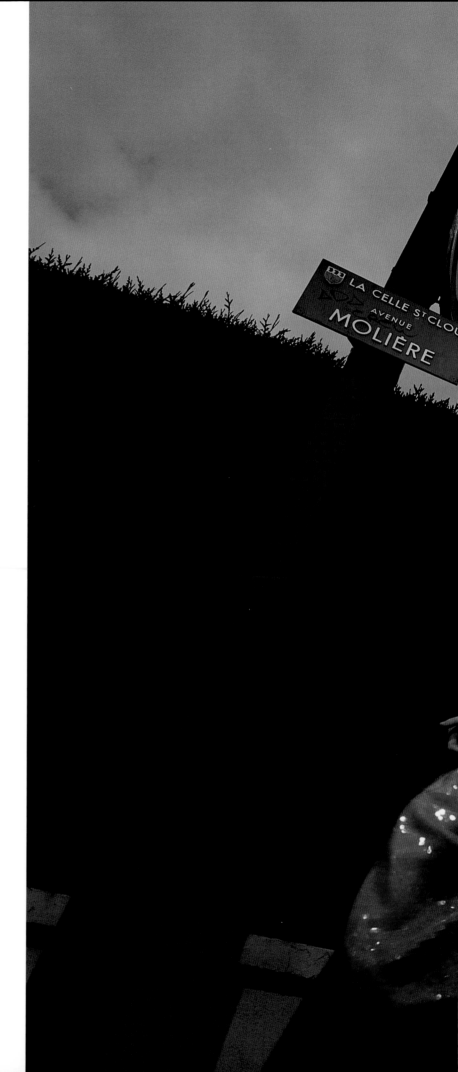

∞ Comfortable and easy describe designer Giorgio Armani's approach to dress, whether for day or evening. However, his masterful use of exuberant color, exquisite brocade and sequinned silk clearly transforms these simple, relaxed shapes into free-spirited evening-wear that corresponds with the 1970s approach to fashion.

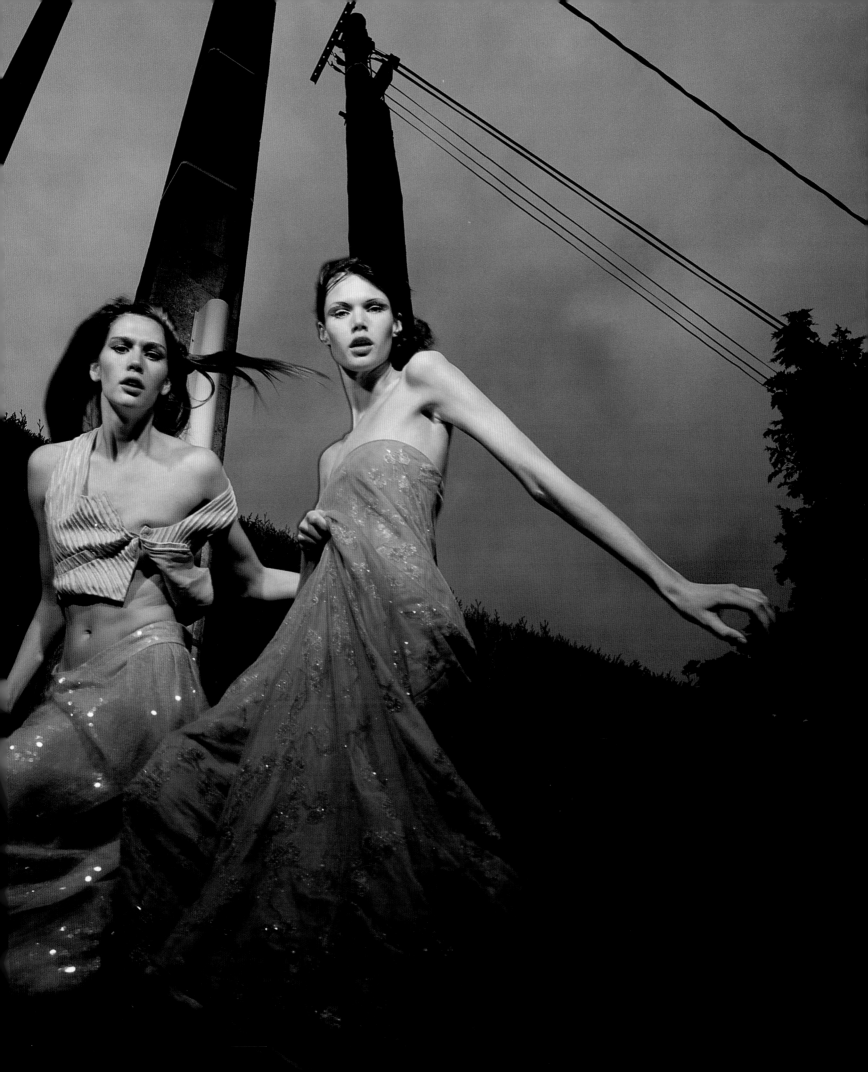

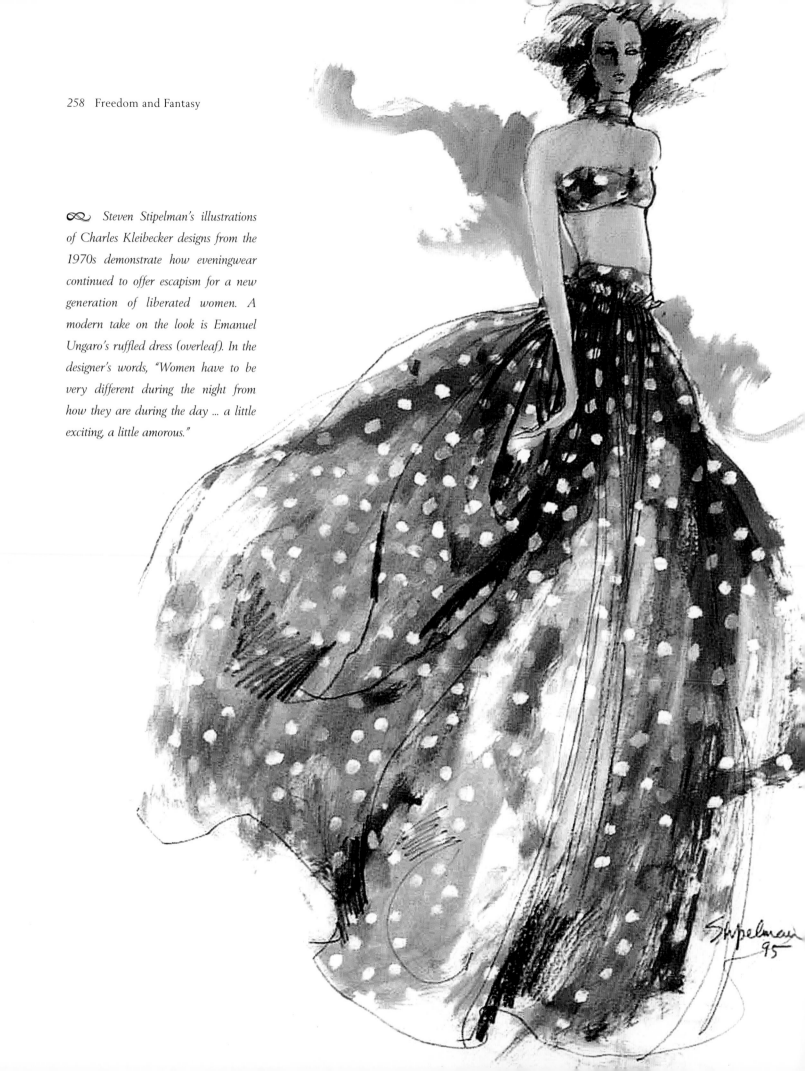

❧ *Steven Stipelman's illustrations of Charles Kleibecker designs from the 1970s demonstrate how eveningwear continued to offer escapism for a new generation of liberated women. A modern take on the look is Emanuel Ungaro's ruffled dress (overleaf). In the designer's words, "Women have to be very different during the night from how they are during the day ... a little exciting, a little amorous."*

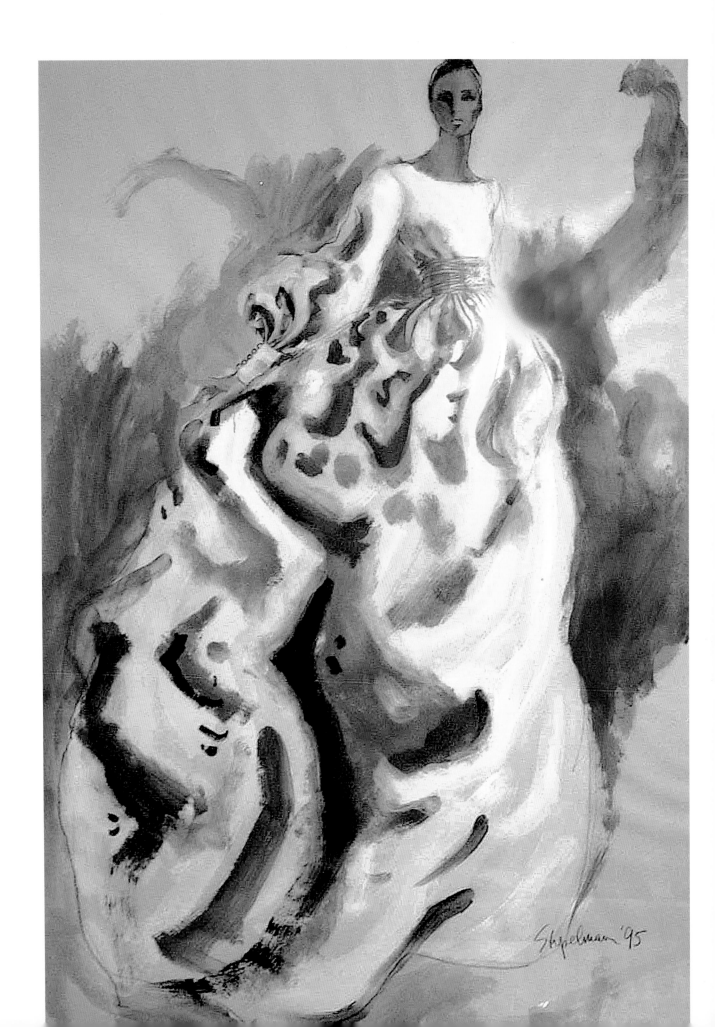

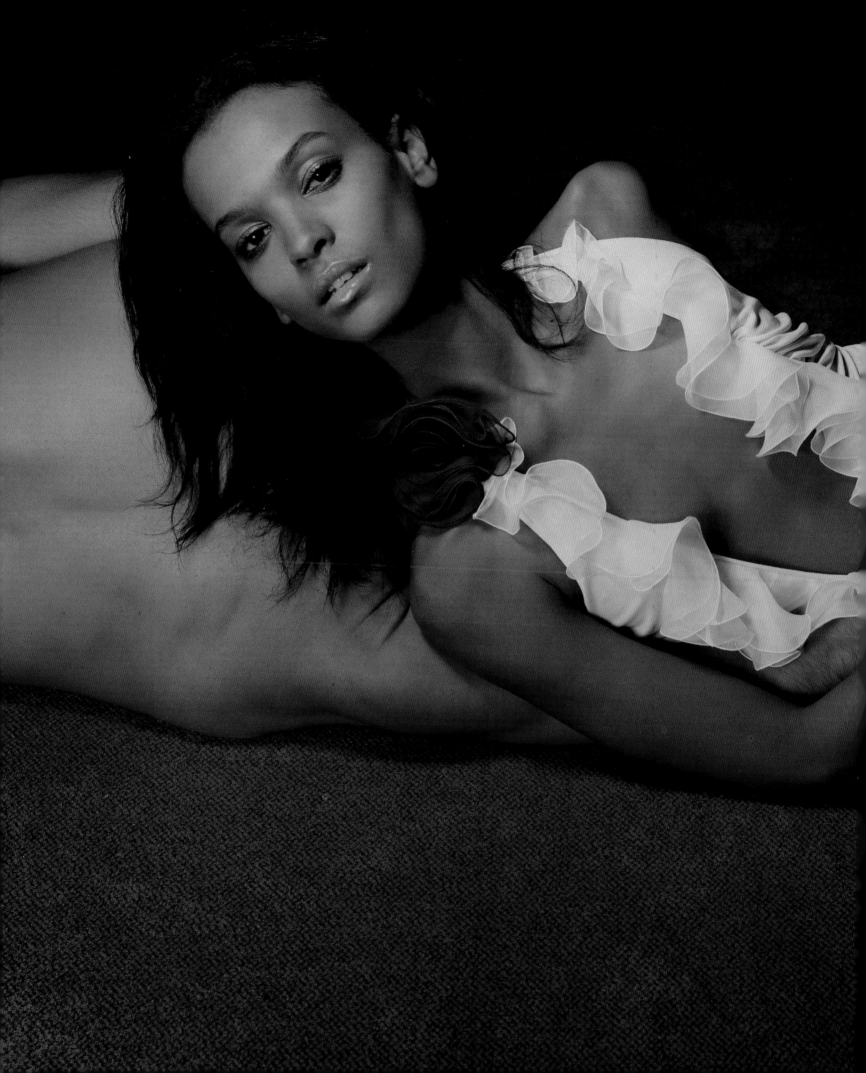

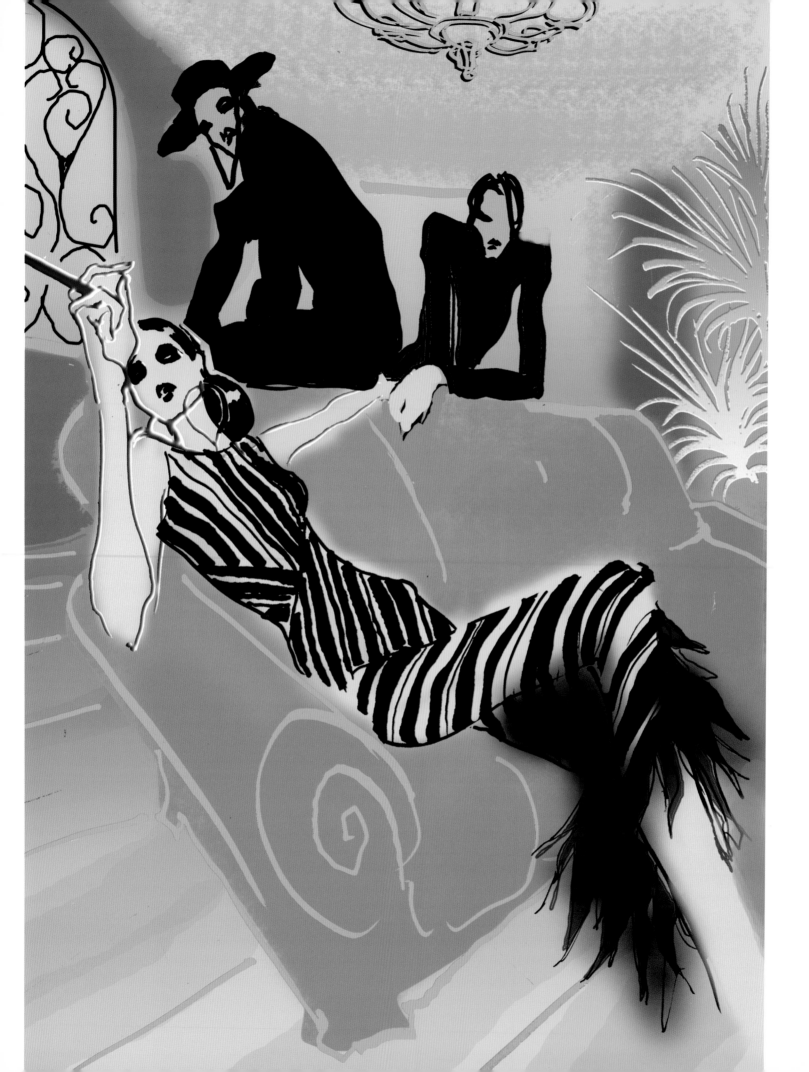

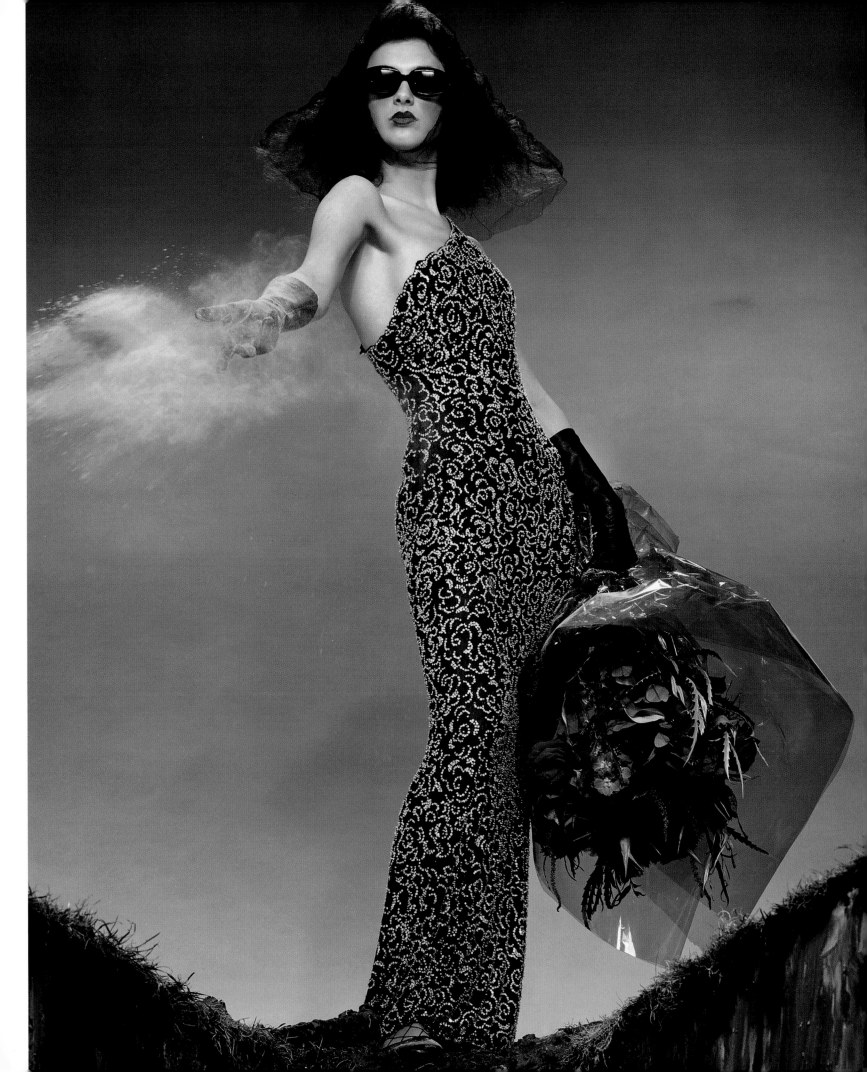

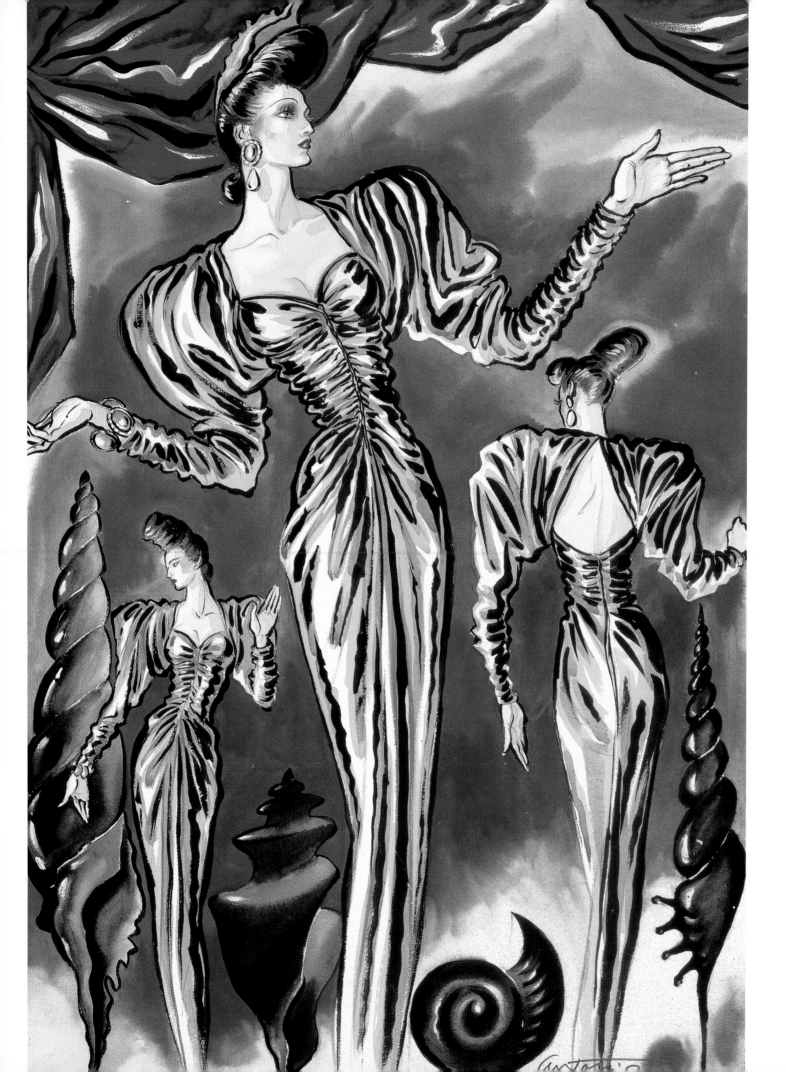

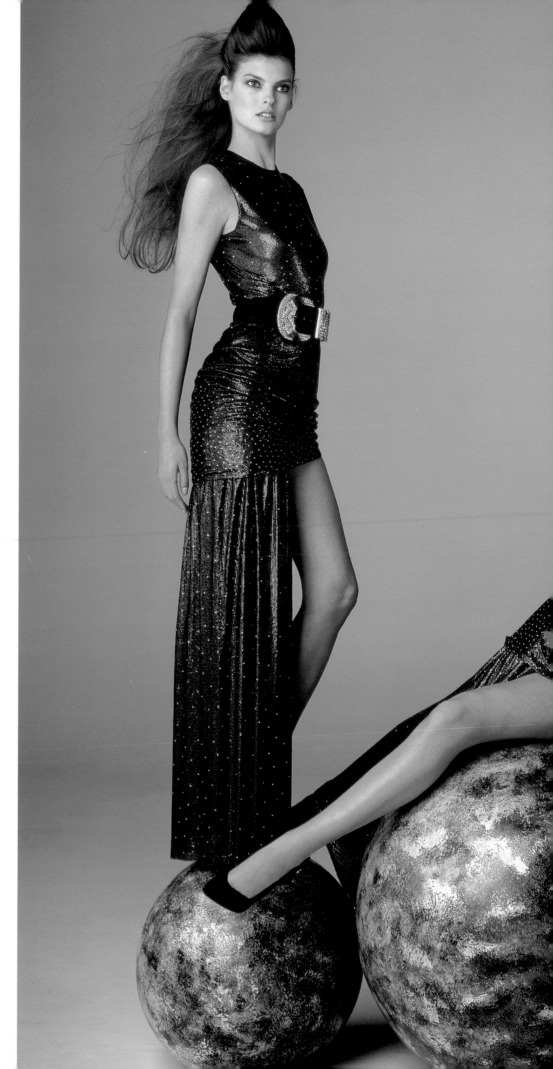

∞ *Three dresses by Gianni Versace, photographed by Michel Comte for Vogue Italia in 1994. They clearly show the trend for using asymmetric cuts and stretch fabrics. They also display Versace's penchant for bondage themes. Designer Jeremy Scott has cited Versace as one of the most influential designers of the previous decade, explaining: "Versace's Italia haute prostitute glamour became the ultimate symbol of late Eighties and early Nineties excess."*

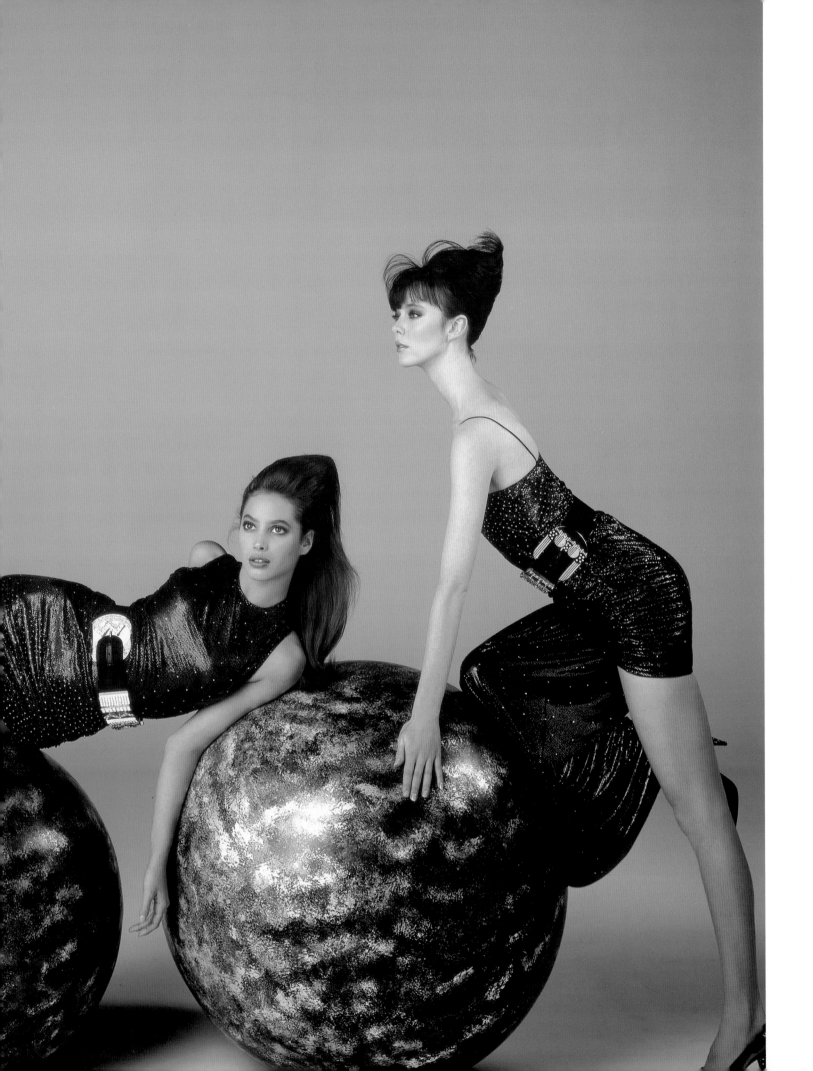

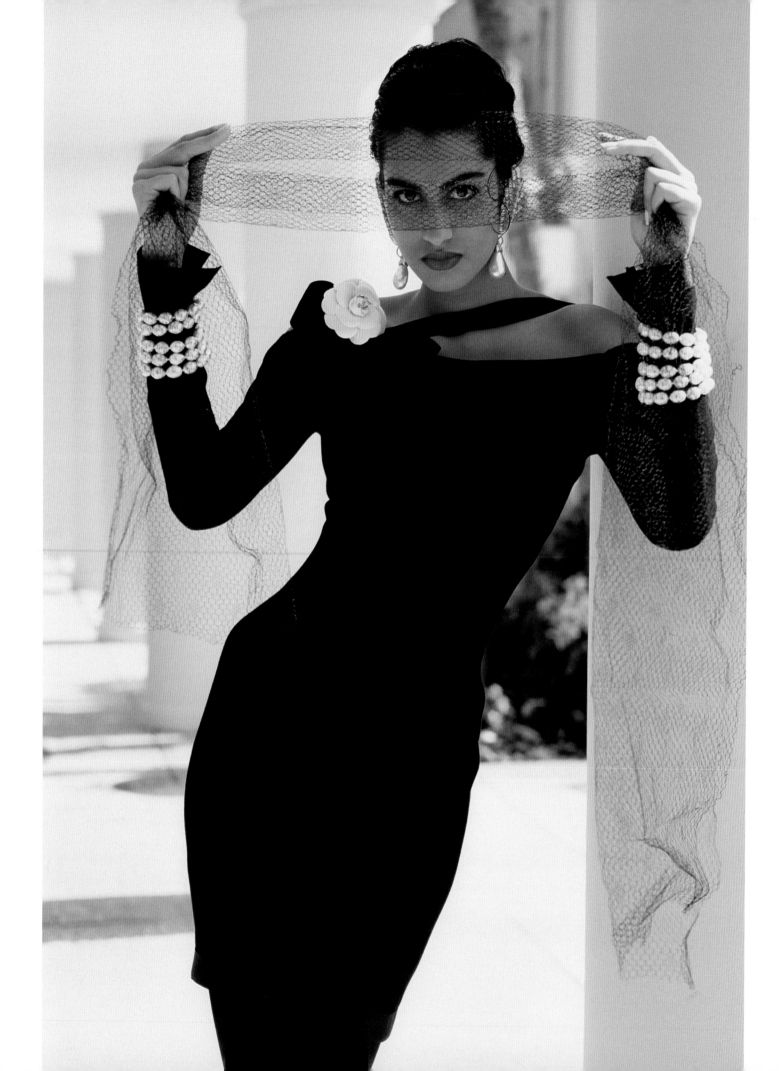

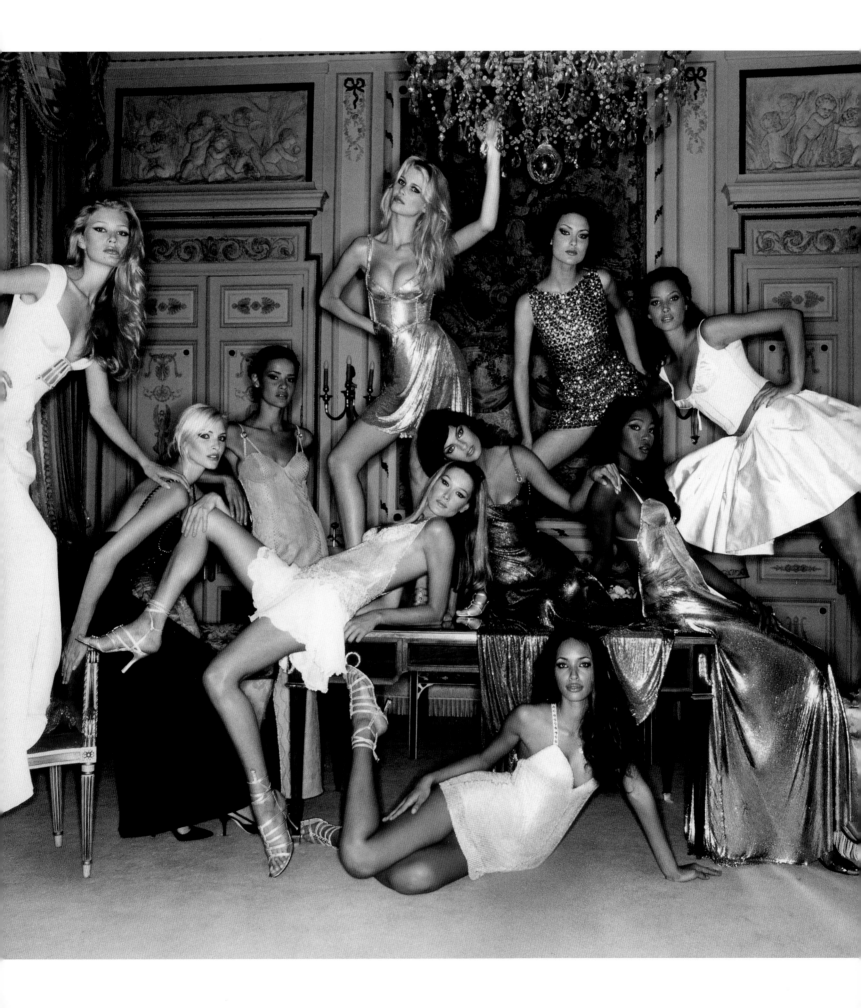

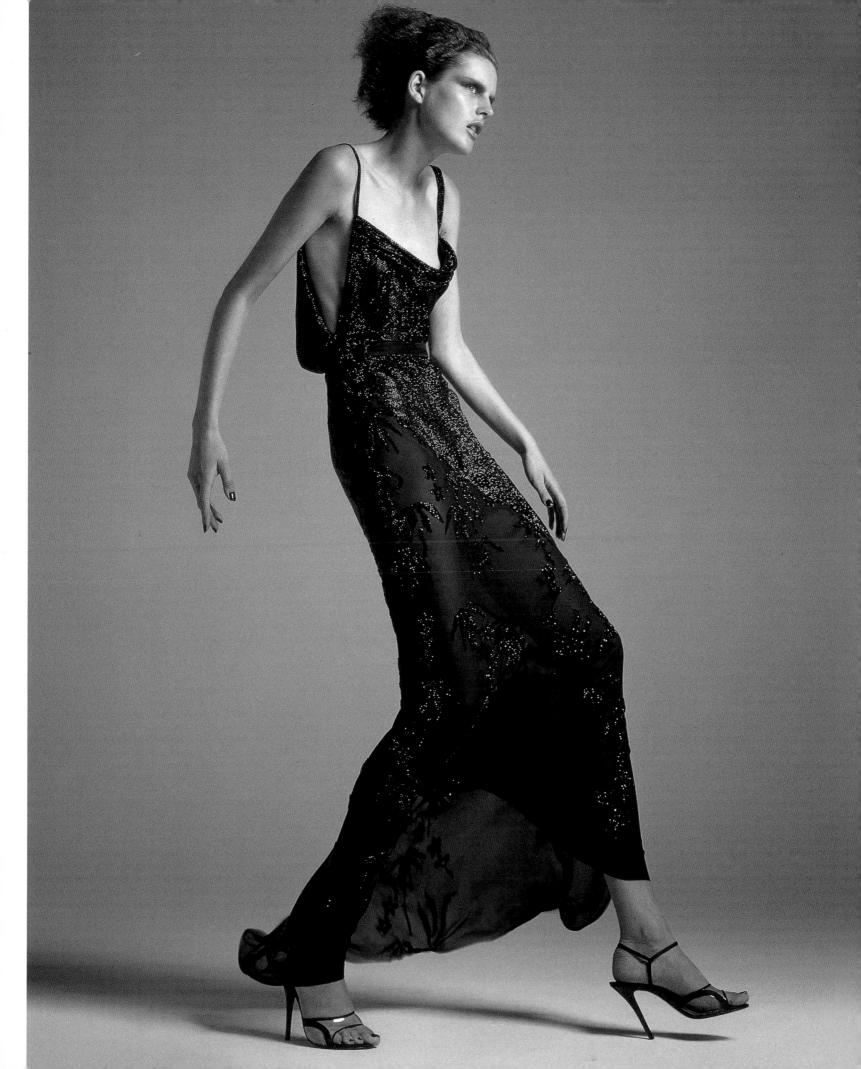

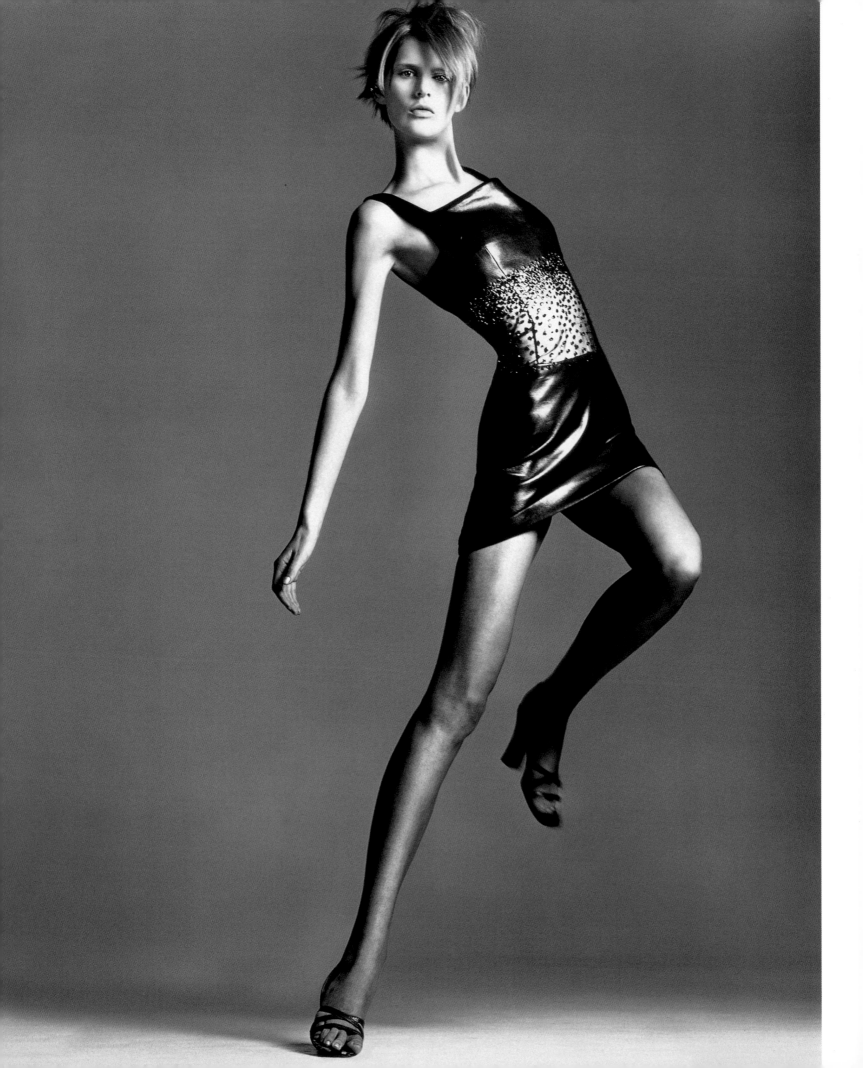

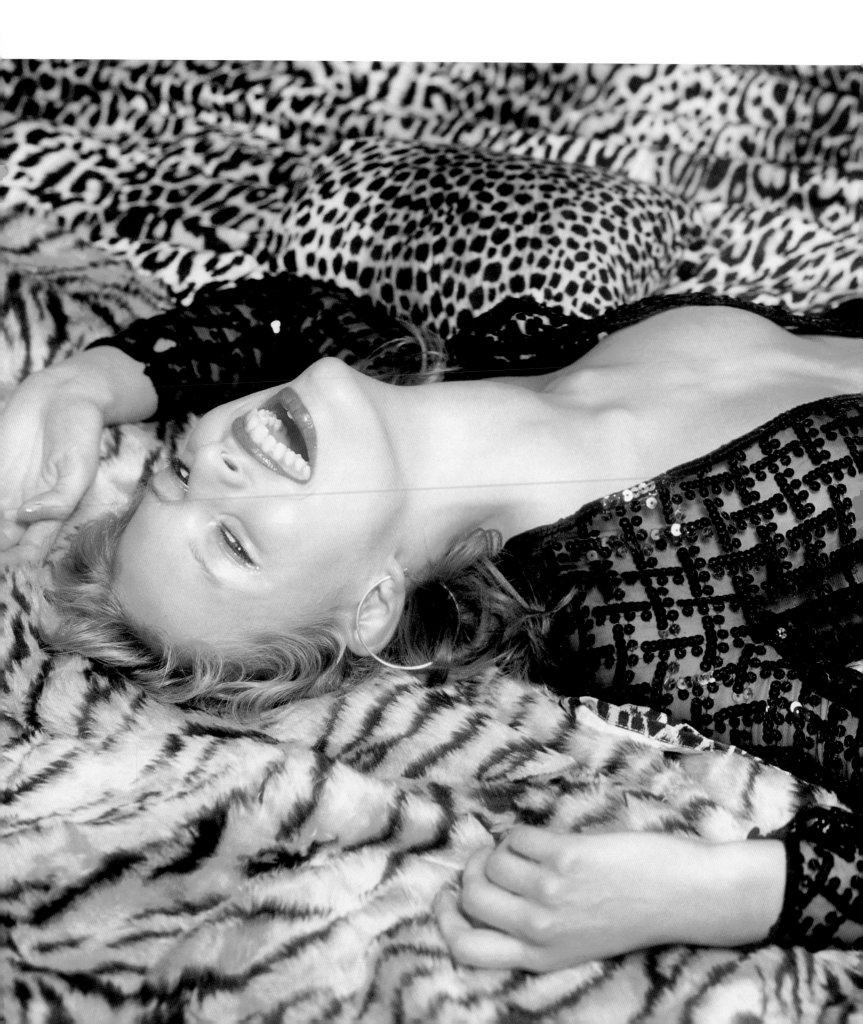

But then this was the 1980s, and sober elegance was not an option. Yet in his masterful handling of the various design considerations, Lagerfeld showed he was not literally interpreting the "Rich Look"; rather he was assembling it in a postmodern way. References to street culture, elements appropriated from different sartorial genres, and his constant reinterpretation of the Chanel logo and signature house styles from the past made his clothes completely of the moment. In this sense Lagerfeld was well suited to adaptation and he made a smooth transition to the 1990s.

The catalyst for fashion change at the end of the 1980s was the Wall Street collapse of October 1987. Designers responded by paring down the "Rich Look" and softening the bold and voluminous silhouettes of the mid-to-late 1980s into a more natural curvaceous line. *Women's Wear Daily* covered the Paris collections for fall 1989 under the headline "Europe's Soft Touch". "Europeans once again play up the feminine mystique for early fall and fall," it reported, "Whether in evening looks that pour over the body or in softly shaped daytime suits, the emphasis is on curves."

In her study of eveningwear in Louisiana 1896–1996, Mary Edna Sullivan, curator of Costumes and Textiles at the State Museum Louisiana concluded that in the 1980s, "Opulent displays mirrored the success and wealth of the decade; some women spent thousands of dollars on gowns for Carnival balls. But styles in Louisiana became more restrained after the oil bust of the mid 1980s. Women bought fewer new gowns and recycled old ones. Some even

∝ *The "body" emerged in the mid-1980s as a new kind of wardrobe basic, for both day and evening. The body worked especially well for night as it eliminated excess fabric and created a smooth line under skirts or trousers. This plunging, sheer sequinned body (opposite) is by Giorgio Armani.*

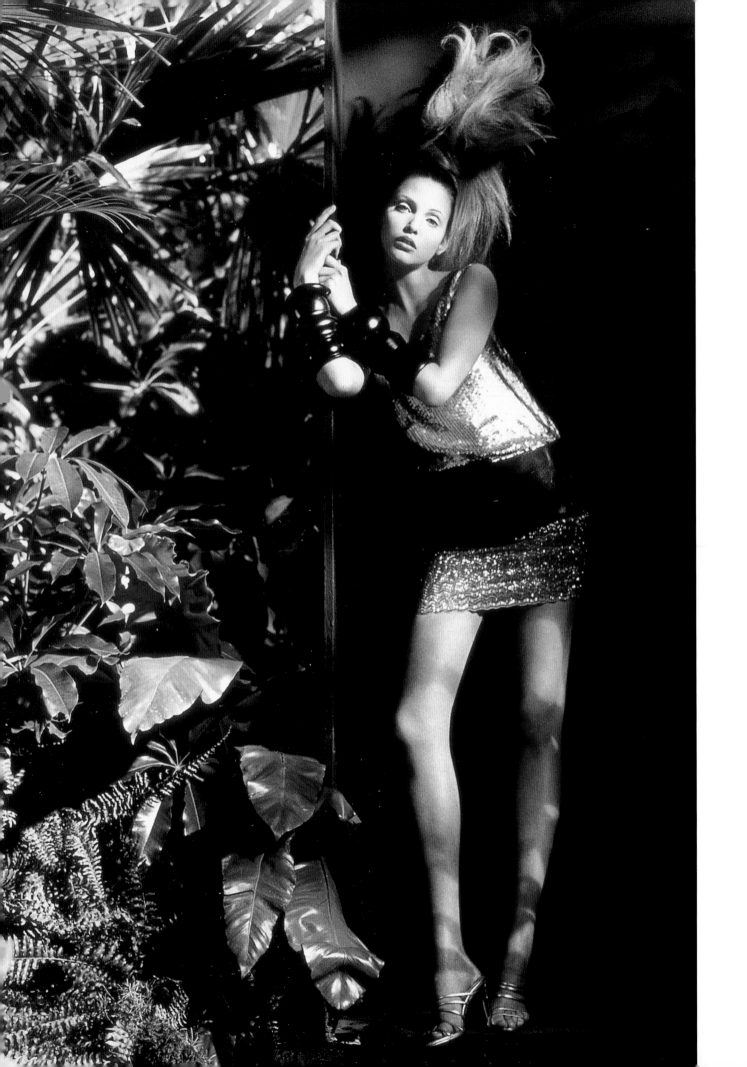

One of the key evening themes to emerge in the late twentieth century was that of the Amazon – a strong woman with an athletic body and assertive will, reflecting an increasing sense of economic clout. Gianfranco Ferre has said he designs for the woman who wants powerful clothes, embodied in his dresses from 1981 (left) and 1993 (preceding page, left). Giorgio Armani also aims to empower women through dress, such as his stretch mini that fits like a second skin and moves with the body (preceding page, right).

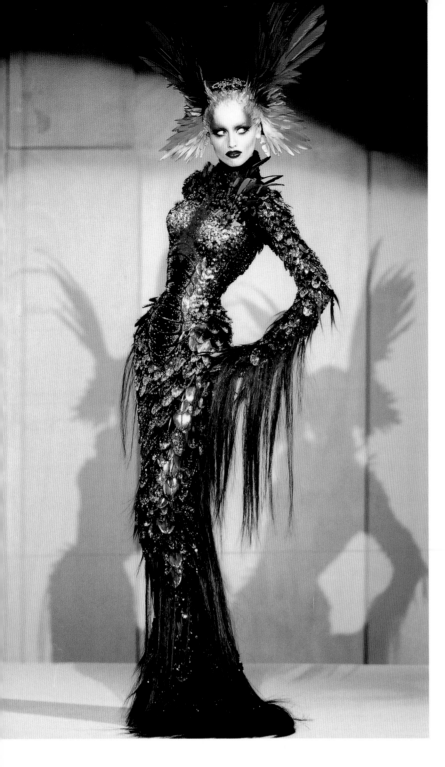

☙ Evening dress in the late 1990s revealed the wearer's body both through skin-tight figure-hugging styles, such as Thierry Mugler's creation of 1997 (above), and through transparent panels that gave an overall impression of modesty while selectively focusing attention on erotic zones. Gianfranco Ferre's evening dress of 1997 (opposite) is an example.

turned to 1950s vintage gowns, which had the double attraction of bargain-basement prices and a strapless 'retro' look. These trends segued into the 1990s, when understated styles ruled."

In 1990 writer Vicky Carnegy set out her prediction for how women would dress in the decade ahead. "Age looks set to be a dominant factor in the fashion of the nineties," she remarked. "The populations of North America and Europe are changing, with many more people in the forty-five to sixty-five bracket and fewer sixteen to twenty-four year-olds. The traditional youth market may become less important ... Fashions will have to adapt to dressing the woopie — the 'well-off older person'; who will have the money and leisure to spend on expensive clothes and accessories."

In hindsight her forecast can be seen as pretty accurate. For evening the 1990s in general offered a new grown-up take on eveningwear that was streamlined, minimal and chic. Fashion overall dissolved into numerous and varied styles for the numerous and varied style "tribes", and designers toyed with different ideas — grunge, the monastic look — before striking moderate ground. Sexy minimalism emerged as the dominant theme for evening.

Giorgio Armani, whose suits for day had been the choice of yuppies in the 1980s, came into his own for eveningwear in the 1990s. The natural lines, restrained style and subtle colors of his evening clothes were very much in vogue. Calvin Klein, too, enjoyed popularity for his sleek dresses in neutral shades.

Perhaps one of the most interesting eveningwear icons in the 1990s was Princess Diana. If anyone in that decade had the occasion to dress up, and the purse to match, it was Diana, and her evening looks throughout the decade mirrored changing fashion trends. In the 1980s, the princess

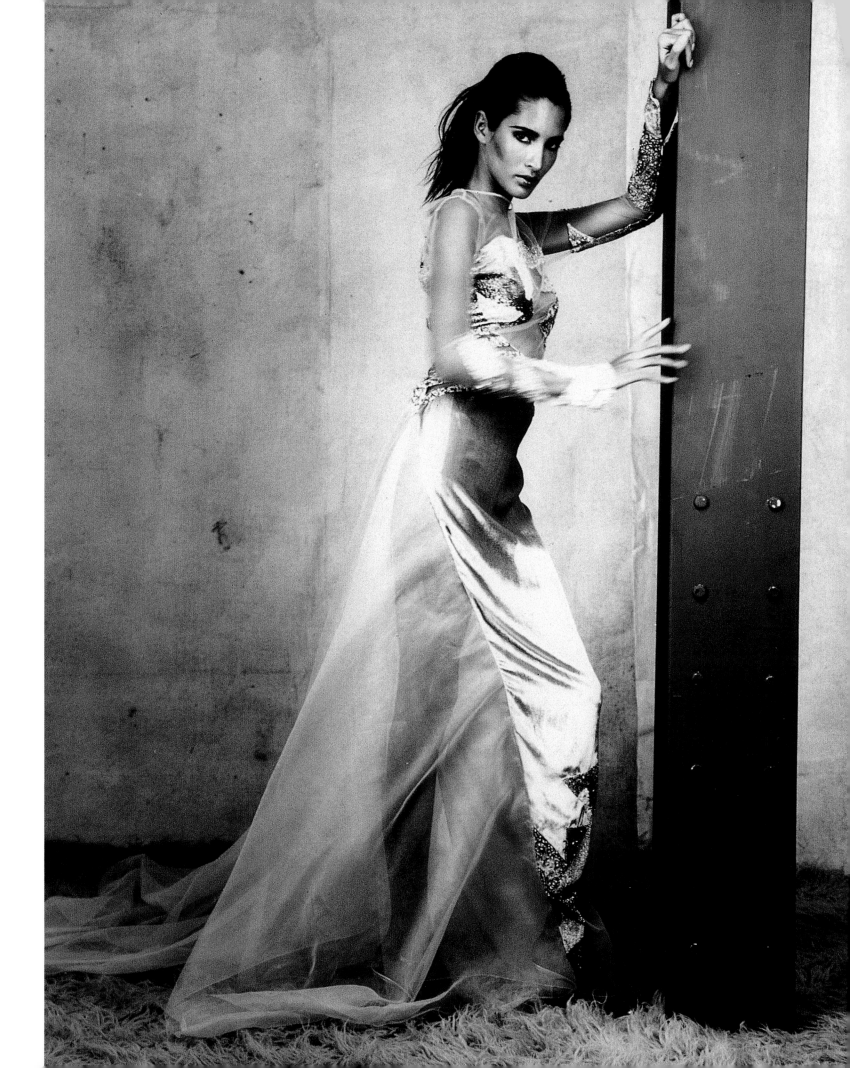

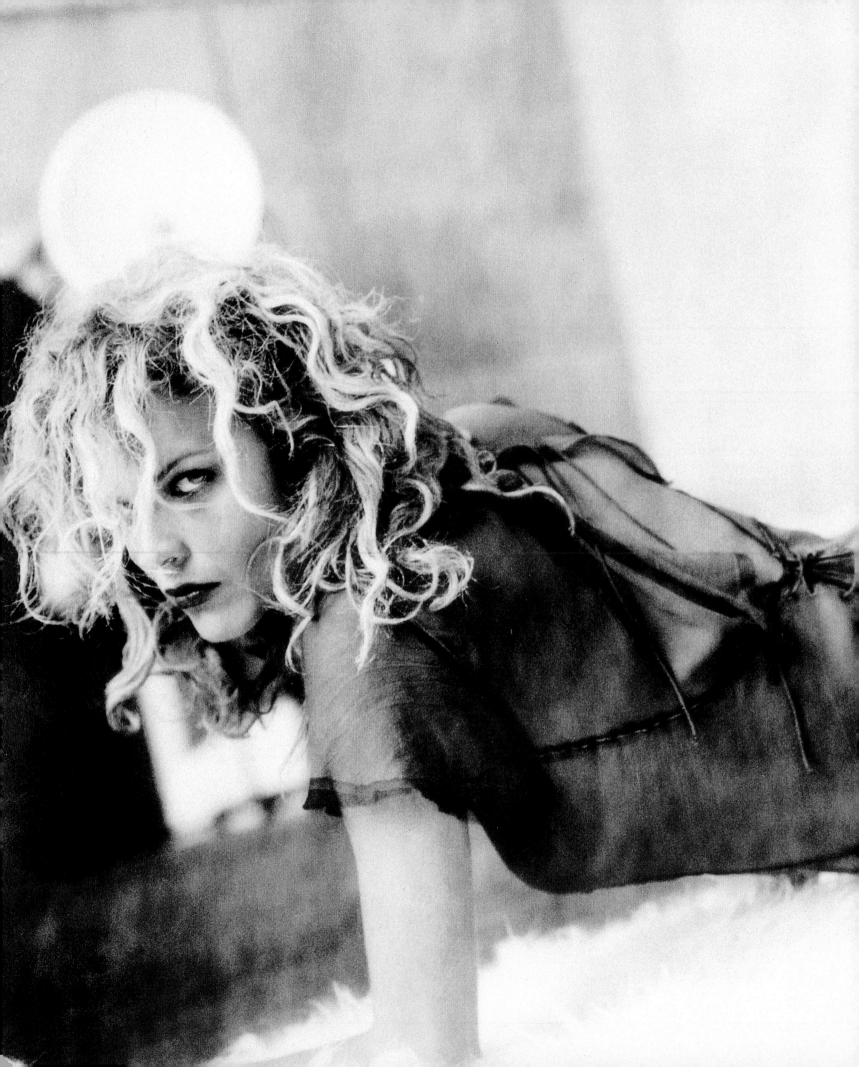

∞ *The deconstruction of dress has influenced eveningwear, which by definition invites designers to be more adventurous in their ideas. Alberta Ferretti has here wrought a dress in which intentionally visible seams trace the contours of the body.*

had been the yuppie's role model when it came to what to wear for a night out. By no means cutting-edge in fashion terms, she nevertheless had enormous mainstream appeal and her romantic outfits for evening were much admired, and copied.

She commissioned local British designers such as Belville Sassoon, Victor Edelstein and Catherine Walker to create eyecatching gowns. They were characterized by full skirts and bright colors, especially shades of blue, with a fairytale aura. Diana herself developed an eye for what would work best for gala occasions; dresses that would stand out from the crowd and photograph well. Her look was so admired that when she famously auctioned her collection of British designer gowns at Christie's in 1997, it was not just costume galleries and museums that attended to bid, as would usually be the case. Ordinary people crowded to get inside the auction house and bid for a special piece of fashion history. Broadcaster Diane Sawyer covered the event live for the ABC network: "You're looking at the scene outside Christie's this evening just before the people filed in for that big event. The charity auction of dresses direct from the closet of the Princess of Wales." Voicing the thoughts of countless women across the United States, she continued, "And let's 'fess up here. Who among us hasn't had a little fantasy of how we'd look in one of them?"

The auction signalled quite a radical change in Diana's look, one that evolved during the 1990s, particularly after her split from the Prince of Wales. Gone, literally, were the grand gowns of her early years. In their place Diana adopted a chic, minimal and sexy look. David Sassoon

designed one of Diana's first evening dresses, a romantic off-the-shoulder design with a satin waistband and a long full skirt. It was in stark contrast to her last commission from him, a simple black dress that draped across the front and featured embroidered chains as straps. Sassoon noted the change in her style. "As soon as she was no longer married, she changed," he has said. "Once she became an independent woman she didn't have to wear English clothes — she could spread her wings. It gave a completely different slant to her style."

From the mid-1990s Diana changed the way she dressed. Instead of always ordering gowns from her established designers of the previous decade, she now often bought off the peg, or ordered from European designers. Gianni Versace became a favourite. In her book *Dressing Diana*, Georgina Howell writes: "What Versace did for Diana was what he did for all his customers: he gave her sex appeal and a strongly modern style. During the eighties, he was nicknamed the King of Glitz and he epitomized flashy Italian dressing, with garish baroque prints, gilt geegaws and collections inspired by bondage and brothels. But as the nineties unfolded, Versace discovered minimalism and stripped down his designs to make plain pastel suits with discreet little buttons and dresses that dazzled with their daring cutting rather than their brightly colored prints. The timing was perfect and the new look Versace suited Diana admirably."

Alexander McQueen once said of Gianni Versace, "During my adolescence he intrigued me with the way he used fashion to show the power of women; women could

∞ *Avante-garde New York designer Isabel Toledo emerged in 1986 and came to prominence for her dresses made from fabrics that drape and flow. In the words of fashion historian Valerie Steele, "Toledo designs clothes that are structural, even architectural, and sometimes (as she says) rather severe — a lot of black and strong shapes." Three dresses by Isabel Toledo, illustrated by Ruben Toledo.*

look powerful coming from a working-class background." Although she certainly did not come from a working-class background, Diana did seem in need of empowerment, so Versace was a logical choice of designer.

Versace gowns featured prominently in her public engagements. For a performance by Pavarotti in Italy in 1995, for example, she commissioned a white silk crepe dress with low-cut neckline and diamanté buckles. As Gorgina Howell explains, "Although she would never have gone as far as the dramatic dress barely secured by safety pins worn by Elizabeth Hurley, the evening gowns she wore by Versace, as well as the cocktail dresses and tailored suits, held her in, pushed her up and gave her length — and curves — in all the right places."

Versace was not the only designer to enjoy Diana's patronage. For her appearance as the guest of honour at the opening of the Christian Dior retrospective at The Metropolitan Museum of Art in New York in 1996, Diana turned to the newly installed head designer at Christian Dior, John Galliano. The lingerie-inspired dress of midnight-blue satin crepe was seen in all the major newspapers the following day and generated huge interest in both

∝ *Since opening his first studio at the foot of the Spanish Steps in Rome in 1959, Valentino has become synonymous with evening elegance (below). In 1968 the fashion press declared him the King of Fashion and the Sheik of Chic. According to costume historian Harold Koda, "What Valentino does is make outrageously pretty dresses without making them seem silly."*

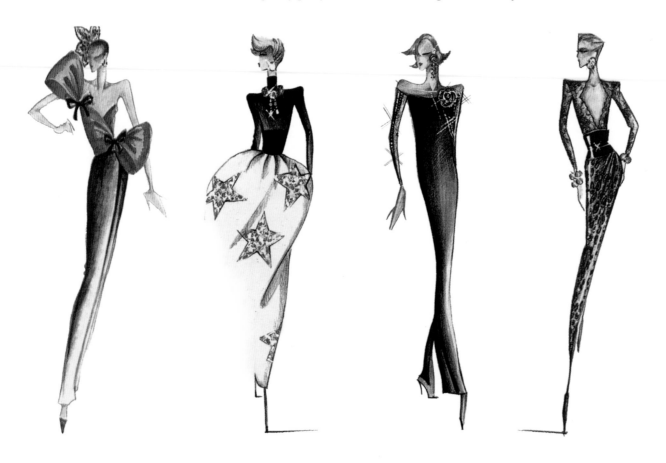

Galliano and the House of Dior.

The choice of Galliano was timely. The influence of this then-rising star of fashion on eveningwear has grown and flourished. The revival of bias cutting, a strong sense of fantasy, a love of fashion history and the influence of street culture made his couture clothes among the most innovative of the late 1990s and the early years of the twenty-first century. Like his rival at the house of Chanel, Galliano is a master of conjuring evening glamour by mixing historical and ethnic references with popular culture.

In 2001, *Women's Wear Daily* surveyed fifty fashion designers to ask them who they would pick as the three most important designers since 1980. The same names kept recurring — Rei Kawakubo for her radical genius, Jean Paul Gaultier for his sense of irony, Gianni Versace and Azzedine Alaia; but out on top were Giorgio Armani and Karl Lagerfeld.

Donatella Versace was one of the designers who picked Karl Lagerfeld: "A revolutionary designer," Donatella said, "especially when he was designing Chloé. I remember the gorgeous evening dresses with sneakers. That was genius; this image has stayed in my mind forever." Gianfranco Ferre, himself a considerable force in women's eveningwear, also voted for Karl Lagerfeld, "for projecting an unmistakable and timeless style into the future."

When the Metropolitan Museum of New York staged its Haute Couture exhibition in 1995, several Chanel evening outfits by Karl Lagerfeld were on display. One in particular seems to demonstrate the designer's genius for the postmodern, for creating new looks within a framework of historical references deliberately used for effect. It is an evening ensemble for Chanel's spring/summer 1995 collection, comprising a white silk-satin sailor top with thin horizontal blue-black stripes, entirely covered in an embroidered surface of white and blue-black seed beads,

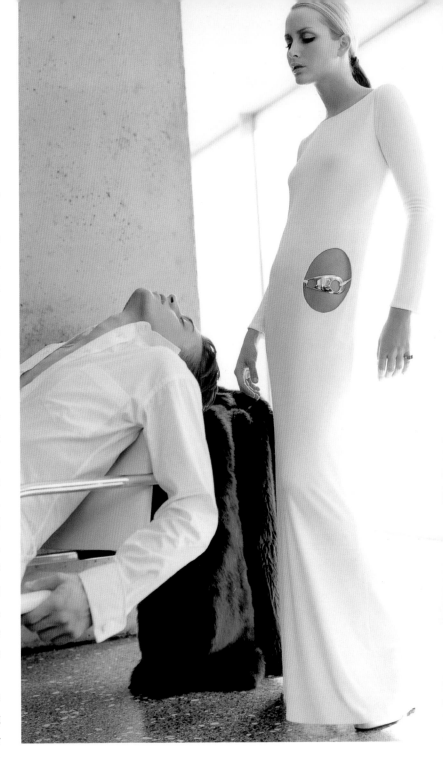

∞ *The end of the twentienth century was marked by an obsession with the body, and a nostalgia for past decades. Tom Ford reworks the 1970s motifs of T-shirt shapes and cutouts in his slinky white dress for Gucci (above). Gianfranco Ferre plays with transparency and the transforming power of dress in his embroidered, sequin-encrusted tulle evening dress (opposite).*

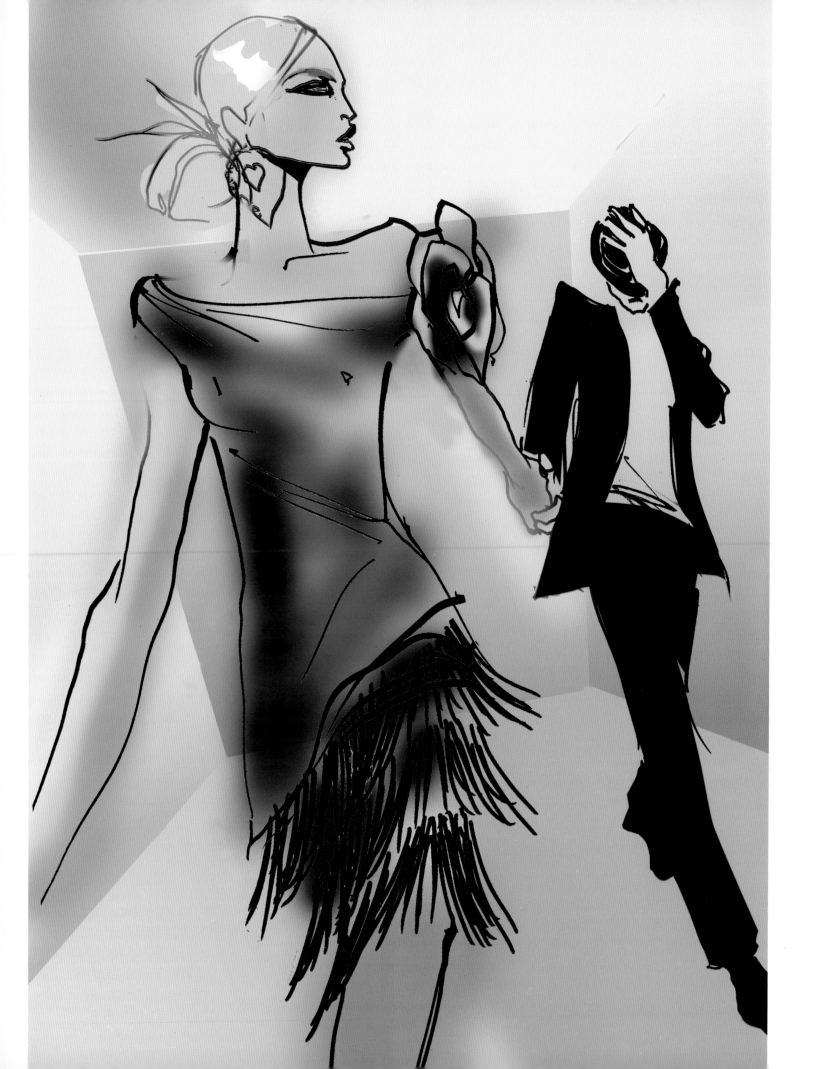

paired with a black silk chiffon skirt.

In the book that accompanied the Haute Couture exhibition, curators Richard Martin and Harold Koda commented that "Lagerfeld offers the deliberate paradox of a sailor's sweater from vernacular dress rendered in the luxury of couture. The designer's zeal for common clothing and popular themes, especially for the house of Chanel, where the acumen about menswear and practical clothing has always prevailed, does not vitiate his commitment to the excellence in design and technique of the couture. On the contrary, it is as if the juxtaposition of the two polar levels of fashion refines the couture's virtues and stimulates the couture's imagination." Indeed, this one evening outfit could be said to embody all the values we currently apply to eveningwear — historical references, luxurious yet relaxed, with a sense of street chic, and a revived interest in the uniqueness of couture.

What, then, is the future of the evening dress? Is its role now relegated to red-carpet events and as the showstopper of the couture and ready-to-wear catwalk shows? In a time of relative fashion confusion, and informal living styles, where the approach to dressing is more pick-and-mix than head-to-toe, designers, and the women who wear their clothes, are questioning what looks right for evening. In years to come will we be wearing more than simply jeans with heels and a glittery top, which seems to pass for eveningwear at almost any venue these days?

As we travel further into the twenty-first century, the overwhelming influence on eveningwear is the past. In recent years flapper looks, 1930s-style backless satin gowns, and ladylike waisted 1950s dresses have all been paraded on the catwalks and publicized on the red carpet by celebrities. Perhaps the style of dress is becoming less important, the uniqueness of the garment more important. The special qualities of bespoke gowns and the value of the couture are being reevaluated.

Some designers have gone so far as to herald the death of the evening dress. Even Roberto Capucci, who built his reputation on incredible gowns sculpted like works of art, has said that evening dress is irrelevant in these informal times. However, this seems unlikely. As fashion historian Valerie Steele has concluded, "Like language, the decoration of the human body seems to be the defining characteristic of the human race." Indeed, as daytime fashion continues to tend toward the casual, it seems virtually certain that eveningwear will remain the medium for indulging in a little beauty, glamour and, ultimately, escapism. This has, arguably, always been the case. But in the current cultural domain, where there are countless versions of beauty, and fashion has become a sophisticated form of communication, the power of the evening dress to take the wearer beyond the mundane is perhaps more relevant than ever.

∞ *As daywear becomes more casual, women become more inclined to splash out on something special for evening like this dress by Coccapani (opposite): a rare chance to swap functional clothes for potentially liberating fashion. In the words of Vivienne Westwood, "In this sea of banality, distinction and elegance of dress is of more value today than it ever was before."*

CREDITS

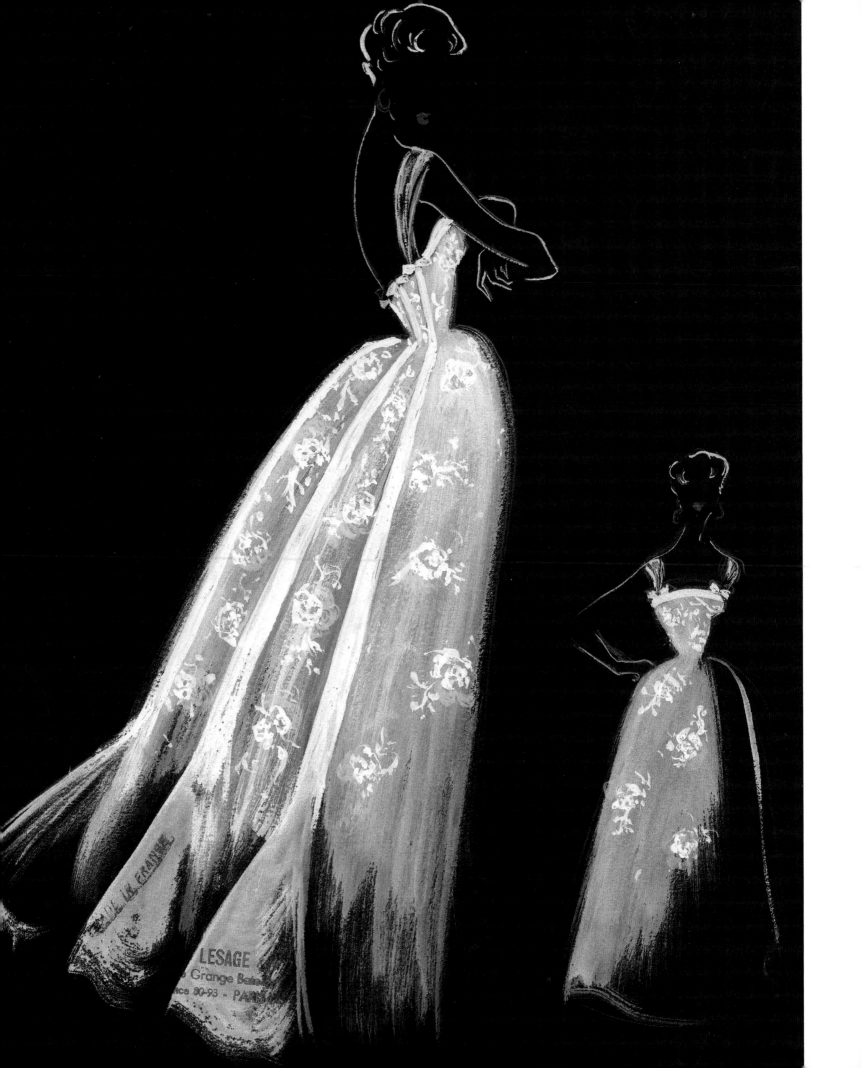

CHAPTER THREE

PAGE 156
photo: Bradd Nicholls

PAGE 301
*courtesy Valentino,
'Valentino: trent' anni
di magia', Leonardo*

PAGE 301
*courtesy Valentino,
'Valentino: trent' anni
di magia', Leonardo*

PAGE 158
*photo: Louise Dahl-
Wolfe, courtesy
National Museum of
Women in the Arts*

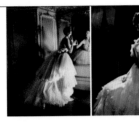

PAGE 161
*Australian Picture
Library/Corbis*

PAGE 170
*LoomisDean/
Timepix/Snapper Media*

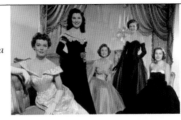

PAGE 162
*photo: Mario Testino
for British* Vogue

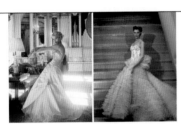

PAGE 163
courtesy Christian Dior

PAGE 173
*photo: Norman
Parkinson,
©Fiona Cowan*

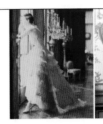

PAGE 175
*photo: Karl Lagerfeld,
courtesy Chanel;
model: Christy
Turlington*

PAGE 164
courtesy Reem Acra

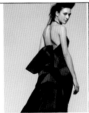
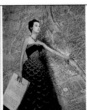

PAGE 165
*photo: Louise Dahl-
Wolfe, courtesy
National Museum of
Women in the Arts*

PAGE 177
*Allan Grant/Timepix/
Snapper Media*

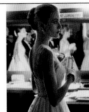

PAGE 178
*Illustration by Karl
Lagerfeld, courtesy
Chanel*

PAGE 166
*© Loomis Dean/
Timepix/Snapper Media*

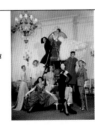

PAGE 167
*Illustration and dress
by Pauline Trigere,
courtesy The Fashion
School, Kent State
University*

PAGE 179
*Illustration by Karl
Lagerfeld, courtesy
Chanel*

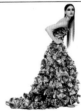

PAGE 180
*photo: Bruno Ripoche;
makeup: Pat McGrath;
hair: Guido Palau;
courtesy Valentino,
spring/summer 2003
couture collection*

CHAPTER THREE

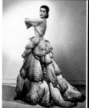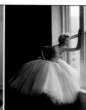

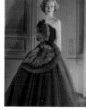
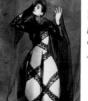
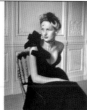
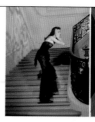
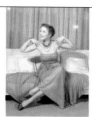
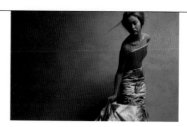

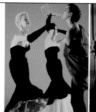

CHAPTER FOUR

PAGE 202
*courtesy Valentino,
'Valentino: trent' anni
di magia', Leonardo*

PAGE 208
photo: Bradd Nicholls

PAGE 203
*Nina Leen/Timepix/
Snapper Media*

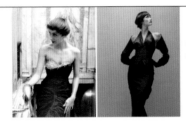

PAGE 204
*photo: Bryan Adams
for Hardy Amies;
designer: Ian Garlant;
model: Lisa Butcher*

PAGE 210
*Australian Picture
Library/Corbis*

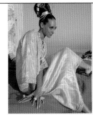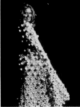

PAGE 212
*courtesy Emanuel
Ungaro*

PAGE 205
*photo: Mike Dulmen,
courtesy Christian Dior*

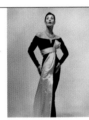

PAGE 207
*Illustration and dress
by Zac Posen*

PAGE 213
*courtesy Mila Schön,
1969 haute couture col-
lection*

PAGE 214
courtesy Oleg Cassini

PAGE 215
courtesy Oleg Cassini

PAGE 216–217
courtesy Oleg Cassini

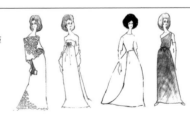

CHAPTER FOUR

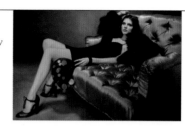

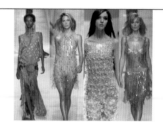

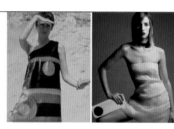
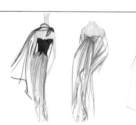

PAGE 236
*photo: Melvin Sokolsky,
courtesy Staley-Wise
gallery, New York*

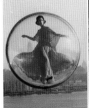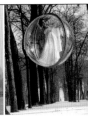

PAGE 237
*photo: Melvin Sokolsky,
courtesy Staley-Wise
gallery, New York*

PAGE 244–245
*photo: Norman
Parkinson
© Fiona Cowan*

PAGE 238
*photo: Amedeo Volpe,
courtesy Roberto
Capucci*

PAGE 246
*courtesy Valentino,
'Valentino: trent' anni
di magia', Leonardo*

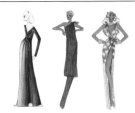

PAGE 240
*Illustration and dress
by Sonia Rykiel*

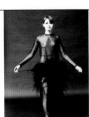

PAGE 241
*Bill Ray/Timepix/
Snapper Media*

PAGE 247
*photo: Norman
Parkinson
© Fiona Cowan*

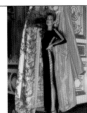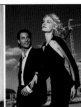

PAGE 248
courtesy Joop!

PAGE 242
*courtesy Valentino,
'Valentino: trent' anni
di magia', Leonardo*

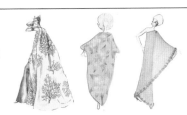

PAGE 250
*courtesy Alexander
McQueen*

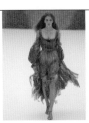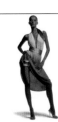

PAGE 251
*photo: Patrick
Demarchelier,
courtesy Celine*

PAGE 243
photo: Greg Kadel

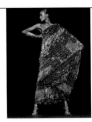

PAGE 252-253
*photo: David
LaChapelle, courtesy
Iceberg*

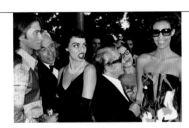

CHAPTER FOUR

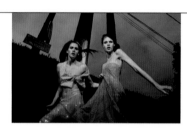

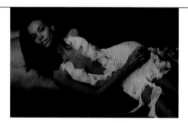
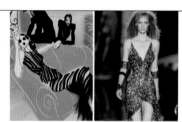

CHAPTER FIVE

PAGE 266-267
photo: Bradd Nicholls

PAGE 276
Photo: Bruno Pellerin, courtesy Scherrer, Autumn/Winter 2001–2

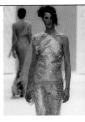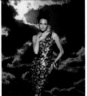

PAGE 277
courtesy Belville Sassoon

PAGE 268
photo: Greg Kadel

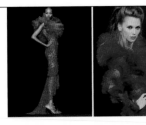

PAGE 270, LEFT
photo: Patrice Stable, courtesy Torrente Couture

PAGE 278, LEFT
courtesy Roberto Cavalli

PAGE 278, RIGHT
courtesy Roberto Cavalli

PAGE 270, RIGHT
photo: Patrice Stable, courtesy Torrente Couture

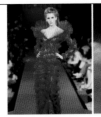

PAGE 271
© Giorgio Armani, courtesy Solomon R Guggenheim Museum

PAGE 279
Illustration courtesy Belville Sassoon

PAGE 272
Illustration by Antonio, courtesy Paul Caranicas

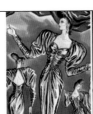

PAGE 273
photo: Patrice Stable, courtesy Thierry Mugler

PAGE 280–281
photo: Michel Comte, courtesy Versace

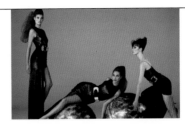

PAGE 274
photo: Fiorenzo Niccoli, courtesy Roberto Capucci

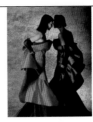

PAGE 275
courtesy Valentino, 'Valentino: trent' anni di magia', Leonardo

PAGE 282
photo: Karl Lagerfeld, courtesy Chanel; model: Yasmeen Ghauri

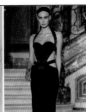

PAGE 283
photo: Patrice Stable, courtesy Givenchy

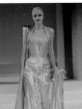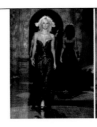

CHAPTER FIVE

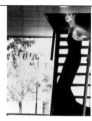
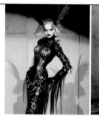
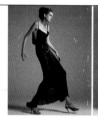
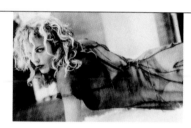
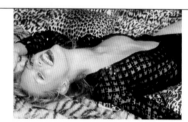

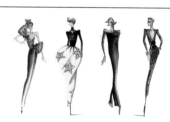

PAGE 305
*Illustration and dress
by Stephane Rolland,
courtesy Jean-Louis
Scherrer Couture*

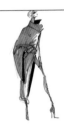

PAGE 314
*Illustration of Jacques
Fath gown, courtesy
The Fashion School,
Kent State University*

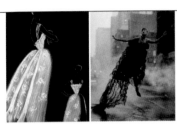

PAGE 332
*photo: Peter Lindbergh
for* Harper's Bazaar*;
model: Linda
Evangelista*

PAGE 306
*Illustration and dress
by Stephane Rolland,
courtesy Jean-Louis
Scherrer Couture*

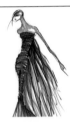

PAGE 307
*Illustration and dress
by Stephane Rolland,
courtesy Jean-Louis
Scherrer Couture*

PAGE 308
*photo: Michel Comte,
courtesy of Gianfranco
Ferre*

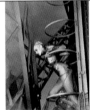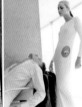

PAGE 309
*photo: Mario Testino,
courtesy Gucci*

PAGE 310
*Illustration by Thierry
Perez, courtesy
Coccapani*

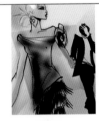

PAGE 312–313
photo: Bradd Nicholls

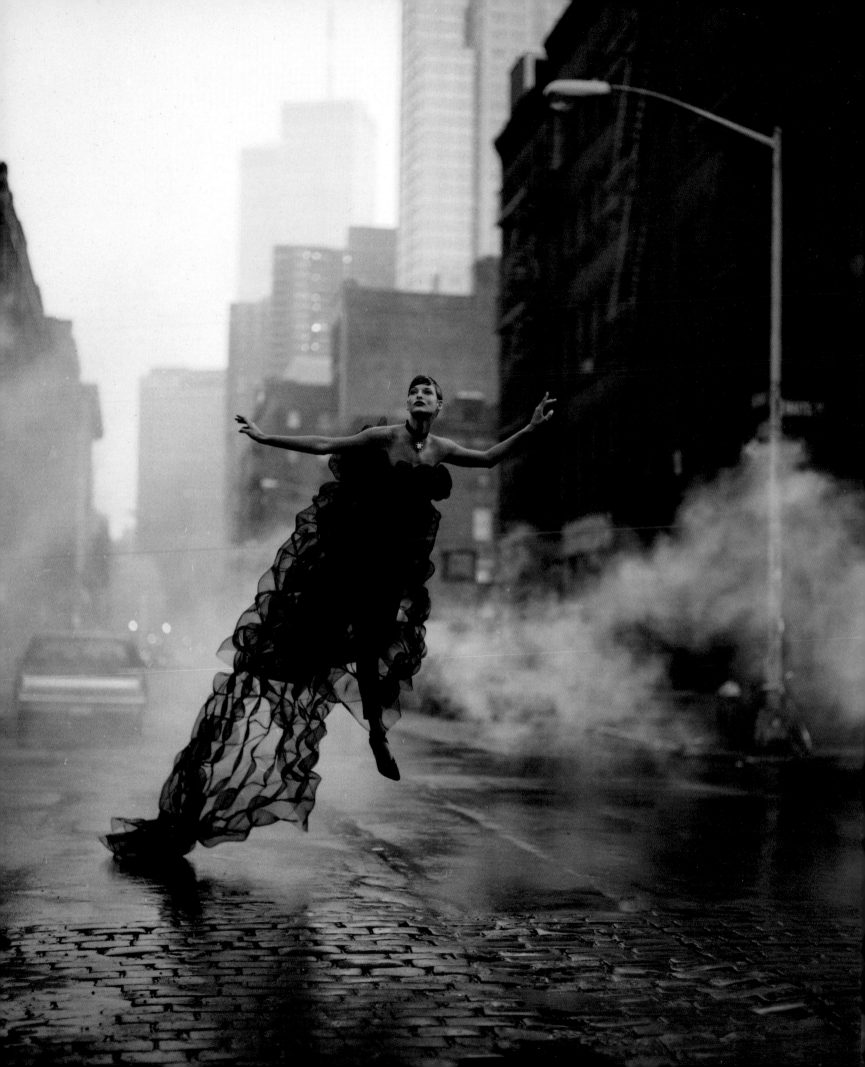

SELECTED BIBLIOGRAPHY

Ashelford, Jane *Dress in the Age of Elizabeth I*, B T Batsford Ltd., London 1988.

Baudot, Francois *Alaia*, Thames and Hudson, London 1996.

Beaton, Cecil *The Glass of Fashion*, Weidenfeld and Nicholson, London 1954.

Benbow-Pfalzgraf, Taryn, ed. *Contemporary Fashion*, St James Press, Michigan 2002.

Bradfield, Nancy *Costume in Detail: Women's Dress 1730–1930*, Harrap London 1968.

Buxbaum, Gerda, ed. *Icons of Fashion: The 20th Century*, Prestel, Munich 1999.

Carnegy, Vicky *Fashions of a Decade: The 1980s*, Facts on File, New York 1990.

Carter, Ernestine *The Changing World of Fashion*, Weidenfeld and Nicholson, London 1977.

Cawthorne, Nigel et al, *Key Moments in Fashion: The Evolution of Style*, Hamlyn, London 1998.

Constantino, Maria *Fashions of a Decade: The 1930s*, Facts on File, New York 1992.

Cunnington, C Willett *English Women's Clothing in the 19th Century*, Dover Publications, New York 1990.

DeBrett's Etiquette and Modern Manners, DeBrett's Peerage Ltd., London 1981.

de Réthy, Esmerald *Christian Dior: the early years 1947–57*, Thames and Hudson, London 2001.

Drake, Nicholas *The Fifties in Vogue*, Henry Holt & Co., New York 1987.

Ewing, Elizabeth *History of 20th Century Fashion*, B T Batsford, London 1992.

Ginsburg, Madeleine et al *Four Hunderd Years of Fashion*, William Collins Sons and Co. Ltd., London 1984.

Glynn, Prudence *In Fashion*, George Allen and Unwin, New York 1978.

Graham, Tim and Blanchard, Tasmin *Dressing Diana*, Weidenfeld and Nicholson, London 1998.

Herald, Jacqueline *Fashions of a Decade: The 1920s*, Facts on File, New York 1991.

Howell, Georgina *In Vogue: six decades of fashion*, Allen Lane, London 1979.

Lacroix, Christian *The Diary of a Collection*, Simon and Schuster Editions, London 1996.

Langer, Lawrence *The Importance of Wearing Clothes*, Elysium Growth Press, Los Angeles 1991.

Laver, James *Costume and fashion: A concise history*, Thames and Hudson Ltd, London 1992.

Lehnert, Gertrud *A History of Fashion in the 20th Century*, Könemann, Cologne 2000.

Lurie, Alison *The Language of Clothes*, Randon House, New York 1981.

Martin, Richard and Koda, Harold *Haute Couture*, The Metropolitan Museum of Art, New York 1995.

Mc Dowell, Colin, ed. *The Pimlico Companion to Fashion*, Pimlico, London 1998.

Mulvagh, Jane *Vogue History of Twentieth Century Fashion*, Viking, London 1988.

Muphy, Sophia *The Duchess of Devonshire's Ball*, Sidgwick and Jackson, London 1984.

Murray, Maggie Pexton *Changing Styles in Fashion: Who, What, Why*, Fairchild Publications, New York 1989.

Newton, Stella Mary *The Dress of the Venetians*, Scolar Press, England 1988.

Peacock, John *Fashion Sourcebooks: The 1920s*, Thames and Hudson, London 1997.

Racinet, Albert *The Historical Encyclopedia of Costumes*, Facts on File, New York 1988.

Ribeiro, Aileen *Fashion in the French Revolution*, B T Batsford Ltd., London 1988.

Schnurnberger, Lynn *Let There be Clothes*, Workman Publishing, New York 1991.

Sichel, Marion *Costume Reference Five: The Regency*, B T Batsford, London 1978.

Starobinski, Jean et al *Revolution in Fashion: European Clothing 1715–1815*, The Kyoto Costume Institute, Kyoto 1989.

Steele, Valerie *Fifty Years of Fashion*, Yale University Press, New Haven 2000.

Walkley, Christina *Dressed To Impress 1840–1914*, B T Batsford Ltd., London 1989.

Watt, Judith *The Penguin Book of 20th Century Fashion Writing*, Viking, London 1999.

White, Palmer *Elsa Schiaparelli: Empress of Paris Fashion*, Aurum Press, London 1986.

Wilcox, Claire and Mendes, Valerie *Modern Fashion in Detail*, Victoria and Albert Museum, London 1991.

British *Vogue* magazine, issues 1930–1990, Condé Nast.

American *Vogue* magazine, issues 1930–1990, Condé Nast.

INDEX

Page numbers in *italics* refer to
illustrations/captions

ACKNOWLEDGMENTS

Numerous people have kindly lent their time and talents to the creation and execution of this book. There are almost too many to mention by name but in particular the author gratefully acknowledges the contribution and support of the following: Bradd Nicholls, Melissa Kelly at Snapper Media, Susie Stenmark and Marika Genty at Chanel, Madame Sonia Rykiel, Caroline Boué at Sonia Rykiel, Stephane Rolland at Jean Louis Scherrer, Gabriel Scarvelli and Laura, Millicent Myers at Worling Saunders, Christopher Jeney, Penny Culliton and Akira Isogawa, Library staff of The Powerhouse Museum, Alyssa Kolsky at *Harper's Bazaar*, Barbara Haughton at David Jones' Archive, Violante Valdettaro at Valentino, Rolande Pozo at Paco Rabanne, Toni Maticevski, Trish at Line Communications, Zac Posen, Andrea Unterberger and Ruben Toledo, Nina at Nick Knight's studio, Nick Knight, Laura Giudici at Bluemarine, Steven Meisel, Debbie Lovejoy at Ben De Lisi, Daniela at Caroline Charles, Clive Arrowsmith, Patricia Astruc at Carven, Yvonne at Roberto Capucci, Georgette Johnson at *Vogue Australia*, Alison Clark at Yellow Door, Alexandra Boes at René Lezard, Emanuella Barbieri at Roberto Cavalli, Paul Caranicus, Pepita Weber and Ian Garlant at Hardy Amies, Bryan Adams, Greg Kadel, Sally McPherson at Giorgio Armani, Anna Hägglund at Studio Luce, Paolo Roversi, Christiane Dickson and Soizic Pfaff at Christian Dior, Peter Lindbergh's studio, Charlene Clifford at Celine, Linda Edgerly and Deborah Shea at Bill Blass Archives, Sophie Da Fonseca at Gucci, Mylène Lajoix at Givenchy, Shaun Malavich and Marcello at Versace, Staley Wise Gallery, Sebastian Wormell at Harrod's Archive, Juliette Airault at Paule Ka, Giulia Baragiola at Alberta Ferretti, Isabella Maffettini, Albert Watson, Paola Locati at Dolce & Gabbana, Michel Nafziger, Zan at Steven Klein's studio, Caroline Livchitz at Torrente, Valerie Lachance at Nina Ricci, Ilaria Alber at Gianfranco Ferre, Corinne Kunz and Eva Sieber at Akris, Pritty Ramjee, Alessia at Grimaldi Giardina, David Sassoon, Yvonne Caban and Cedric Edon at Karla Otto, Patrick Demarchelier, Mario Testino, Elizabeth Rhodes at Kent State University, Odile Fraigneau at Lanvin, Catrin Ehlers at Joop, Elena Perazzo and Giuseppina Graham at Prada, Judith Stora at Emanuel Ungaro. Special thanks to Beatrice Vincenzini, David Shannon, David Mackintosh and Ruth Deary at Scriptum Editions.